THE
OUTDOOR
ARCHIVE

THE OUTDOOR ARCHIVE

The Ultimate Collection of Adventure & Sporting Graphics, Illustrations and Gear

With over 600 illustrations

Chase Anderson & Clint Pumphrey
Foreword by Chris Burkard

Chris Burkard
Jeff Staple
Nur Abbas
Yoon Ahn
Saeed Al-Rubeyi
Conrad Anker
Amy Auscherman
Brittany Bosco
Thibo Denis
Ronnie Fieg
Elizabeth Goodspeed
Dr Rachel S. Gross
Shigeru Kaneko
Dr Julie Lamarra
Alasdair Leighton-Crawford
Katie Hargrave and Meredith Laura Lynn
Nick and Willamina Martire
W. David Marx
Nicole McLaughlin
Kimou Meyer
Nova / Marianna Mukhametzyanova
Jeanine Pesce
Solene Roge
Charles Ross
Ashima Shiraishi
Jaimus Tailor
Lei Takanashi
Avery Trufelman
Wai Tsui

CONTENTS

Foreword 7
Reflections 9
Introduction 11

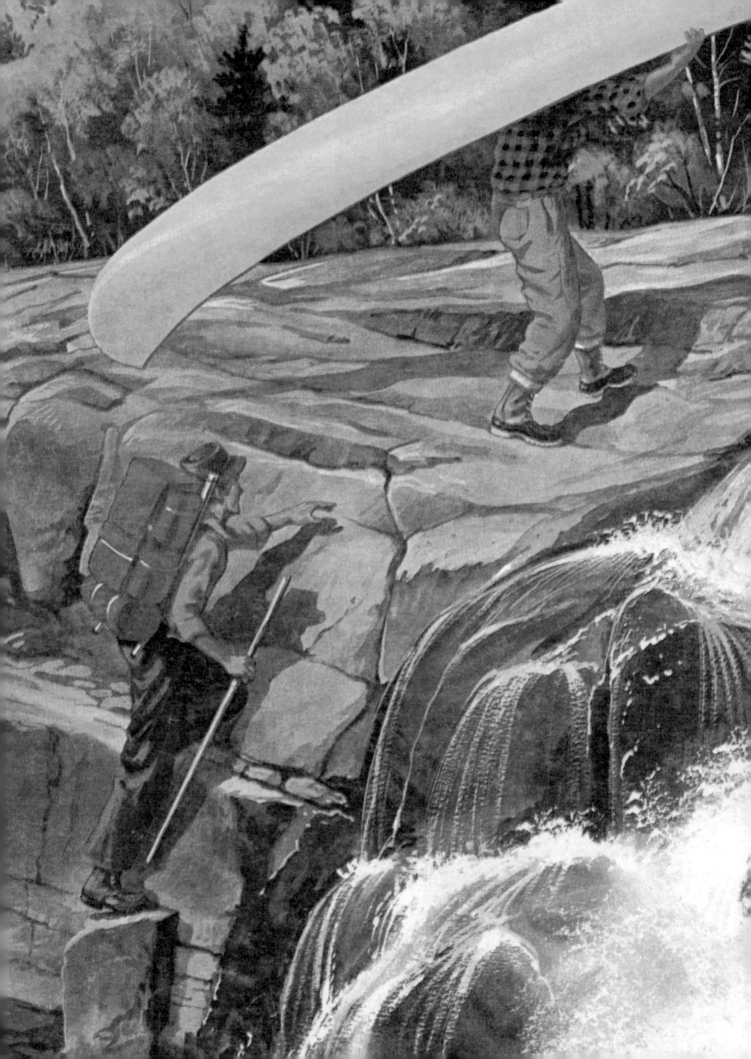

CHRIS BURKARD
Outdoor photographer

The Outdoor Archive holds an unlikely collection: pages and pages of long-forgotten catalogues and magazines that were possibly only flipped through or looked at for a few minutes before making their way into the recycling bin. They may have provided inspiration for future trips or much-needed gear for time spent outside — a practical means to an end.

For some people, however, like those holding this book in their hands, these catalogues and magazines meant much, much more. They were something to be marvelled at, kept near the nightstand; their pages torn out and plastered on mood boards and college dorm rooms, or even pasted onto the front of a binder. They served as a constant reminder that what we value most is time in nature and the gear that gets us there.

As a photographer, outdoor catalogues served as my early bible and reference point in an ever-growing industry that I sought to understand and study in order to create better images and stories. I hoarded catalogues, keeping them nearby at all times. Like the magazines I loved, they served as a key touchpoint, allowing me to keep a pulse on what was 'cool' and who was leading the charge in the outdoor space. Growing up in a small town, far away from the outdoorsy cultural hubs that captivated me, these catalogues and magazines were my lifeline.

For many of us, the day a new Columbia catalogue or North Face magazine came to the door was a day to celebrate — to pore over the adventures, from far and wide, of the athletes, activists and storytellers wearing their gear. Their pages were a connection to a broader world, one of natural splendour and great adventure. Living a small-town existence, I needed to see and know what was out there; Caribou, Holubar and Osprey gave us a much-needed pressure release by showing us what was possible. The images themselves were often gritty, reflecting a photojournalistic approach to storytelling and adventure photography, mixing the two in a way that felt palpable, as if you could step into the scene. The everyman or woman was on show: someone relatable who didn't seem to be wearing make-up or had just had their hair done. That was the difference between the outdoor advertising world that I fell in love with and the general fashion industry. The rougher the better I always thought, and when I saw a product being shown in a way in which it looked truly used and worn, it immediately gained my respect.

In some ways, this book now feels like a reflection on a different time. Today, we're often sold more polished advertising campaigns and pseudo adventures, which is why holding onto something like this has never been more important. Looking back through these iconic catalogue and magazine covers, I'm struck by how the images rouse my senses. They don't feel commercial in the sense we understand today. Back then, it was less about the bottom line and more about a beautiful cover photo that could have been stripped from the pages of *National Geographic*.

The Outdoor Archive reminds us of what matters most: our experiences in nature, and the gear that makes it possible. This enviable collection stands as a true testament to the work of teams of creatives, photographers and photo editors — and the consumers and dreamers that kept these brands going.

L. L. Bean, 1972, 23 × 20 cm (9 × 7.75 in), 120 pages
Team: Chuck Ripper

JEFF STAPLE
Fashion and footwear designer

Throughout my career, exploration and adventure have been constant sources of inspiration. For more than thirty years, outdoor apparel and equipment have not only sparked my creativity but also served as essential companions in my personal pursuits as a skier, snowboarder and hiker. I've traversed the highest peaks and navigated the deepest trails, understanding first hand how the right gear doesn't just elevate the experience — it can literally save your life. This book is a testament to these vital tools, weaving together a narrative of performance, innovation, aesthetics and sustainability in outdoor gear.

As I peruse this collection, I'm also intrigued by the lifecycle of the brands themselves — the reasons behind their rise, fall and sometimes resurgence. I ponder the fate of dormant brands that may one day re-emerge as household names and consider how I might contribute to such a revival. The cyclical nature of brand popularity, from inception to zenith, decline and rebirth, is a captivating aspect of the industry.

But why create an archive, or indeed a printed book, in this digital age? While some of these images may exist online, there's profound value in curating them systematically, showcasing the industry's evolution through a tangible, page-by-page journey. Such a collection goes beyond a simple retrospective; it offers a lens through which we can influence the direction of outdoor gear as well as broader design practices, including graphic design, photography, typography and clothing design.

In fact, the choice for brands to present their collection in print form is deliberate. While digital formats like e-books and PDFs are more accessible, they lack the tactile quality and commitment required for printed media. Creating a printed catalogue demands perfection — from high-resolution images and precise colour separation to flawless grammar and typography. There's no 'undo' button in print. A beautifully crafted catalogue reflects the quality and thoughtfulness of the collection it represents. I adhere to the principle: 'Fast, Cheap or Good — choose two'. In my experience, the dedication to quality evident in a printed book often signifies the excellence of the collection it showcases.

I truly hope this book — and the archive on which it's based — will serve as inspiration for generations to come.

Summit, 1972, 28 × 22 cm (11 × 8.75 in), 44 pages

CHASE ANDERSON AND CLINT PUMPHREY
Industry Relations Manager and Manuscript Curator, The Outdoor Archive, Utah State University

For decades, outdoor brands have put daring and aspirational images on the covers of their magazines and consumer catalogues — from grainy climbing photographs to homely illustrations of happy campers and cinematic landscapes. This fascinating resource of outdoor covers, drawn from the Outdoor Archive at Utah State University, highlights some of the collection's most striking imagery.

Standing at about six thousand one hundred items (and growing), the Archive catalogue collection is a veritable encyclopaedia of outdoor fashion and design history. It contains items dating from 1900 to the present day and features more than nine hundred brands, from centenarians like Coleman and Lowa to relative newcomers such as Mountain Hardwear and Jack Wolfskin. The magazine collection, loaded with articles evaluating gear and educating readers about how to use it, currently holds around seven thousand one hundred items across two hundred and fifty titles, ranging from 1907 to today. The following pages showcase a curated selection of these rich collections, highlighting captivating cover images from seventy-one outdoor brand catalogues and two of the Archive's most visually engaging magazines, *Summit* and *Mountain Gazette*. Together, they make up a stunning pictorial sequence that traverses generations, sports, styles and continents.

Never has there been more interest in the history of outdoor clothing and gear. As many of the companies associated with the modern outdoor industry — from The North Face and Salomon to Black Diamond Equipment and Snow Peak — celebrate milestone anniversaries, brands, designers and consumers are feeling nostalgic. Companies are rereleasing throwback product lines; creatives are seeking out vintage inspiration in their fashion and graphic designs; and consumers are increasingly drawn to upcycled and second-hand goods, both for the classic styling and sustainable qualities. It was into this context that Utah State University's Outdoor Recreation Archive was born in 2018, through a partnership between the school's Merrill-Cazier Library and the Outdoor Product Design and Development programme. The most wide-ranging, publicly available assemblage of outdoor clothing and gear history in the world, the Archive contains something for anyone interested in vintage outdoor design, including documents, photographs and print materials.

The outdoor catalogues and magazines in the collection have taken on new meaning and purpose since first hitting consumers' mailboxes decades ago. Back then, they might have been given a cursory glance or a quick read before being relegated to the bin. Some might even have been labelled 'junk mail'. But as many scholars, creatives and enthusiasts now realize, this description betrays the great creativity, care and wealth

Black Diamond Equipment, 1992, 26 × 18 cm (10.25 × 7 in), 39 pages
Team: Mugs Stump

of information that went into creating the imagery, layouts and copy for outdoor catalogues and magazines. As it turns out, these items aren't just forgotten relics of the past; they are, collectively, a repository for inspirational outdoor design elements ripe for reimagining.

One of the most appealing characteristics of the catalogue and magazine imagery is the sheer variation in sports and landscapes that are represented. Activities and gear featured on the covers reflect what many recreationists would consider non-motorized outdoor pursuits — including camping, hiking, backpacking, skiing, snowboarding, snowshoeing, climbing, mountaineering, kayaking, rafting, canoeing, trail running and mountain biking. Iconic shooting locations span the USA — Utah's Red Rock Desert, the Colorado Rockies, California's Yosemite Valley — and the Nepalese Himalayas, the French Alps and many others, offering a world tour of popular recreation destinations.

Similarly varied are the cover designs themselves. The earliest examples, dating back to the early-to-mid twentieth century, reflect a simpler time when a painting or line drawing stamped with the company's name would suffice. Many even lacked brand logos. When companies did hire professionals, they often worked alone rather than with a team of photographers, marketers and designers that many companies now have at their disposal. Rather than appearing amateurish, however, the rawness of these pioneering covers reflects a playfulness and character that can be hard to replicate with today's more polished marketing and design processes. Technology, too, has changed how catalogue and magazine covers are designed. The gradual improvement of printing capabilities, photographic editing processes and design tools took a giant leap forward with the proliferation of computers and the covers reflect these changes. More complex design elements and photographic treatments became common by the end of the century, marking a significant departure from the simplicity of the early days.

To showcase this inspirational variety of subject matter and de-sign found within the Archive's thirteen thousand catalogues and magazines, this book contains an unfurling sequence of more than six hundred covers categorized by medium and process. Certainly, there are many other possible ways to organize this imagery. Chronologically by publication date, alphabetically by company, thematically by landscape or sport — or some combination of these — are just a few possibilities. The choice to organize them by design characteristics, however, reflects one of the Archive's largest, most influential and most enthusiastic audiences: brand creatives, including graphic designers, fashion designers, marketing professionals, artists and photographers. By categorizing the covers based on elements like form, composition, treatment and subject matter, this book seeks to illuminate the evolution of various design approaches over time and across brands. At the same time, it invites a wider global audience — including journalists, filmmakers, podcasters, historians, athletes and gear enthusiasts — to consider the intention and skill that go into putting together these catalogues and magazines.

Categorizing the cover imagery in this way threw up a number of challenges. The subjectivity of category selection, the cross-category nature of some covers and the need to place imagery with infinite design characteristics into finite categories all presented hurdles, but ultimately ten chapters emerged. The 'Nature' and 'Object' chapters highlight the familiar genres of landscape and wildlife photography, and product shots of outdoor gear, respectively. Interesting patterns or details are the focus of 'Abstraction', while 'Processed' features images with bold treatments. These sections show how artful manipulation can transform the viewing experience, revealing unexpected sides to potentially familiar subjects. Heavily directed photography with models — what some might consider 'staged' — constitutes the 'On Set' chapter. At the other end of the spectrum, 'Documentary' and 'Live' capture the day-to-day experience of athletes undertaking outdoor pursuits, with the latter

focused specifically on movement. More design-oriented are 'Remixed', featuring compositions built from the collaged layering of text, imagery and graphic elements, and 'Words and Letterforms', where typeface and typesetting stand out above all else. 'Lines', meanwhile, highlights a range of artwork styles, from oil paintings and watercolours to pen-and-ink sketches and coloured pencil drawings. Viewing the material in this way gives an appreciation of the breadth of approaches on offer, as well as showing just how much skill, creativity and artistry is at play.

What, then, is the appeal of outdoor-catalogue and magazine imagery? For many, it's a source of inspiration. There is no better resource than the Archive for those looking to recapture the look and feel of an earlier time, whether it's for marketing materials or an outdoor clothing line. Not only are its materials rich with vintage product and outdoor imagery, but much of the material is untapped by creatives. While online image searches and social media provide easy access to some vintage outdoor resources, their scope is limited by what people have taken the time to digitize and upload. The result is an online echo chamber that risks the creation of a circular economy for mood boards, where the same images are repurposed over and over again. The Archive's catalogues and magazines, on the other hand, feature hundreds of thousands of pages that most people have never seen and couldn't otherwise access, a carefully chosen and curated sampling of which is represented by the cover images in this book.

The Archive's outdoor imagery also presents an opportunity for brands to rediscover their own DNA while recapturing the character of early outdoor design. After all, what better place for a company to reconnect with their roots than consumer catalogues, which were for many years a brand's most direct connection with its customers? Once landing in mailboxes across the globe, they were thoughtfully designed, exuding creativity and flair, and encapsulated a company's identity. The covers, in particular, were more than just a place to feature a new clothing or gear line. It was here that companies communicated who they were, and just as importantly, who their customers could strive to be. By exploring and grounding themselves in these founding business and design principles, today's brands can use history itself as an asset through which to establish their legacy in the industry and build trust with consumers.

Ultimately, the Archive means different things to different people. The catalogue and magazine imagery that speaks to one person may not speak to another. To capture these various perspectives, the cover images featured in the following chapters are interspersed with reflections from a spectrum of outdoor industry professionals and enthusiasts, from athletes and designers to journalists and artists. Prompted by these unique perspectives, readers are encouraged to develop their own connections to the imagery and determine what is meaningful and useful to them. Hopefully, this process of self-reflection on the past sparks ideas for a great new contribution to outdoor design and fashion.

That's what the Archive, and by extension this book, is all about: creating new things from old. Just because some items date back more than a century doesn't mean the Archive is stuck in the past. In fact, the captivating imagery contained among its pages can seem surprisingly relevant. Recent trends have placed vintage outdoor design squarely into the mainstream with retro-themed marketing materials and heritage-inspired fashion. If these products are the fruits, the Archive is the seed. And with hundreds of thousands of images yet to be rediscovered, the possibilities for inspiration are enticing. Who knows what ideas could spring from the pages of the catalogues and magazines filed away in neat rows of acid-free boxes on the shelves at Utah State University? Who knows what inspiration might emerge from the curated collection in this book? That's the excitement of the Archive. *The Outdoor Archive.*

NATURE
Outdoor photography that focuses on the natural environment.

Contributions by Alasdair Leighton-Crawford (p. 19), Nur Abbas (p. 27), Jeanine Pesce (p. 31), Wai Tsui (p. 37)

One of the most common genres that outdoor brands have used to promote their gear actually has very little to do with gear itself. Nature photography, featuring sweeping landscapes or extraordinary wildlife, has long graced the covers of catalogues, and for good reason. It brings the consumer face to face with nature – allowing them to imagine being outside, whether it's in an idyllic meadow filled with wildflowers or on a windswept mountain summit. Often the photographs are framed within the larger cover design, drawing the viewer's eye to the image, like a portal through which they are transported outdoors. Animals may also be shown in attention-grabbing ways, like the 2000 Marmot catalogue featuring the brand's namesake rodent inquisitively staring from the cover (p. 22).

The people who appear in these images generally aren't the focus; their existence is in the context of nature. They may be a small, silhouetted figure on a mountain vista, providing scale for the truly grand landscape around them, or otherwise melting into the background. When people are in the foreground, they aren't facing the camera. Rather, their gaze directs the viewer's eye to a distant horizon. These images evoke the photography of nineteenth-century explorers, in which solitary figures posed in desolate panoramas, communicating the isolation and wildness of places that few back home had ever – or would ever – see. But the pages behind the front cover of a catalogue, which feature the latest in outdoor clothing and gear, offer the possibility that consumers can visit these places for real. Their destination is just a mail-order form, toll-free phone call or website-click away.

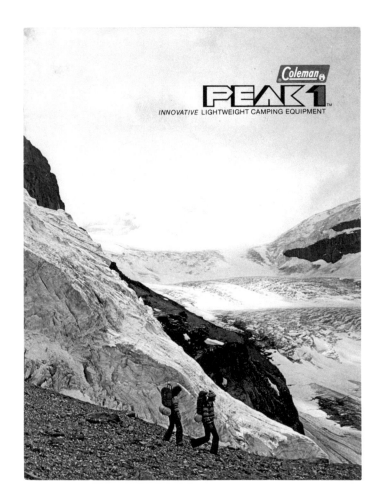

Coleman	
YEAR:	UNKNOWN
DIMS:	28 × 22 CM
	11 × 8.75 IN
PAGES:	15
TEAM:	UNKNOWN

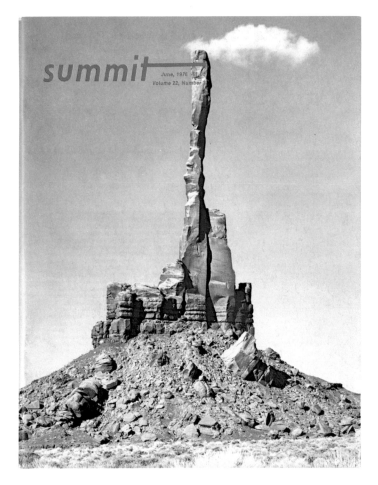

Summit	
YEAR:	1976
DIMS:	28 × 22 CM
	11 × 8.75 IN
PAGES:	52
TEAM:	ED COOPER

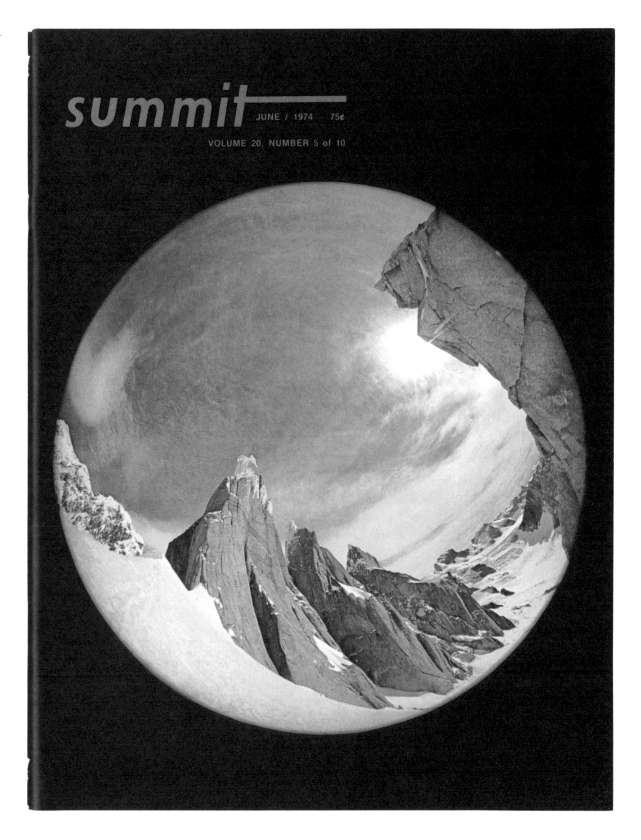

Summit		YEAR:	1974
DIMS:	28 × 22 CM (11 × 8.75 IN)	TEAM:	LEO DICKINSON
PAGES:	36		

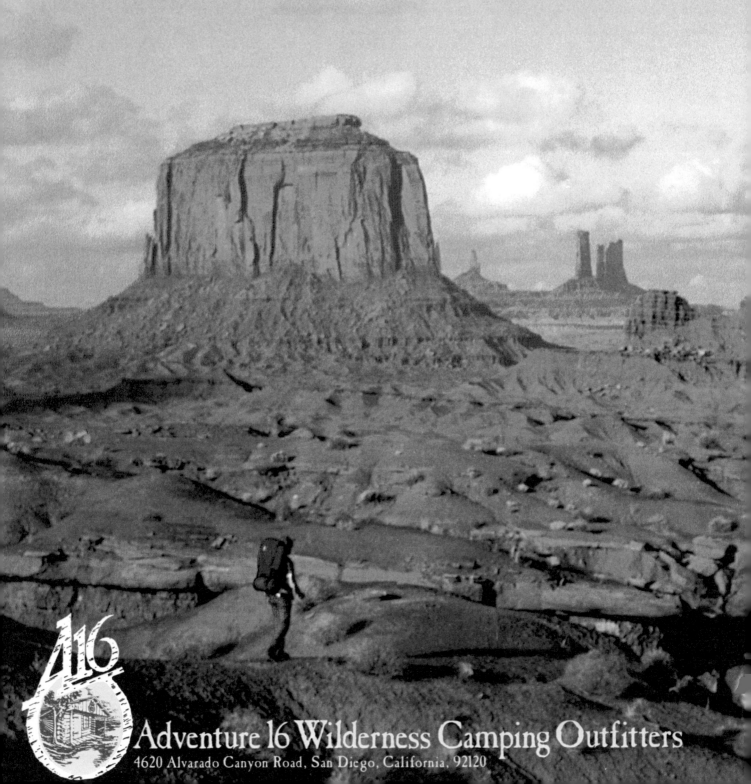

THINGS OF QUALITY
HAVE NO FEAR OF TIME.

Adventure 16 Wilderness Camping Outfitters
4620 Alvarado Canyon Road, San Diego, California, 92120

ALASDAIR LEIGHTON-CRAWFORD
Craftsman and designer

This image expresses the thrill of being out in a barren extreme landscape where you are entirely dependent on your equipment to survive. As the advert states, quality is timeless; outdoor products must be built to last and endure adventures.

Not much of today's gear is designed to this standard — to build something that's rugged and fit-for-purpose with many years of service is an art. For quality over quantity, thought must go into everything, from the selection of materials to fabrication. Depending on your gear is something that you shouldn't be worrying about; it should just work. However, only a small number of people push their outdoor equipment to the absolute limit and as a consequence, many of them are either gear testers or tinkerers who adapt and shape what they have to suit their specific needs.

While there are other catalogue covers from the same era that focus on quality first, A16 are being more direct with the message. By pairing a strong tagline — printed against an endless rolling sky — with an iconic, cinematic view of Monument Valley, the image says 'timeless' in multiple ways.

The message is to make gear well, and to make it last, with a focus around durability. In today's market, the best products must also be fast (packable) and light, as well as engaging with sustainability, reuse and recycling. As technology and sports move forwards, high-performance kit must too.

Adventure 16, 1983, 28 × 22 cm (11 × 8.75 in), 4 pages
Team: James Ward

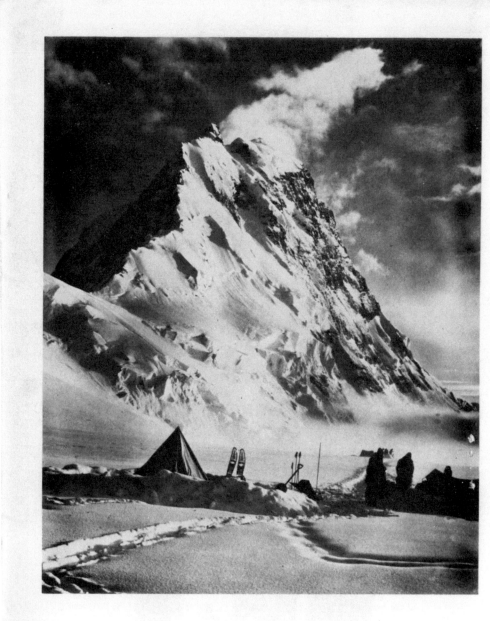

Lowe Alpine Systems		YEAR:	1975
DIMS:	22 × 14 CM (8.75 × 5.5 IN)	TEAM:	GERRY ROACH
PAGES:	14		

Marmot	
YEAR:	1977
DIMS:	15 × 22 CM
	5.75 × 8.75 IN
PAGES:	32
TEAM:	GARY PAHLER, DAVE HUNTLEY, DAVE MARQUARDT, ERIC REYNOLDS

Marmot	
YEAR:	1978
DIMS:	28 × 22 CM
	11 × 8.75 IN
PAGES:	30
TEAM:	UNKNOWN

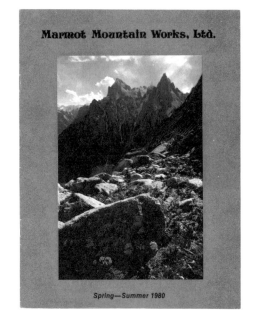

Marmot	
YEAR:	1980
DIMS:	28 × 22 CM
	11 × 8.75 IN
PAGES:	23
TEAM:	GALEN ROWELL

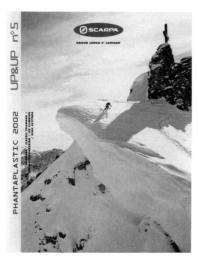

SCARPA, 2002

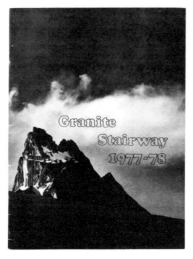

GRANITE STAIRWAY MOUNTAINEERING, 1977

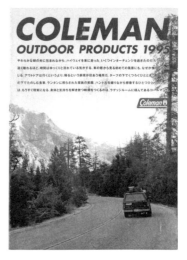

COLEMAN, 1995

WALRUS, 1991

CASCADE DESIGNS, 1995

SCARPA, 2000

LOWE ALPINE SYSTEMS, 1985

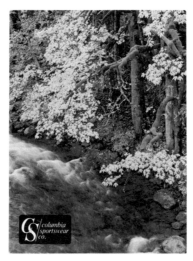

COLUMBIA SPORTSWEAR CO., 1978

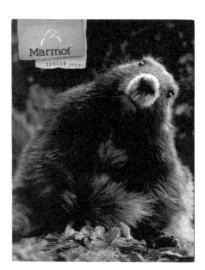

MARMOT, 2000

NATURE

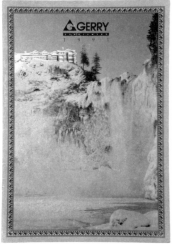

GERRY, 1991

SIERRA DESIGNS, 1974

SLUMBERJACK, 1994

HINE SNOWBRIDGE, 1977

KELTY, 1989

RIVENDELL MOUNTAIN WORKS, UNKNOWN

GRANITE GEAR, 2003

WAVE PRODUCTS, UNKNOWN

GRANITE GEAR, 2004

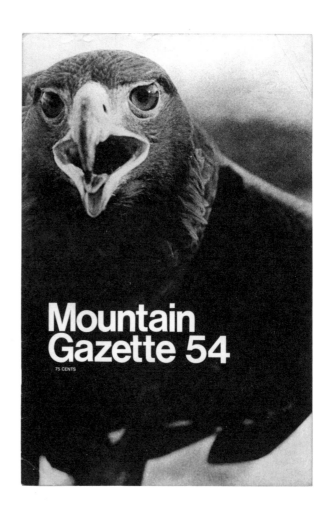

Mountain Gazette	
YEAR:	1977
DIMS:	38 × 26 CM
	15 × 10.25 IN
PAGES:	36
TEAM:	FRANK DAVIDSON

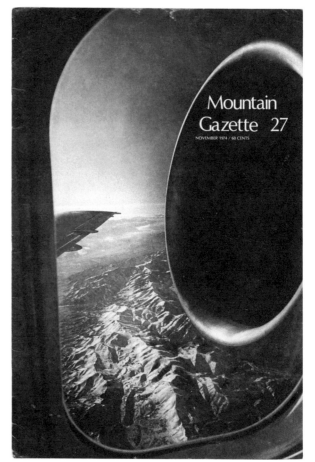

Mountain Gazette	
YEAR:	1974
DIMS:	38 × 26 CM
	15 × 10.25 IN
PAGES:	36
TEAM:	DAVID HISER

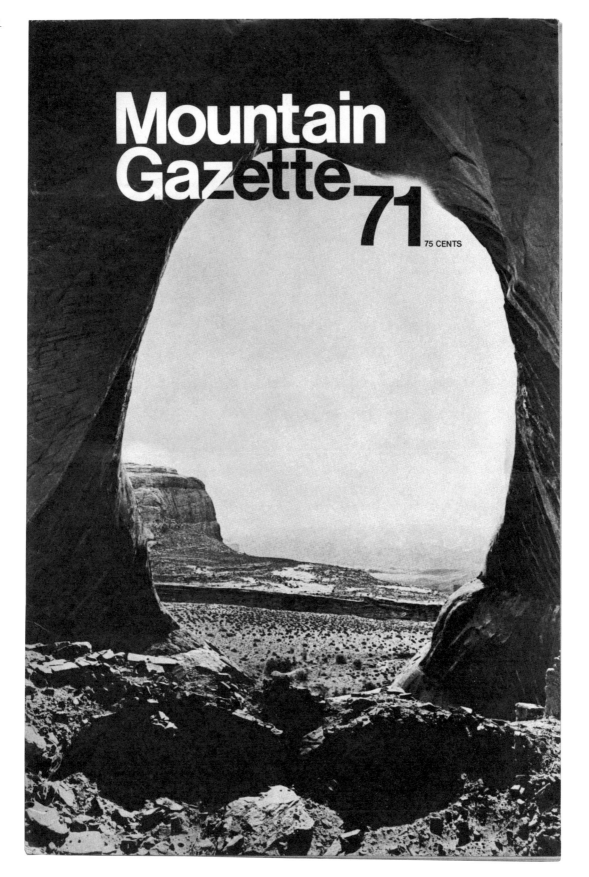

Mountain Gazette		YEAR:	1978
DIMS:	38 × 26 CM (15 × 10.25 IN)	TEAM:	MICHAEL COLLIER
PAGES:	32		

Lowe

1990

PACKS

NUR ABBAS
Designer and founder

I grew up in Lincoln, in the East Midlands of England: a flat, featureless land where the most exciting elevation change was the one hill in the middle of town. It's about as far as you can get from Denali (the snowy peak in the photo), located in Alaska and the tallest mountain in North America. Perhaps this is why, as an adult, I'm fascinated by mountains.

My first experience with outdoor exploration was through the Boy Scouts in the early 90s. My gateway to this world was gear. I remember my first backpack — a turquoise Cordura, Lowe Alpine, full of zips and compartments. It came from Linsports, Lincoln's sole outdoor store. Though no mountaineering took place for me back then, the gear had my imagination. Fast forward a few years, and I found myself immersed in the fashion world of Paris, working with houses like Louis Vuitton and Margiela. Yet, even amidst the glamour, the purposeful beauty of outdoor gear resonated with me.

Moving to the Pacific Northwest truly transformed my perspective. Suddenly, the outdoors wasn't just a second-hand experience; now, I was directly connected to the source. Inspiration comes from direct knowledge of the outdoors, whether it's the colours or patterns found in nature or testing the gear we make in my studio in Portland — taking it out on the trails and mountains surrounding us here.

Lowe Alpine were pioneers. It's no coincidence that the founders, a trio of brothers, were from the Utah area and explored the mountain ranges in this part of the world. It is the same direct connection to the outdoors and nature that has fundamentally changed my work and outlook on design.

Lowe Alpine Systems, 1990, 31 × 22 cm (12.25 × 8.75 in), 21 pages
Team: Glenn Randall

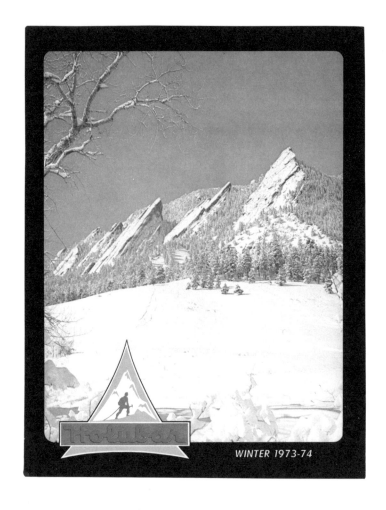

WINTER 1973-74

Holubar	
YEAR:	1973
DIMS:	28 × 22 CM
	11 × 8.75 IN
PAGES:	79
TEAM:	AL MORGAN
	FELIX DUNBAR

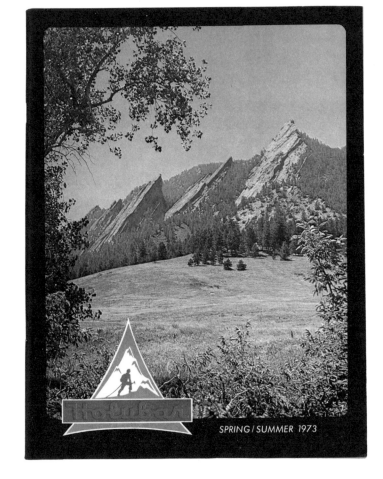

SPRING / SUMMER 1973

Holubar	
YEAR:	1973
DIMS:	28 × 22 CM
	11 × 8.75 IN
PAGES:	79
TEAM:	AL MORGAN
	FELIX DUNBAR

Snow Peak		YEAR:	2017
DIMS:	23 × 15 CM (9 × 5.75 IN)	TEAM:	UNKNOWN
PAGES:	47		

WARMLITE

PERHAPS THE INNER NEVER LOST RAPPORT WE HOLD
WITH THE EARTH, LIGHT, AIR, TREES, ETC. IS NOT TO
BE REALIZED THROUGH EYES AND MIND ONLY, BUT
THROUGH THE WHOLE CORPOREAL BODY . . . SWEET,
SANE, TILL NAKEDNESS IN NATURE!

. . . THERE ARE MOODS WHEN THESE CLOTHES OF OURS
ARE NOT ONLY TOO IRKSOME TO WEAR, BUT ARE
THEMSELVES INDECENT. PERHAPS INDEED HE OR
SHE TO WHOM THE FREE EXHILIRATING ECSTASY OF
NAKEDNESS IN NATURE HAS NEVER BEEN ELIGIBLE,
HAS NOT REALLY KNOWN WHAT PURITY IS — NOR
WHAT FAITH OR ART OF HEALTH REALLY IS.

Walt Whitman.

JEANINE PESCE
Brand strategist and trend forecaster

This image, a compelling representation of the female form within the Warmlite 'Main' catalogue, initially captivated me with its exceptional composition and historical context. The 'famously infamous' cover, showcasing a nude woman in a poppy-filled field alongside lines from Walt Whitman's poem 'To Bryant, the Poet of Nature', defies the societal norms of its time. This daring choice of model and setting stirred controversy in the outdoor industry, leaving a lasting impact on Warmlite's history.

Founded in the 1950s by aerospace engineer Jack Stephenson, Warmlite pioneered innovative US-made outdoor gear. Stephenson, a radical thinker, inherited his unconventional preference for natural living from his parents, intertwining his personal and professional beliefs with the provocative imagery on the catalogue cover.

The model's shape, reminiscent of a Greek or Roman sculpture, with the curvature of her back and her face obscured by cascading hair, transcends mere sensuality. Instead, it resembles a Renaissance work of art, subtly evoking feelings of mystery and modesty.

Captured in 1974, amid the Sexual Revolution and the tail-end of second-wave feminism, the image encapsulates the duality of women during the late 60s and early 70s. It alludes to timeless archetypes, inviting viewers to project their ideas about a woman's place in the outdoors — is she the Mother or the Maiden, the Sinner or Saint?

This cover prompts viewers to question its intentions. Is it a celebration of the model's strength and confidence, or does it perpetuate unbalanced power dynamics associated with the male gaze in a male-dominated industry? As a woman navigating the outdoor industry, I've personally encountered this juxtaposition of ideals. It serves as a stark reminder that despite progress, we still grapple with the same stigmas and barriers today.

In a delicate dance between divine femininity and masculine narratives, this cover pays homage to both, reclaiming ownership of Mother Nature. It symbolizes not only Warmlite's bold ethos but also the ongoing struggle to dismantle stereotypes within the outdoor industry — a reminder that the journey toward inclusivity is an ongoing, collective endeavour.

Stephenson's Warmlite Equipment, 1974, 28 × 21 cm (11 × 8.25 in), 47 pages

Black Diamond Equipment	
YEAR:	1996
DIMS:	22 × 19 CM
	8.75 × 7.25 IN
PAGES:	55
TEAM:	KENNAN HARVEY

Black Diamond Equipment	
YEAR:	1998
DIMS:	31 × 26 CM
	12.25 × 10.25 IN
PAGES:	51
TEAM:	STEVE HOUSE

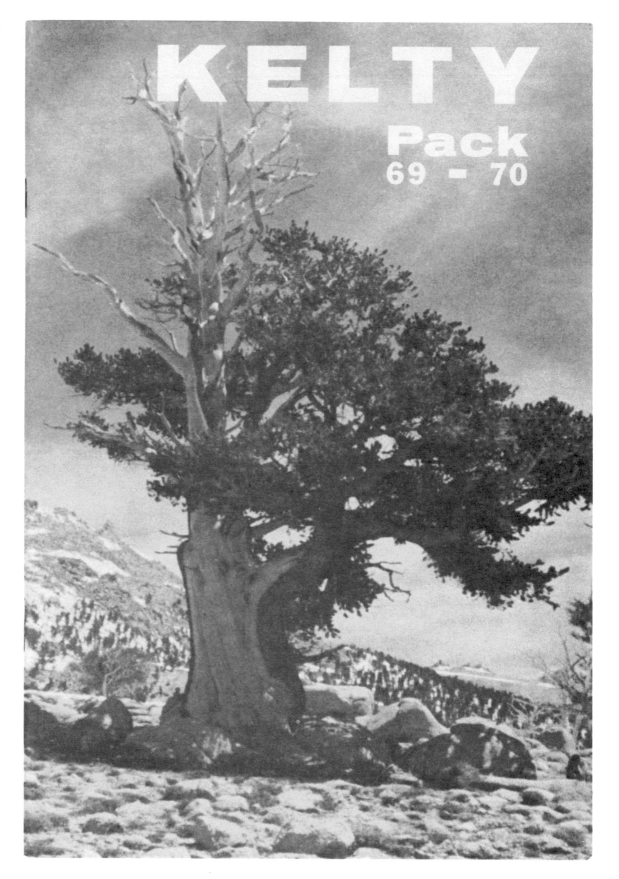

Kelty		YEAR:	1969
DIMS:	26 × 18 CM (10.25 × 7 IN)	TEAM:	UNKNOWN
PAGES:	33		

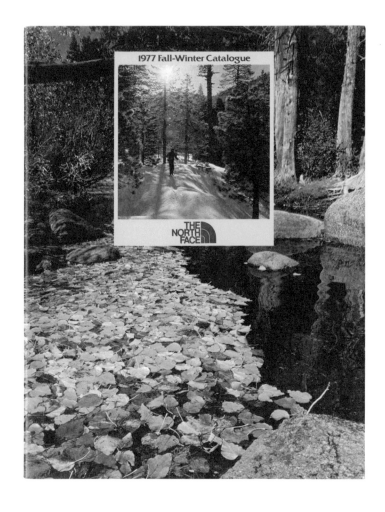

The North Face	
YEAR:	1977
DIMS:	28 × 22 CM
	11 × 8.75 IN
PAGES:	47
TEAM:	ROLAND DARE

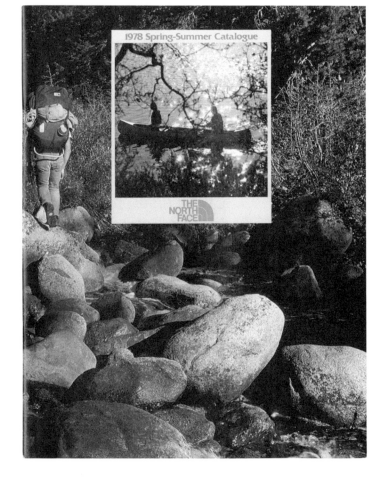

The North Face	
YEAR:	1978
DIMS:	28 × 22 CM
	11 × 8.75 IN
PAGES:	47
TEAM:	ROLAND DARE

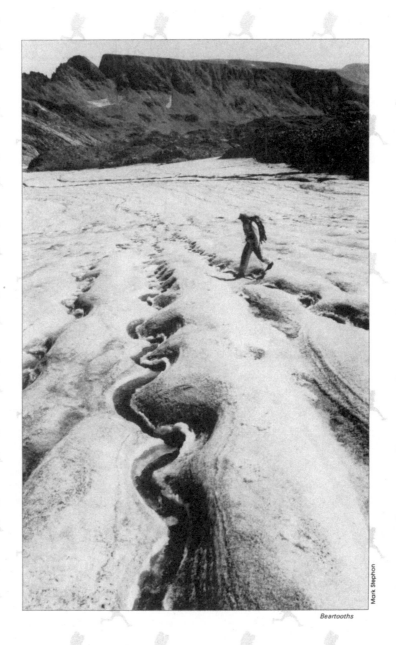

Beartooths

Mark Stephon

DANA DESIGN 1989

Dana Design		YEAR:	1989
DIMS:	28 × 22 CM (11 × 8.75 IN)	TEAM:	MARK STEPHON
PAGES:	18		

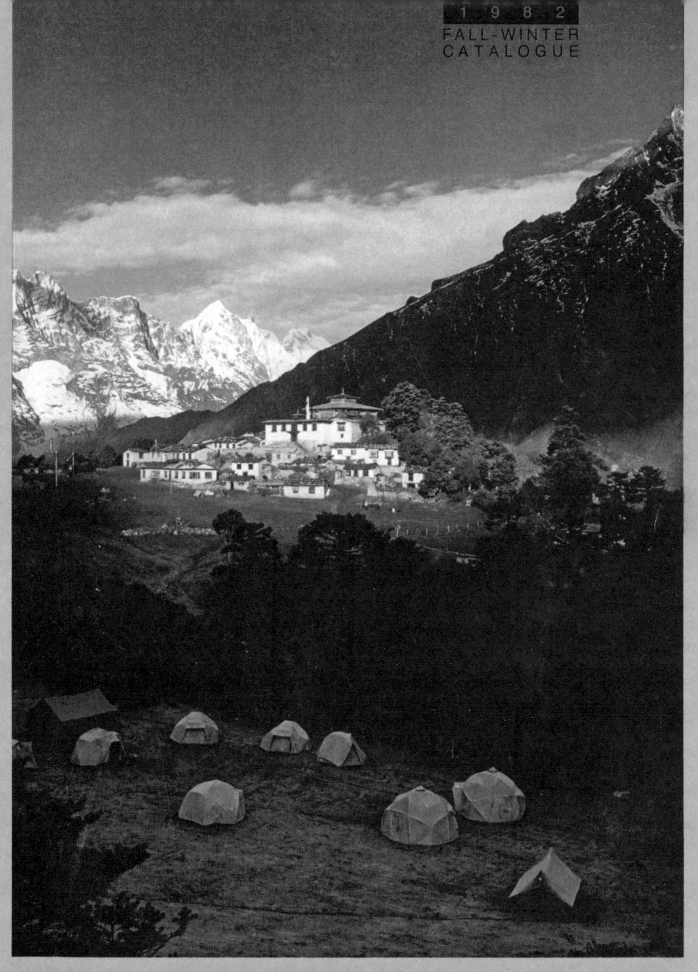

THE
NORTH
FACE

WAI TSUI
Founder and creative director

I'm totally taken with this picture. Essentially, it's just a few tents at the bottom of some big mountains, but it's so much more than that. This is what freedom looks like to me. Sure, it's about going to places nobody's been before, but it's also about discovering parts of ourselves.

Everything's so quiet here, you can almost hear an adventure waiting to happen. The tents, all bright and colourful against the rugged background, seem to suggest we're always searching for something. It's not just about checking out the scenery, it's about digging deep into what makes us tick. The mountains are so snowy and tall; they make you want to break out of your everyday bubble, see what you're made of and come face-to-face with this huge, wild world. It's pulling at us to explore.

This image makes me remember why getting outside is so good. It ties you to the earth, to the natural way things flow and to life's big cycles. Staring at this ageless beauty, you feel part of a bigger story. I'm also reminded how we're all just trying to fit in with the world around us. The tents, neat and orderly, provide a stark contrast to the untamed land. But it also shows that we want to get along with the great outdoors — to be part of the action, rather than just watching from the side lines.

The local houses and the temple are not just part of the background but pivotal elements of the scene. These structures, bathed in a gentle spotlight, symbolize the enduring presence and cultural richness of the local community. They contrast with the Western tents, highlighting a blend of tradition and modernity. Their inclusion underscores the importance of acknowledging and respecting the local community infrastructure, integral to understanding the landscape's full story.

In the quiet of these mighty places, you understand what freedom's really about. The endless sky, the towering mountains, the explorer's pop-up homes … this is the thrill of the outdoors, the release you can't help but feel when surrounded by nature's grand space. This image doesn't sit passively with the words on the page. Instead, it's showing us what we're all looking for: adventure, connection and the kind of joy that comes from feeling part of the wide-open world. And that's what real freedom is like. It's not about having no rules, it's about endless possibilities.

The North Face, 1982, 28 × 22 cm (11 × 8.75 in), 47 pages
Team: Roland Dare, Barbara Cushman-Rowell

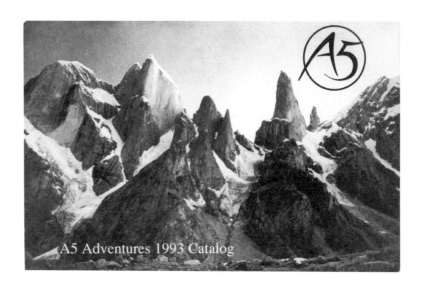

A5 Adventures	
YEAR:	1993
DIMS:	14 × 22 CM
	5.5 × 8.75 IN
PAGES:	14
TEAM:	ACE KVALE

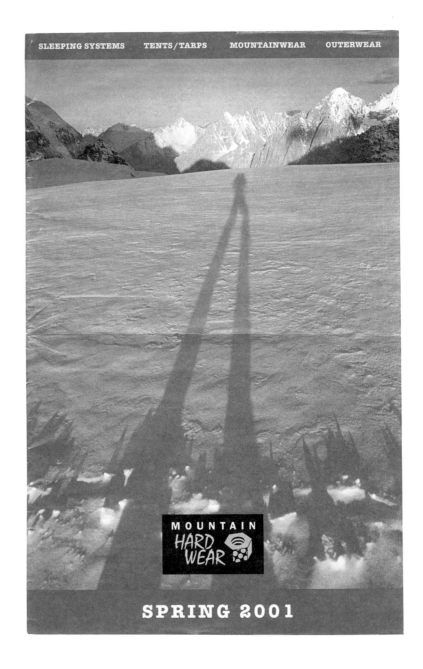

Mountain Hardwear	
YEAR:	2001
DIMS:	44 × 29 CM
	17.25 × 11.25 IN
PAGES:	63
TEAM:	MIKE LIBECKI

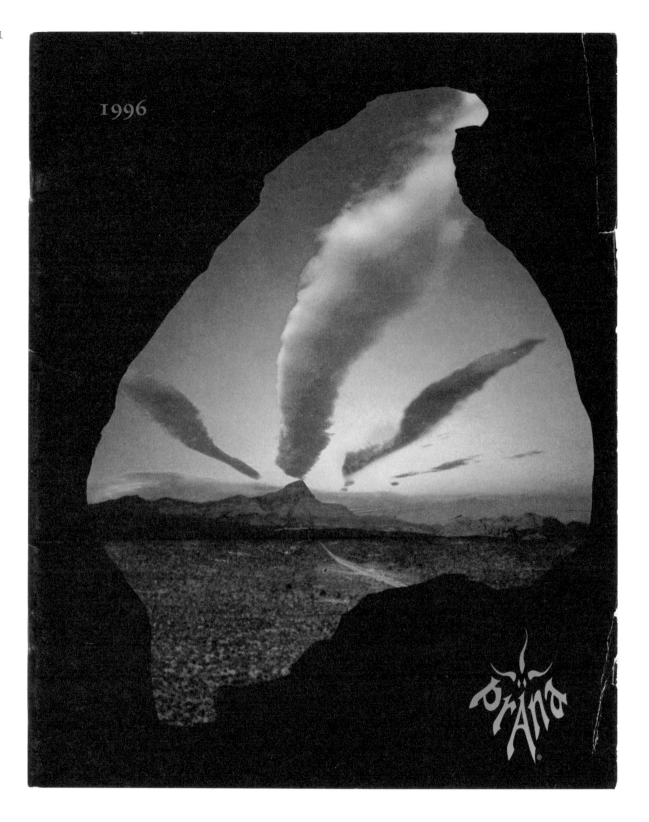

Prana			YEAR:	1996
DIMS:	27 × 22 CM (10.75 × 8.75 IN)		TEAM:	EPPERSON, WORRAL, DE SOTO, PARRISH, MANTOANI, GREENE, THORNBURG, FALKENSTEIN, GRAY, LORENTI, RASMUSSEN
PAGES:	14			

A5

ADVENTURES

Catalog 2
1989

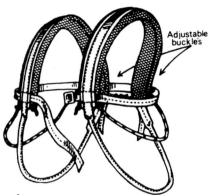

/A5 Adjustable Big-Wall Double Gear Sling

Our Big-wall racking sling shows that experience and design create the best equipment. The wide padded gear slings are constructed of 1" webbing with adjustable buckles on both sides; 1/2" foam covered by soft bunting and lock-mesh forms the padding. An adjustable 1" web strap chest strap secures the harness to your torso creating a good chest harness. The 4mm secondary gear sling is great for all your extra biners. The slings can be used individually when the chest strap and perlon are removed. If you're looking for a great gear sling we have it!
One size, assorted colors.
Weight: 28 oz.
Price: $30.00

/A5 Stuff bags

Essential for big-wall organization. With clip-in loop and 36" tie-in string inside. Drawstring closure. Made of 8 oz. pack cloth. Colors: random.

Small: $3.00
Med.: $4.00
Large: $5.00

Wild A5 Colors:
Red
Black
Purple
Fuschia
Turquoise
Lime Green
Electric Blue

/A5 Skyscraper Haulbag

The A5 Skyscraper: constucted of 1050 nylon Ballistics with fully taped seams. The Skyscraper has a four point haul suspension, and a double clip-in loop on the bottom. A large internal zippered pocket keeps your small stuff together and easy to get to on the wall. The Skyscaper comes with a removable padded harness system for comfort while trudging loads to the base. 5mm cord drawstring closure. Two sizes.

Regular: 7,000 cu. in.
(2-4 day routes). $85.00
Large: 10,000 cu. in.
(4+ day routes). $100.00

/A5 Assault Pack

We've designed the assault pack around the alpine climber. The pack is designed with a very low profile and anatomical shape. Made to be worn while climbing, the pack has adjustable and removable racking slings on both sides. Three SR1 buckles on the sides and top act as compression straps and convienient clip-on straps for ropes or gear. This is a great ice climbing pack! The pack has a full-length ballistic crampon patch (and bottom) with two 1" daisies sewn to both sides. Two ice axe loops sewn into the bottom.
Volume: 1000 cu. in.
Weight: 18 oz.
Price: $80.00

Price: $20.00

/A5 Bolt Bag

Big-wall experience has made this the ultimate bolt-bag design. The internal pockets make it easy to keep gea arranged: a large pouch for bolts and a special tool pocket (4 slots) to keep bits and wrench in place. Three solid D-rings (one internal for attaching a drift-pin leash) allow for easy tie-in o tools and good clip-in points. One inch web holster outside of bag keeps the drill or hammer handy. Drawstring closure. Made from 11 oz. Cordura

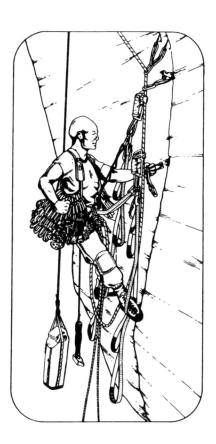

Big-Wall Hardware

A5 supplies the finest in rock-climbing gear. Our selection process is based on #1: Quality; #2: Function and Utility, and #3: Value. Extensive in-field testing of new products assures only the best!

Standard Big-Wall Rack for a Moderate Nail-up.

√ 2-3 sets of Friends (or equivalent).
√ 1-2 sets TCU's.
√ 2-3 sets Wired Stoppers.
√ 2-3 sets small Wired Brass Nuts.
√ 80 Carabiners.
√ Hook selection (3-5 of the standard types).
√ Copperhead selection (10-25).
√ Pitons (5-10 knifeblades, 10-20 horizontals, 15-25 angles).
√ Small Bolt Kit (optional).
√ Tie-offs (25), Runners (10-20).

A5 Grade VI

SMC's high quality, all-purpose oval carabiner now available at a special price.
Strength: 4000 lbs. Wt: 2.1oz.
Price: 10 for $35

A.

Carabiners

Type	Str.(kg)	Wt.(g)	Price
A. A5 Grade VI	2000	62	$3.50
B. SMC New Oval	2300	63	$6.25
C. SMC Lite D -red body	2100	48	$4.95
D. SMC Locking D	2700	74	$7.95
E. Bonaitti D -red gate	3000	65	$6.50
F. Bonaitti Large D	2600	70	$6.00
G. Bonaitti Large Locking D	2900	80	$6.50
H. Clog HMS Screwgate	2200	92	$11.50
I. Clog HMS Twistgate	2200	95	$16.50
J. Chouinard New Standard	2100	49	$5.85
K. 5.10 Helium Biner	2250	31	$7.95

A. C. E. G. I. K.

B. D. F. H. J.

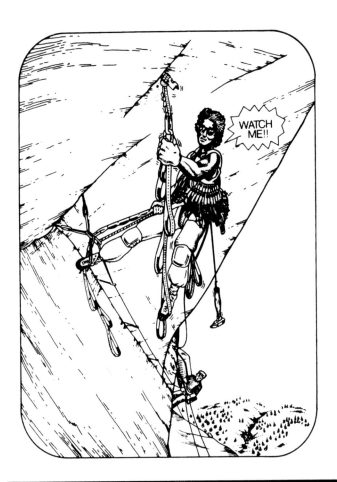

Piton Craft

Piton craft is fast becomming a lost art. The subtle points of pounding on iron, though simple in principle, can be learned only through experience. Learning *not* to overdrive pins takes time. Cleaning your own leads is a good lesson. Many routes like the Zodiac and the Shield are succumbing to the heavy battering from the unskilled hammer.

A good nailer is an aggressive cleaner but is aware of rock destruction. Knocking a pin back & forth the full length it can travel is the most efficient method. To prevent dropping a piton, a "cleaner biner" attached to a sling is clipped in as the pin gets loose; pulling and applying leverage with the cleaner biner/sling aids in final removal.

Expanding flakes, once the nailer's nemesis, have been tamed with modern gear. Clever use of pitons, nuts, and camming units reduces expando from its voodoo reputation to a fairly sane activity. Still, however, cruxes of many modern nail-ups are often thin expanding flakes where a <u>feel</u> for the placement is necessary. Clipping into successive placements with a daisy is recommended with expando.

Stacking pins can be a rewarding challenge. Leeper Z-tons are commonly stacked with angles, but many combinations of pins can be stacked together. A tie-off threaded though the eyes of stacked pins prevents losing them. Often, a sawed off pin can more efficiently take the place of stacked pins.

--Steve Quinlan

Pitons

Chouinard Angles

	Type	Length	Price
A.	1/2" Baby	4"	$4.70
B.	5/8" Baby	4 1/4"	$4.85
C.	3/4" Std.	5 5/8"	$5.20
D.	1" Angle	5 5/8"	$5.45
E.	1 1/4" Angle	5 5/8"	$6.90
F.	1 1/2" Angle	5 3/4"	$7.30

SMC Angles

	Type	Length	Price
B.	5/8" Baby	4 1/4"	$4.00
C.	3/4" Std.	5 5/8"	$4.25
D.	1" Angle	5 5/8"	$4.50
E.	1 1/4" Angle	6"	$5.25
F.	1 1/2" Angle	6"	$5.75
G.	3" Bong	6"	$6.85

<u>Stacker's Kit:</u> Contains the standard big-wall stacking piton selection: 1 SMC shallow angle, and 3 Leeper Z-Pins.
Price: $15.00/kit.

Clog Crack Tacks
K. Flat. Price: $5.00.
L. Bent. Price: $5.00.

M. Leeper Z-Pitons
Price: $4.75 each.

No	Size
AA	1/4" x 2"
A	5/16" x 2 1/2"
B	7/16" x 3"
C	9/16" x 3 1/2"
AS	5/16" x 1 1/2"
BS	7/16" x 1/4"
CS	9/16" x 1 3/4"

N. A5 Birdbeak.
For incipient seam aid
Price: $4.50 each.

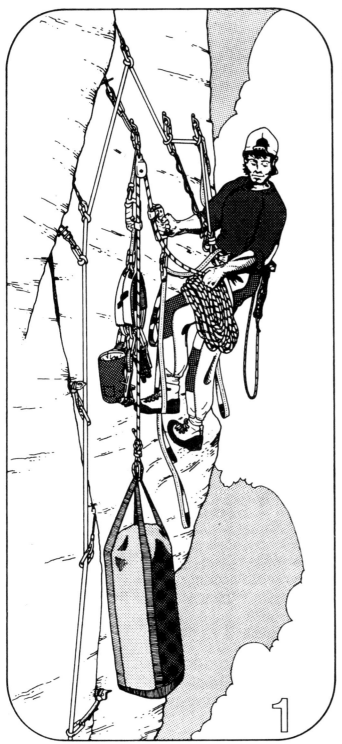

Big-Wall Hauling Technique

Finishing a lead isn't all there is to finishing a pitch, for the haulbag's still gotta be hauled. Getting it off the previous anchor is the first task; cooperation between partners is required. Lowering it out is recommended if the pitch leans or overhangs. The illustrations above show some possible big-wall hauling techniques. Make sure to securely clip the haulbag into each belay in at least two points: the haul-rope and the haul-bag daisy.

Illustrations
1. Leg-Hauling: Ok with a light bag.
2. Body Hauling: Standard technique.
Note: longer length (up to full rope-length) body-hauls are possible. Usually way sporty.

Big Wall Tech Manual
Loaded with info and descriptive illustrations.
50 pages. **Price: $3.50.**

Full Handled Ascenders

	Name	Mfg.	Const.	Ult. Str.	RDS*	Price
A.	Jumars	Switz.	Cast	1080 kg.	770 kg.	$92.00
B.	Petzl	France	Rolled	1600 kg.	500 kg.	$76.00
C.	CMI	U.S.	Extruded	1600 kg.	580 kg.	$90.00
D.	Clog	Britian	Rolled	1500 kg.	n/a	$85.00
E.	Kong**	Italy	Rolled	650 kg.	440 kg.	$89.00

*Rope Damage Strengths (RDS) quoted from WILD Magazine (Australia), April, 1987.
**Kong Ascenders use a leverage action (beter for icy or muddy ropes).

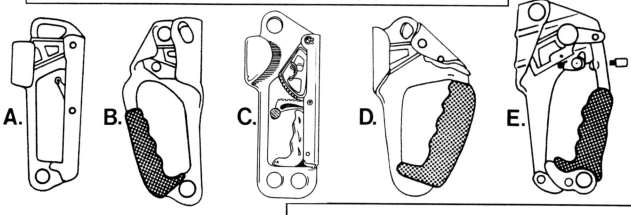

A. B. C. D. E.

Non-handled Ascenders

G. CMI Shorti IV's
Price: $63.50/pr.

G.

H. Petzl Chest Ascender.
Price: $33.00 each.

H.

I. Gibbs Ascender.
Price: $30.00 each.

J. Rock Exotica Ascender.
Price: $60.00 each.

I.

J.

Descenders / Belay Devices

J. CMI Forged Figure 8 **Price: $15.00**
K. Allp Descender **Price: $65.00**
--allows for no-hand descents; screw adjustment works as speed control as well as complete brake. Works with 9mm to 11.5mm ropes. Weight: 9.4 oz.
L. Petzl Stop Descender **Price: $54.50**
--A "let-go-to-stop" descender. Adjustable speed.
M. CMI Micro Plate (for 11mm ropes) **Price: $9.00**

Pulleys

N. SARA Red (bushing). **Price: $18.00**
SARA Blue (bearing). **Price: $22.00**
O. Utility back-up pulley. **Price: $6.00**
--good emergency pulley.
P. Rock Exotica Pulley. **Price: $18.00**

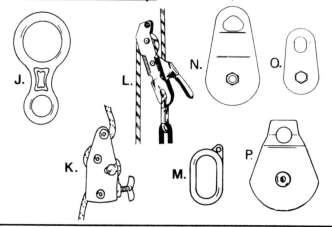

J. K. L. M. N. O. P.

Anguish and Relief on the Big Stone

By Xaver Bongard. Translated from the French by Sherrie.
First Solo Ascent, Lost in America, A5, 5.10, 9 days in 1987.

Here I am, suspended from my sky-hook, ten yards from the Lost in America ledge. Two things hold my life: a bit of rope, and two worthless pitons anchored into a mere quarter inch of rock.

At this precise moment, it's not the fall I fear. Rather, I have the feeling of being lost and forgotten on this breathtaking rock face 1200 feet above the ground.

The more I draw near the end of the pitch, the more cautious I become. It would be sad irony to have a mishap so close to the end, to be thrown from the face only to end up back at the previous belay. If that were to happen, I don't see how I could get myself together again and find the courage to continue. I have no other alternatives; there is but one way out of this predicament and it lies directly above me. To contemplate a retreat from this, one of the most overhanging of faces...best not to even think about it.

As well, it's no use expecting any help from any of my three climbing "companions". One of them inundates my ears at 45 minute intervals with music. The two others, my indispensible haulbag and porta-ledge, are but silent mutes offering no advice whatsoever.

Enough complaining, let us return to my problem. Thirty feet still lie between me and the ledge. The bottom line is that I really don't know what to do. I actually have two choices: a short climb directly above me, or a longer one which would take me around to the right. Which way did the last guy pass?

The situation is getting comical. I cannot arrive at a decision while hanging here quietly suspended from a hook whose hold could give at any moment. Silently I ask myself, "Where would my body end up if the hook did give way?"

I finally decide to move, and my efforts find success once again. As my progress becomes evident, I find myself reassured of what is commonly said: when climbing A4 or harder, one no longer falls. But even for the expert, this maxim only holds true if your energies are fully concentrated on success.

After several days on this monstrous rock wall, I am beginning to experience strange sensations: my mind is slowly becomming frozen by the constant state of concentration and anguish to which it is subjected. The anguish of wanting to give up but feeling a need to continue. Anguish always present, like talking to someone non-stop fifteen hours a day, every day, for more than a week. No wonder then that my senses are playing tricks on me. I feel as though invariably my pitons are coming loose, pulling out of the fissures, while actually they could easily support twice my weight. My reasoning tells me that everything is under control, but what can I do? I can't shake the doubts and frustrations from my over-anxious mind. I suppose it's best to just accept fate and try to get used to it—if I fall I fall. I have the distinct impression of being "cooked", as it is commonly said around here.

At this stage I could decidedly go for a good rest, to lie down on my port-ledge with a bit of gorp and warm beer. But it's not yet time.

The only solution to getting me out of this predicament is to get hold of a good piton, like the one protruding 45 feet above me at the next belay. The 15 Knifeblades required to reach it don't really inspire a lot of confidence.

I could certainly pull out my bolt-kit and drill. That would certainly get me out of this mess. But that would be the easy way out, the defeat of the whole purpose of being here. I won't give up so easily, so quickly, even if the devil himself appeared and offered to drill for me.

It is time to test one's fortitude, to prove that I can finish what I started.

This adventure of mine seems like a funny game filled with doubts and joys, a game filled with moments of anxiety and fear, but rarely fatal. Sensations accentuated by the fact that you are alone, you are your only partner; no one else can share your fears at the moment you grin at the face of death and pass it by.

This game at times seems as dangerous as heroin; addicting and life-threatening. To take part, you must truly be motivated with the impetus it takes to uproot trees, to channel all your energy and concentration on accomplishing a mammoth task few will even attempt. Without that dedication of force, it would be highly inexpedient to pursue a solo on the "big stone". The first slip could be your last.

I have described the situation from the physical perspective, from the mental aspect it is quite a different story. For me, the most difficult time is the evening before the climb. I feel relieved at having finished the arduous task of preparation. Then the doubts arise, penetrating every thought. The last time, before setting up on this climb, the doubts were so intense I almost changed my mind.

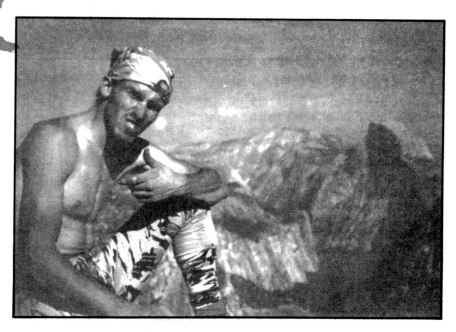

Gold-Eck Sleeping Bags

Gold-Eck Sleeping Bags from Austria have a proprietary synthetic fill, consisting of hollow fibers crimped into intertwining springlike spirals. This new insulation makes the most effective use of dead-air space; Gold-Eck Sleeping Bags equivilate the lightweight performance of down, with the advantages of synthetics (only 15% insulation loss when wet). Construction and design of these bags is of the highest sturdy and innovative quality.

Gold-Eck synthetic fibers are spring-like coils which maximize air entrapment (loft).

Explorer VI--Temperature Rating: -22° F.
Comes with Vario-compression bag.
Weight: 4 lbs, 12 oz.
Fits Person to: 75" (overall length: 88").
Zipper: Top center, with zip draft tube.
Stuffed size (compressed): 10" x 14".
Price: $200.00.

Pole Star--Temperature Rating: 14° F.
Comes with stuff sack.
Weight: 3 lbs., 13 oz.
Fits Person to: 75" (overall length: 85").
Zipper: Side, with draft tubes.
Stuffed size: 7" x 17".
Price: $125.00.

North Pole--Temperature Rating: 5° F.
Comes with stuff sack.
Weight: 4 lbs, 3 oz.
Fits Person to: 77" (overall length: 88")
Zipper: Side, with draft tubes.
Stuffed size: 9" x 17".
Price: $150.00.

Yama Gucci Tights $25.00.
Warm and durable climbing tights.
Specify type and size:
Nylon Lycra: Black Jackson Pollack design.
Cotton Lycra: Multicolored on black.
Sizing: Small: 5' 10" & 130 lbs. (24"-29" waist.)
Medium: 5' 10"+ & 130-170 lbs. (30"-34" waist).

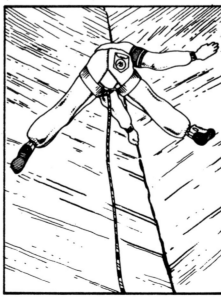

A5 Climbing Pants

A5 climbing pants are low-cost, good quality all-cotton climbing pants, designed for full freedom of movement and comfort. The unique gusseted inseam allows for zero hinderance while climbing crotch-splitting dihedrals or making knee-to-chin high steps. Moreover, they are comfortable street pants.
Features: •Velcro-closure full wallet-sze pocket. •Elastic cuffs •Web/Fastex buckle waist.
Sizes: Small (28" waist or below), medium (28"-32"), or large (32" up).
Price: $20.00

OBJECT
Photographs that highlight one or more particular products.

Contributions by Ashima Shiraishi (p. 55), W. David Marx (p. 57)

In object photography, the gear is front and centre. On covers featuring this type of imagery, every effort is made to make the product stand out, whether it's a down parka or an ice axe. This may be done using dramatic lighting, single-colour backgrounds, creative camera angles or shallow depth of field. While the photographer might include the entire product in the frame, sometimes they choose to zoom in on a particular detail, like the pole sleeve of a tent or the tip of a ski. Close-ups of product tags sewn onto parkas and packs are a popular way to highlight the company's branding, and occasionally props are used to further embellish the image. Another approach is to feature multiple products, making the cover a miniature catalogue of sorts. Generally, people are not pictured using the gear, but when they are, their presence is often diminished by obscuring or blurring their faces.

Highlighting products on catalogue covers may seem intuitive, but the execution is what makes object photography a truly effective form. On a basic level, it clearly communicates to the consumer what they can expect to find when they turn the page and look inside. But through creative composition, outdoor clothing and gear can become works of art, increasing desirability through a focus on quality and detail. Props can further enhance these effects, like the sewing machine that peeks into the frame of the Fall & Winter 1974–75 Holubar catalogue (p. 66), emphasizing the craftsmanship of the sleeping bag beneath it. Other embellishments like the lupine adorning a product tag in the 1977 Kelty cover (p. 52) serve to connect the gear, and brand, to nature. When people are included in the photos, keeping the emphasis more on the product than the person using it can help consumers more easily imagine themselves in the gear. In any case, the goal is to celebrate the artistry and design of the product.

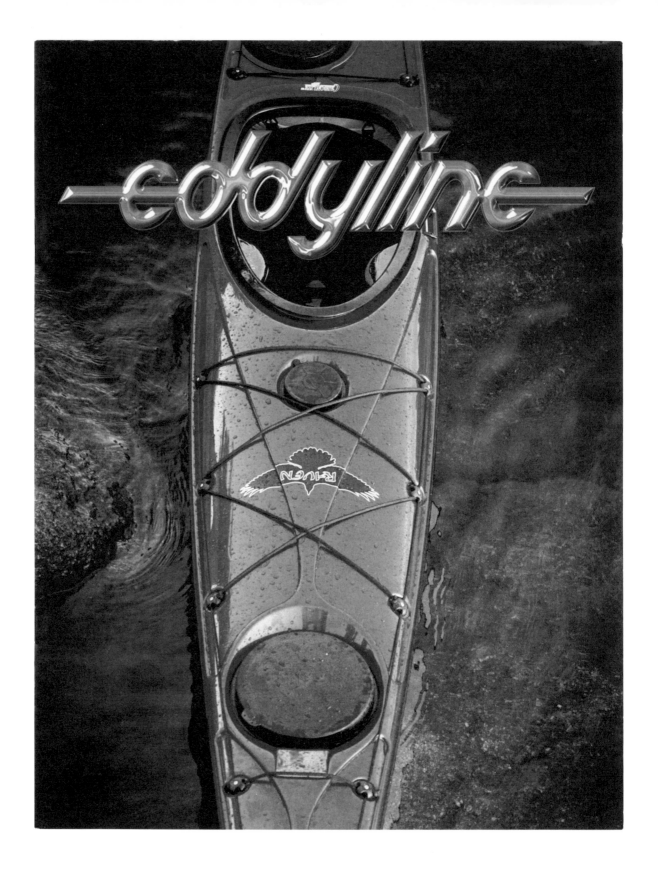

Eddyline		YEAR:	2014
DIMS:	28 × 22 CM (11 × 8.75 IN)	TEAM:	SHEER MADNESS PRODUCTIONS
PAGES:	14		

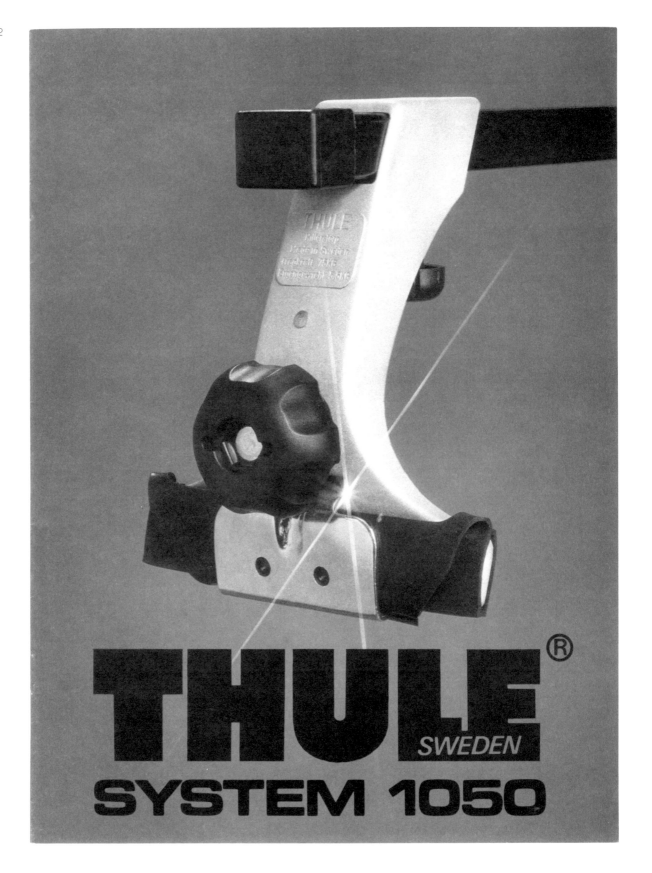

Thule		YEAR:	1982
DIMS:	28 × 21 CM (11 × 8.25 IN)	TEAM:	UNKNOWN
PAGES:	10		

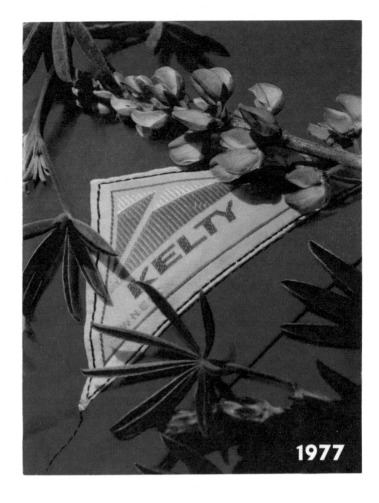

Kelty	
YEAR:	1977
DIMS:	28 × 22 CM
	11 × 8.75 IN
PAGES:	32
TEAM:	BORIS SAVIC

Kelty	
YEAR:	1996
DIMS:	28 × 22 CM
	11 × 8.75 IN
PAGES:	39
TEAM:	JEFF HURN

New Millennium.
New Generation.

GigaPower Stove.

snow peak
outdoor lifestyle creator since 1958

Snow Peak		YEAR:	2000
DIMS:	21 × 10 CM (8.25 × 3.75 IN)	TEAM:	UNKNOWN
PAGES:	26		

kirtland

BOULDER COLORADO

GENERATION II TOURPAKS

Panniers. Handlebar Bags.

MILES AHEAD

Kirtland Tour Pak		YEAR:	1984
DIMS:	29 × 22 CM (11.25 × 8.75 IN)	TEAM:	UNKNOWN
PAGES:	5		

ASHIMA SHIRAISHI
Professional rock climber

This image, taken from a 2004 Snow Peak cover, is rich with allusion for me. The sight of billowing steam transports me to Sensōji, an ancient Buddhist temple in Asakusa, Tokyo. Inside the shrine, swathes of people huddle around the earthenware incense burner to purify their minds, bodies and souls in the smoke. There's something sacred in the elusive nature of steam, in the fluidity of a material whose shape shifts from liquid to vapour, from a solid incense stick to ephemeral smoke. Perhaps it's a reminder of the ever-changing nature of our own existence, too.

Focus is what drives our attention, and our lives. The sharpness of the liquid-holding vessel contrasted against the hazy silhouette of the human in the background reminds me of the human reverence for the creation of object and material to allow us to take the time to go back and dream in the immaterial space. To imagine the manifold possibilities of what can unfold.

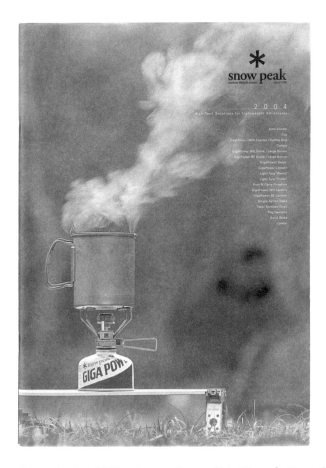

Snow Peak, 2004, 30 × 22 cm (11.75 × 8.75 in), 46 pages

L.L. BEAN
Manufacturer
FREEPORT, MAINE

SPRING 1931

See Page 13

See Page 3

See Page 15

W. DAVID MARX
Culture, fashion and music writer

The word 'fashion' often stands in opposition to 'function'. Fashion describes the superficial parts of life that change for no rational reason. Function enables survival. Acid-washed jeans are frivolous; GoreTex is science. This dichotomy is visible on the cover of the 1931 L. L. Bean catalogue. The images make no appeal to lifestyle aspirations — just three useful objects for hiking, camping and hunting.

With this great rivalry between fashion and function, what prompted the hybridization of outdoor gear and style that marks our current age? Today, L. L. Bean is an apparel giant. One major catalyst was the 1980s *Official Preppy Handbook*, which turned the company's Norwegian sweaters and duck boots into desirable accessories for American teens.

Five years prior, however, outdoor gear and style had already merged in Japan as part of a fashion trend called 'Heavy Duty' — think: Sierra Designs 60/40 parkas, Levi's 501 jeans or corduroy slacks and hiking boots. The look's primary instigator was an illustrator and editor named Yasuhiko Kobayashi. He spent his teen years in the postwar period reading catalogues left by American families who lived in his mother's rental apartments. For Kobayashi, the catalogues represented a dream world of consumer goods that were wholly unavailable in Japan.

In 1969, Kobayashi picked up a copy of the *Whole Earth Catalog* while visiting New York City. He didn't really understand it, but he kept pushing his editors to do a 'Japanese version'. This culminated in the legendary catalogue-magazine *Made in U.S.A.* in 1975 — a guide to every desirable consumer object in the US, including Pendleton knockabout cardigans, Jeff Ho's Zephyr Production surfboards and even generic tools from suburban garages. *Made in U.S.A.* also contained a fifty-six-page reprint of the 1974–75 Hudson's Camping Headquarters mailer. The opening essay explained, 'Americans use the terms "catalog[ue] joy" and "catalog[ue] freak" for people who like to look at and collect well-known catalog[ue]s.' Whether or not these were real English words, they made catalogues cool in Japan.

Made in U.S.A. was a runaway hit, and teens dressed accordingly in the 'Heavy Duty' style. But its more enduring influence was creating the 'catalogue-magazine' format that still informs the design of Japanese fashion publications today. Japanese magazine covers still resemble that L. L. Bean cover from 1931 — just now it's considered to be fashion, not function.

L. L. Bean, 1931, 23 × 20 cm (9 × 7.75 in), 24 pages

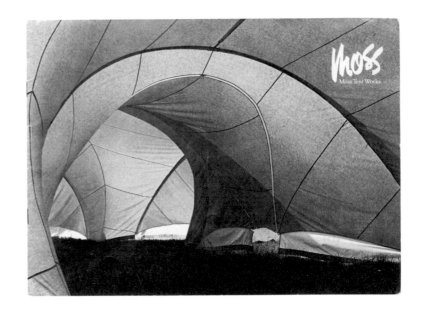

Moss Tent Works	
YEAR:	1979
DIMS:	21 × 30 CM
	8.25 × 11.75 IN
PAGES:	10
TEAM:	RICHARD WARNER

Company founder Bill Moss was an artist by training who painted for *Ford Times* before launching his tent brand in 1975. Known for his innovative and beautiful designs, Moss once said, '[a] tent to me is a piece of sculpture you can get into'.

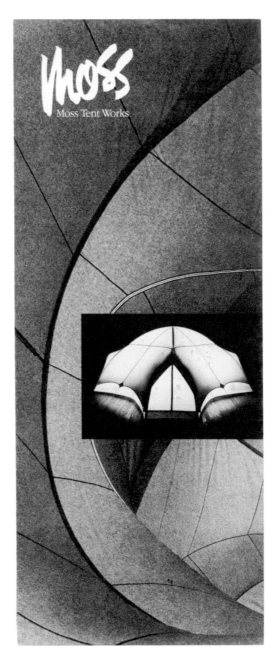

Moss Tent Works	
YEAR:	1983
DIMS:	28 × 12 CM
	11 × 4.75 IN
PAGES:	14
TEAM:	BENJAMIN MAGRO

Salomon		YEAR:	1996
DIMS:	22 × 11 CM (8.75 × 4.25 IN)	TEAM:	UNKNOWN
PAGES:	11		

Enjoy
Sleeping Comfort
Anywhere

The warmest, most comfortable sleeping pad.

Therm-A-Rest		YEAR:	1984
DIMS:	22 × 10 CM (8.75 × 3.75 IN)	TEAM:	UNKNOWN
PAGES:	5		

60

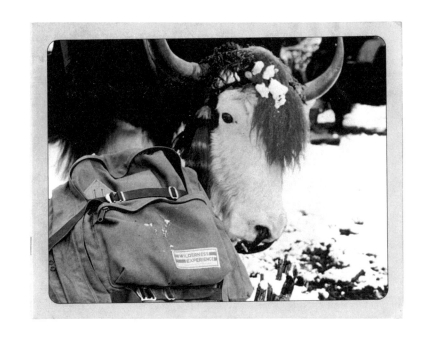

Wilderness Experience	
YEAR:	UNKNOWN
DIMS:	22 × 28 CM
	8.75 × 11 IN
PAGES:	14
TEAM:	LAURIE ENGEL

Mystery Ranch	
YEAR:	2000
DIMS:	15 × 15 CM
	5.75 × 5.75 IN
PAGES:	7
TEAM:	THIBEAULT ADVERTISING

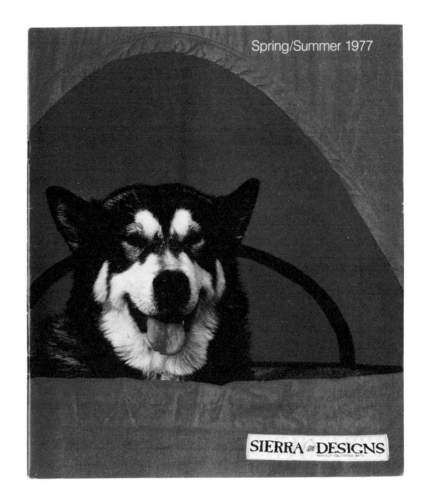

Spring/Summer 1977

SIERRA DESIGNS

Sierra Designs	
YEAR:	1977
DIMS:	28 × 24 CM
	11 × 9.5 IN
PAGES:	48
TEAM:	UNKNOWN

Fall/Winter 1976/77

Sierra Designs	
YEAR:	1976
DIMS:	26 × 23 CM
	10.25 × 8.9 IN
PAGES:	63
TEAM:	UNKNOWN

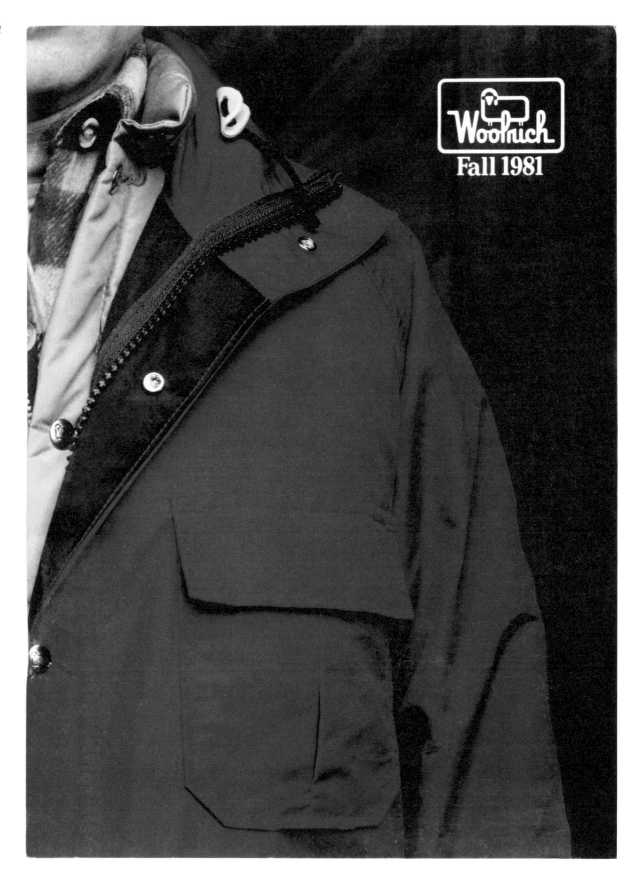

Woolrich		YEAR:	1981
DIMS:	30 × 22 CM (11.75 × 8.75 IN)	TEAM:	UNKNOWN
PAGES:	51		

Woolrich	
YEAR:	1986
DIMS:	28 × 22 CM
	11 × 8.75 IN
PAGES:	18
TEAM:	UNKNOWN

Woolrich	
YEAR:	1980
DIMS:	29 × 22 CM
	11.25 × 8.75 IN
PAGES:	15
TEAM:	UNKNOWN

75 CENTS

Mountain Gazette 55

Mountain Gazette		YEAR:	1977
DIMS:	38 × 26 CM (15 × 10.25 IN)	TEAM:	RICHARD J. MURPHY
PAGES:	36		

KELTY, UNKNOWN

KELTY, UNKNOWN

CHUMS, 1999

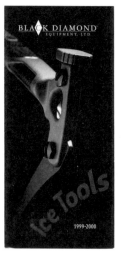

BLACK DIAMOND EQUIPMENT, 1999

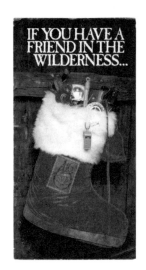

ADVENTURE 16, 1981

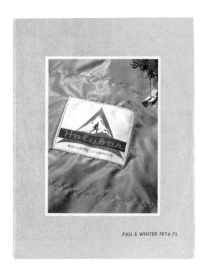

HOLUBAR, 1974

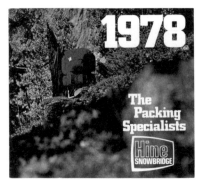

HINE SNOWBRIDGE, 1978

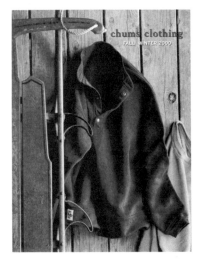

CHUMS, 2000

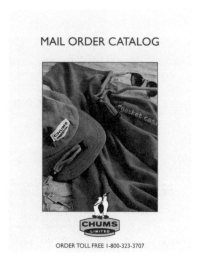

CHUMS, UNKNOWN

66

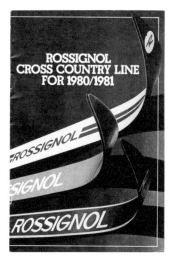

ROSSIGNOL, 1980

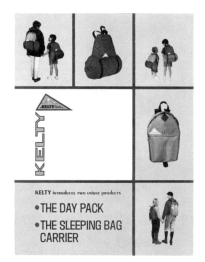

KELTY, UNKNOWN

SALOMON, 1996

DANNER, 1983

ROSSIGNOL, 1984

SIERRA DESIGNS, 1977

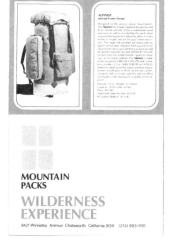

WILDERNESS EXPERIENCE, 1974

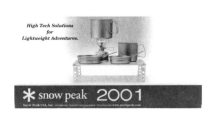

SNOW PEAK, 2001

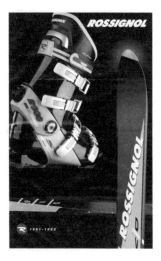

ROSSIGNOL, 1991

67

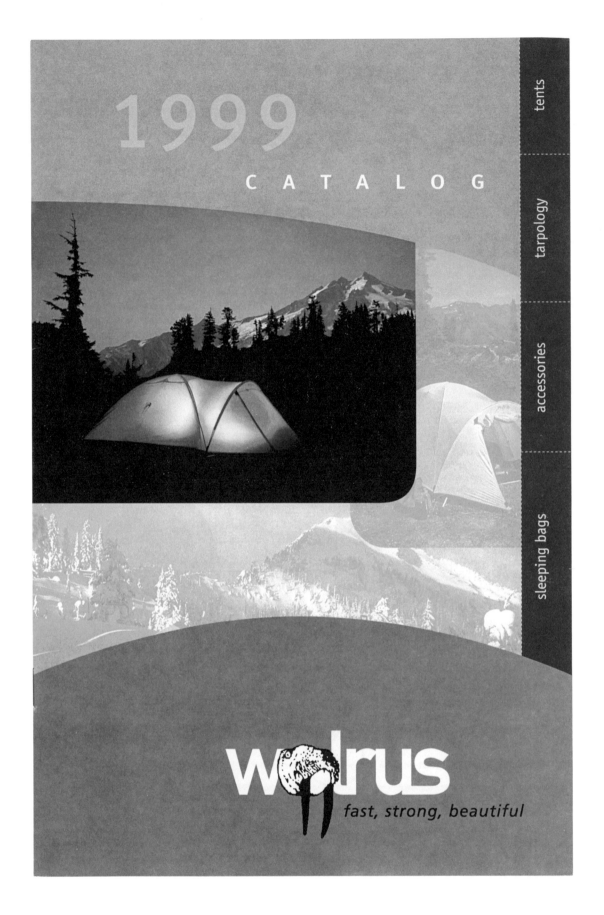

tents

tarpology

accessories

sleeping bags

walrus
fast, strong, beautiful

Walrus		YEAR:	1999	Friends had long compared George Marks to a Walrus due to his bushy mutton chops, so when he co-founded a tent brand with Bob Swanson in 1984, they named it after the tusked marine mammal.
DIMS:	27 × 18 CM	PAGES:	18	
	10.75 × 7 IN	TEAM:	TOD BLOXHAM	

Mountain Safety Research (MSR)	
YEAR:	1981
DIMS:	28 × 22 CM
	11 × 8.75 IN
PAGES:	11
TEAM:	UNKNOWN

Mountain Safety Research (MSR)	
YEAR:	2005
DIMS:	26 × 21 CM
	10.25 × 8.25 IN
PAGES:	33
TEAM:	UNKNOWN

69

Summit		YEAR:	1983
DIMS:	28 × 22 CM (11 × 8.75 IN)	TEAM:	DOUGLAS S. HANSEN
PAGES:	36		

Athleta		YEAR:	1999
DIMS:	28 × 21 CM (11 × 8.25 IN)	TEAM:	UNKNOWN
PAGES:	31		

Kelty 1997

Kelty		YEAR:	1997
DIMS:	28 × 22 CM (11 × 8.75 IN)	TEAM:	JEFF HURN
PAGES:	39		

OSPREY

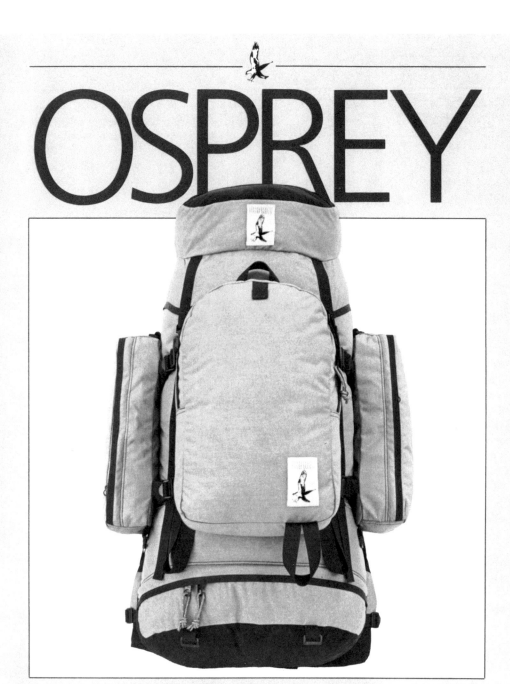

I N T E R N A L · F R A M E
P A C K S

Osprey		YEAR:	1986
DIMS:	29 × 22 CM (11.25 × 8.75 IN)	TEAM:	UNKNOWN
PAGES:	6		

Coleman	
YEAR:	1963
DIMS:	28 × 22 CM
	11 × 8.75 IN
PAGES:	12
TEAM:	UNKNOWN

Ibex	
YEAR:	UNKNOWN
DIMS:	16 × 21 CM
	6.25 × 8.25 IN
PAGES:	1
TEAM:	UNKNOWN

Blacks		YEAR:	1972
DIMS:	30 × 21 CM (11.75 × 8.25 IN)	TEAM:	UNKNOWN
PAGES:	22		

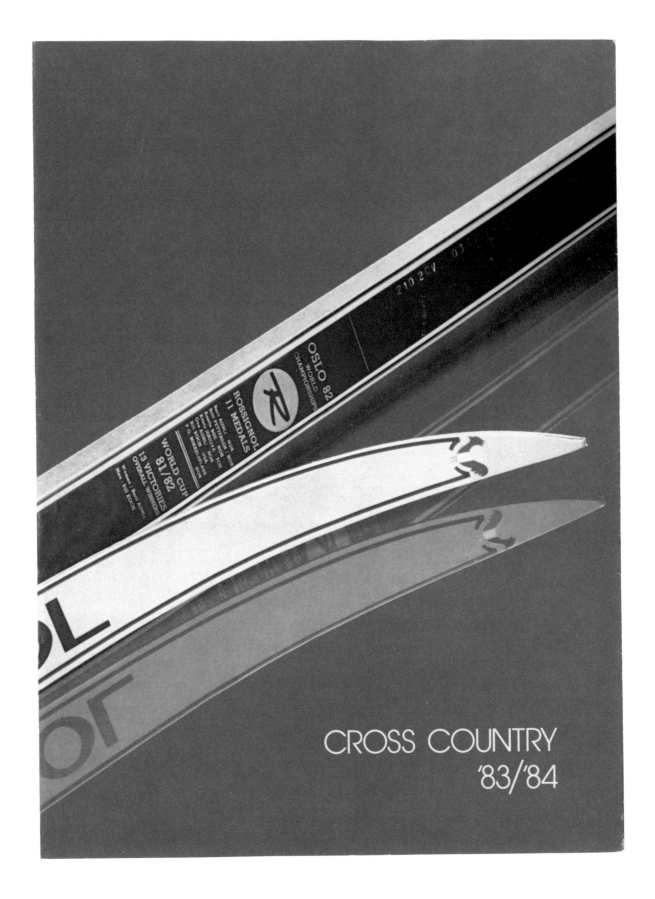

CROSS COUNTRY
'83/'84

Rossignol		YEAR:	1983
DIMS:	28 × 21 CM (11 × 8.25 IN)	TEAM:	UNKNOWN
PAGES:	6		

Atomic	
YEAR:	1993
DIMS:	28 × 22 CM
	11 × 8.75 IN
PAGES:	4
TEAM:	UNKNOWN

Salomon	
YEAR:	UNKNOWN
DIMS:	24 × 11 CM
	9.5 × 4.25 IN
PAGES:	11
TEAM:	UNKNOWN

ABSTRACTION
Photography capturing simplified, textural forms and details.

Contributions by Amy Auscherman (p. 84), Ronnie Fieg (p. 85)

Both natural and manufactured creations boast visual features that produce eye-catching patterns, textures and details. Showing such abstraction on catalogue covers can force viewers to linger on an image, admiring a subtle repetition, interpreting the 'feel' of an otherwise smooth page, or pondering a close-up that's nearly unrecognizable without the context of the greater whole. This approach can seem almost elemental, framing nature in a way that highlights the dirt, rock, ice and snow rather than the mountain on which they are found. Similarly, gear is not shown as a functional whole, but as mesh, stitching and fibres. Simplicity should not be mistaken for a lack of meaning, however. Patterns like the striated rock in the 1993 Dana Design catalogue (p. 95) or the smooth texture of flowing water in the 1994 Moss Tent Works catalogue (p. 83) can even suggest a different dimension: the passage of time.

By concentrating on the basics, abstraction can prompt viewers to think more deeply about what they're seeing and how they relate to it. Imagery focused on shadows rather than the trees that cast them, or close-ups of the delicate features on a forbidding rock face, can challenge the way viewers perceive nature and motivate them to consider it from a different perspective. Pattern or texture may even inspire certain feelings — like order, calm, peace or wonder. On a more practical level, abstraction can also be used to evoke gear — and the sensation of using it — without showing it. On the 2002 Black Diamond catalogue (p. 82), two parallel lines of flying snow suggest skis floating through deep powder, though the equipment is never seen. In these ways, employing such imagery is a perfect way to build a meaningful connection with the viewer.

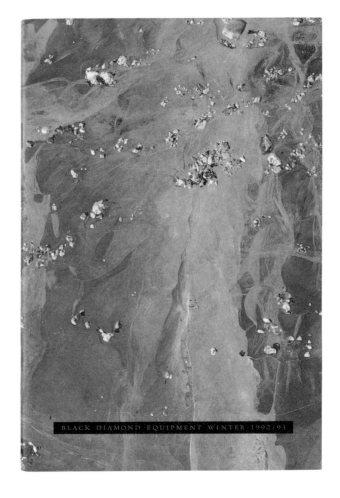

Black Diamond Equipment	
YEAR:	1992
DIMS:	26 × 18 CM
	10.25 × 7 IN
PAGES:	39
TEAM:	MUGS STUMP

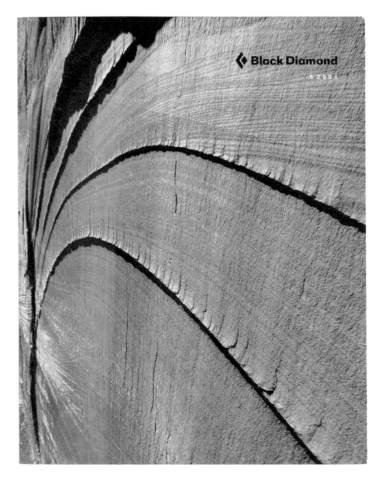

Black Diamond Equipment	
YEAR:	2001
DIMS:	26 × 21 CM
	10.25 × 8.25 IN
PAGES:	81
TEAM:	ERIC DRAPER

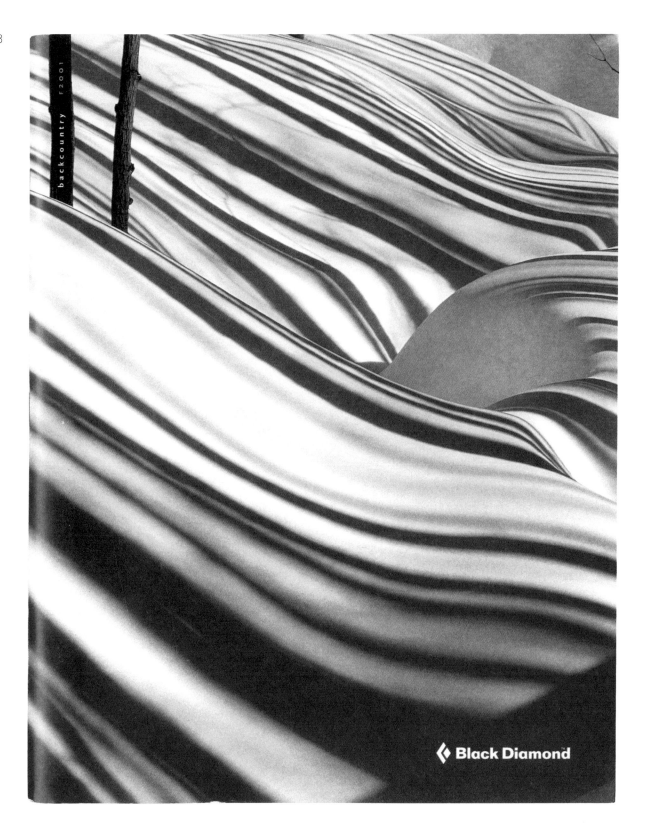

Black Diamond Equipment		YEAR:	2001
DIMS:	27 × 21 CM (10.75 × 8.25 IN)	TEAM:	MICHAEL CLARK
PAGES:	47		

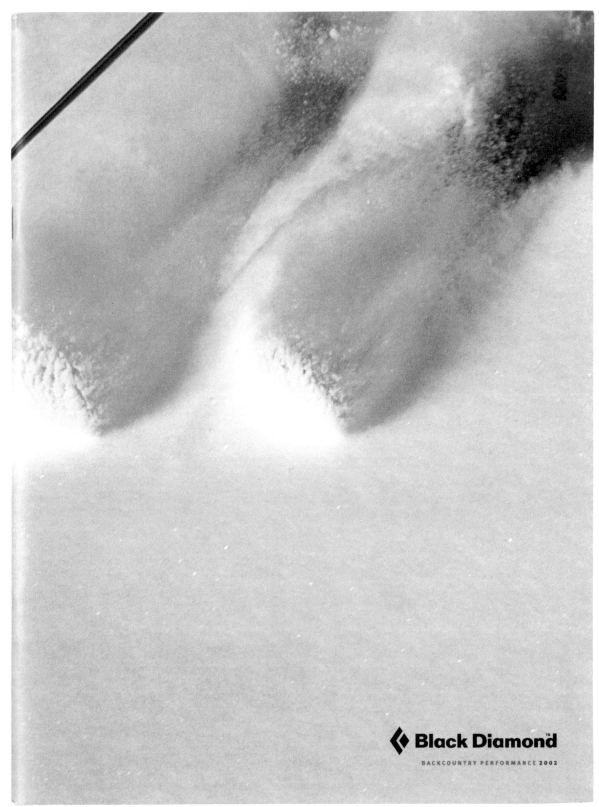

Black Diamond Equipment		YEAR:	2002
DIMS:	28 × 22 CM (11 × 8.75 IN)	TEAM:	JAMIE PIERRE
PAGES:	49		

Gerry	
YEAR:	1973
DIMS:	24 × 30 CM
	9.5 × 11.75 IN
PAGES:	16
TEAM:	UNKNOWN

Moss Tent Works	
YEAR:	1994
DIMS:	28 × 12 CM
	11 × 4.75 IN
PAGES:	13
TEAM:	UNKNOWN

AMY AUSCHERMAN
Archivist

I don't ski or surf or rock climb, but I do love a hike. Millions of years before the cornfields, oceans covered Indiana and left sandstone valleys that now make up Shades State Park. Some of my earliest outdoor memories are of hiking there with my family. My mum had a pair of Vasque hiking boots that I've since inherited. The shoes have subsequently taken me on numerous hikes in Western Michigan and Northern California.

I am a rock collector. This habit has been encouraged by the collections of designers and artists I am fortunate enough to encounter in my work as an archivist. Alexander Girard made sculpture from driftwood; Georgia O'Keeffe collected rocks; Ray and Charles Eames displayed tumbleweeds as art objects. This quiet Vasque catalogue conjures those collections and my favourite parts of forest bathing: noticing the details, patterns, forms and beauty that occur at all scales in nature.

Vasque, 1999, 28 × 22 cm (11 × 8.75 in), 44 pages

RONNIE FIEG
Founder, CEO and creative director

This Black Diamond cover from 2002 resonates with me because it reminds me that nothing is impossible. The image — showing two climbers hanging precariously from their ice picks, on huge icicles up a sheer rock face — is the sort that I would have framed in my office to serve as a constant source of motivation. It's also a true benchmark for photography.

The image plays with perspective; at a glance, it would be hard to work out the size of the giant, jagged icicles without the climbers in their colourful jackets for scale. This trick on the eye serves to create a greater sense of awe, emphasizing the heights of the climbers' ambition. It is an image my team and I would aspire to create.

Black Diamond Equipment, 2002, 28 × 21 cm (11 × 8.25 in), 35 pages
Team: Peter Mathis

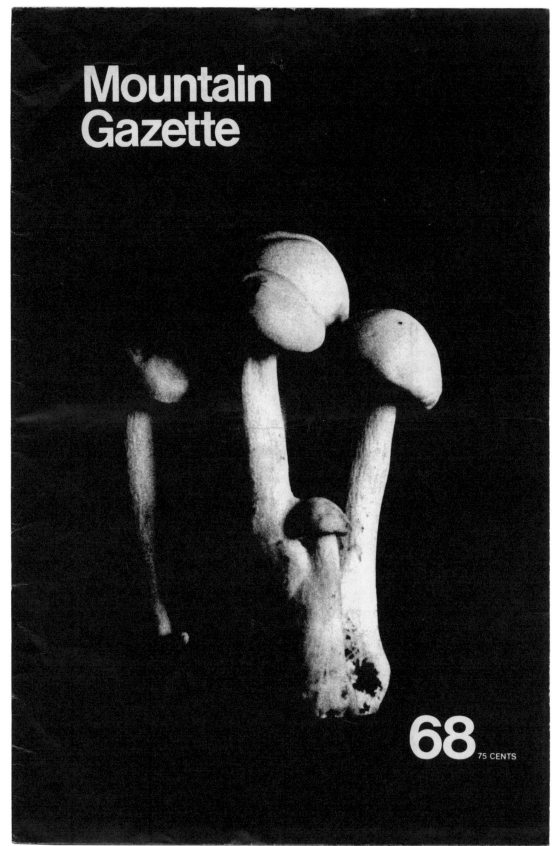

Mountain Gazette

68 75 CENTS

Mountain Gazette		YEAR:	1978
DIMS:	38 × 26 CM (15 × 10.25 IN)	TEAM:	ANN HODGES
PAGES:	36		

75 CENTS

Mountain Gazette 59

Mountain Gazette		YEAR:	1977
DIMS:	38 × 26 CM (15 × 10.25 IN)	TEAM:	ROBERT WHITACRE
PAGES:	36		

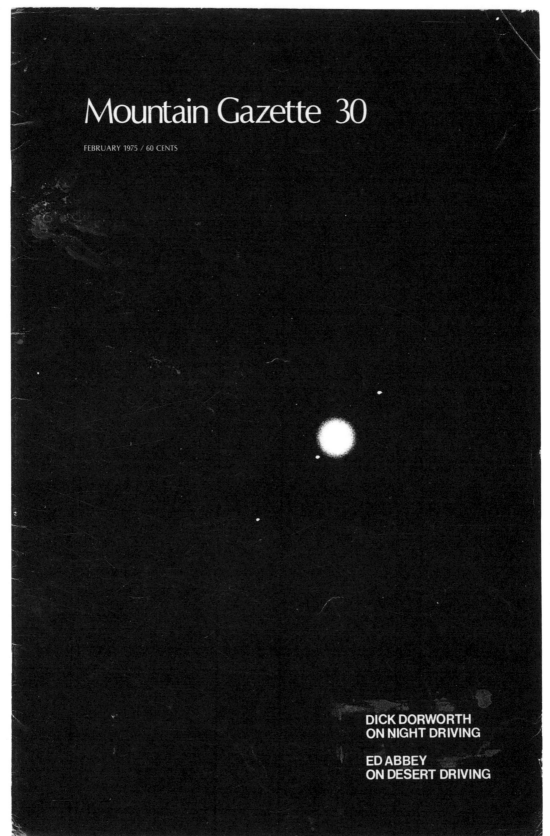

Mountain Gazette 30

FEBRUARY 1975 / 60 CENTS

**DICK DORWORTH
ON NIGHT DRIVING**

**ED ABBEY
ON DESERT DRIVING**

Mountain Gazette		YEAR:	1975
DIMS:	38 × 26 CM (15 × 10.25 IN)	TEAM:	BOB CHAMBERLAIN
PAGES:	36		

'O² yoga

prana

Prana		YEAR:	2002
DIMS:	25 × 18 CM (9.5 × 7 IN)	TEAM:	RICH, SEXTON, WVINNER, BROUDY, PORMAN, DONOHUE, PATITUCCI, FIORENTINO, O'REILLY, DORFMAN, HEXNER, HILL, CHURCHILL, WINOKUR, FIEROTT, THEO
PAGES:	30		

Prana		YEAR:	2002
DIMS:	28 × 18 CM (11 × 7 IN)	TEAM:	UNKNOWN
PAGES:	50		

Prana		YEAR:	2002
DIMS:	26 × 19 CM (10.25 × 7.25 IN)	TEAM:	GOVINDA
PAGES:	30		

Mystery Ranch	
YEAR:	2000
DIMS:	13 × 13 CM
	5.25 × 5.25 IN
PAGES:	30
TEAM:	THIBEAULT ADVERTISING

Granite Gear	
YEAR:	1993
DIMS:	28 × 22 CM
	11 × 8.75 IN
PAGES:	15
TEAM:	UNKNOWN

DOWN

CLOTHING and EQUIPMENT
CATALOGUE • 1963-1964

MOUNTAIN SPORTS / BOULDER, COLO.

Gerry		YEAR:	1963
DIMS:	26 × 18 CM (10.25 × 7 IN)	TEAM:	UNKNOWN
PAGES:	7		

summt september 1963

Summit		YEAR:	1963
DIMS:	27 × 22 CM (10.75 × 8.75 IN)	TEAM:	JERRY LEBECK
PAGES:	32		

Coleman	
YEAR:	2005
DIMS:	25 × 25 CM
	9.75 × 9.75 IN
PAGES:	40
TEAM:	UNKNOWN

Dana Design	
YEAR:	1993
DIMS:	22 × 28 CM
	8.75 × 11 IN
PAGES:	24
TEAM:	JOHN DITTLI

95

Granite Stairway Mountaineering, 1974, 20 × 25 cm (7.75 × 9.75 in),
96 pages
Team: Joe Bakketun, Dan B. Wright, Peter Benjamin, Bill Simon, Stephen
Tucker, Gary Walker, Richard Kelty, Galen A. Rowell

SNOWLION GREATCOAT

The Greatcoat is a three-layer jacket designed for warmth and comfort in high winds and freezing temperatures. It is cut large enough to accommodate additional layers of clothing underneath. The outer layer of the Greatcoat is water repellant 65-35 cloth (65% polyester - 35% cotton) and is sewn at the seams to a down-filled double quilt of 2.2 oz. nylon taffeta. Design features include seven pockets; two 9" x 11" gusseted cargo pockets with snap closures, two down-filled hand warmer pockets, a vertical breast pocket, and two interior storage pockets. It also features a

drawcord waist adjustment, 5 inch velcro wrist tighteners, a 4-1/4 inch high down filled collar, and Snow Lion's extended fabric snap system for attaching the optional hood. Average down fill: 13 oz.

Colors: Dark Blue, Coffee
Sizes: XS, S, M, L, XL
Avg. Down Fill: 14 oz. **Avg. Total Wt:** 44 oz.
Price: 59.00 35.40

GREATCOAT HOOD

A non-sewn-through three layer hood constructed like the Greatcoat. The closure is 4-1/2 inches high and is adjusted with snaps and a drawcord.
Colors: Dark Blue, Coffee
Total Wt: 8 oz. **Price:** 7.50

CLASS 5 GLACIER PARKA

Considered Class 5's "most desirable" parka, the Glacier is a heavy duty jacket built in three layers appropriate for all activities in extremely cold weather. It is a Class-2 parka with a smooth overshell of 65-35 cloth (65% Dacron, 35% Cotton), connected only at the seams. It is extremely warm, as well as highly wind and water repellant. Its versatility is enhanced by its numerous design features, such as two gusseted cargo pockets and two down-filled hand-warmer pockets, a large outside breast pocket, and a back pocket that runs the full width of the garment both with a covered 9 inch coil zipper. It has a draw cord at the waist, and a three inch down filled collar. A separate hood is available.

Colors: Blue, Green, Rasberry, Rust
Sizes: XS, S, M, L
Avg. Down Fill: 12 oz.
Avg. Total Wt: 42 oz.
Price: 73.50

GLACIER HOOD

Constructed of 65-35 cloth with 2.75 oz. of duck down with snap attachments and draw cord.

Colors: Blue, Green, Rasberry, Rust
Total Wt: 6 oz.
Price: 11.00

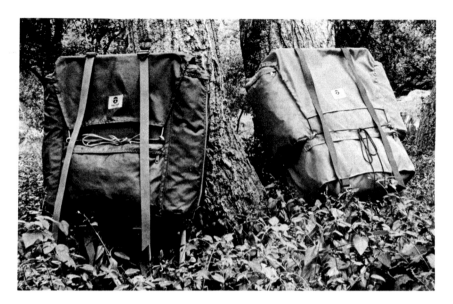
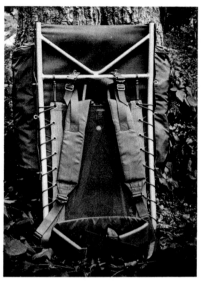

TRAILWISE PACK FRAMES

Trailwise pack frames are designed with comfort, durability and lightness in mind. They are constructed of a 6061-T6 aluminum alloy thick-wall tubing with heli-arc welded joints. The bag is attached with aluminum steel eyebolts and aluminum Rivnuts, and can be mounted in either a high or low position, depending on where the center of gravity is desired. The eyebolt and Rivnut combination has a strength advantage over the usual clevis pin and wire attachment in that the frame need only be drilled from one side, plus the Rivnut helps to reinforce this hole. The frame is well-contoured to place the load as close as possible to the body, and a padded suspension system allows the majority of the load/weight to be placed directly on the hips. The full mesh back panel distributes weight and allows air to circulate between the pack and the wearer.

PACK BAG MODEL 73:

The 73 is a three quarter undivided sack which can be mounted on the frame in either a high or low position. It has two full length side pockets and a back pocket, and has a total capacity of 3476 cubic inches. Made of heavy-duty urethane-coated nylon duck.

Colors: blue, brown, orange
Weight with medium frame: 62 1/2 oz.
Price: 69.00

PACK BAG MODEL 74:

The 74 is a three quarter length sack that is divided into two compartments. The side pockets extend about 2/3 of the length of the sack, and measure 3" x 6" x 11". The bag itself measures 8" x 16" x 21-1/2" and has a capacity of 3322 cubic inches. Made of heavy-duty urethane-coated nylon duck.

Colors: blue, brown, orange
Weight with medium frame: 62 oz.
Price: 69.00

PIVETTA MUIR TRAIL

This is an excellent lightweight trail boot of grey abrasion-resistant suede. Fully lined in smooth calf, it has a padded non-slip tongue and a padded ankle section. With reinforced toe caps and heel counters, a steel shank and Vibram lug soles, the Muir Trail also doubles as a climbing boot.

Avg. Wt: 52 oz. **Sizes:** 5-12
Width: N, M, W **Price:** 42.50

FABIANO 90

Popular for both rock and trails, the 90 is an unusually good fitting and comfortable boot. Constructed of grey reversed leather, it is leather lined with a double layer over the toe for durability. Seams are reversed to prevent snagging on rocks, and the Italian Roccia sole and heel is flush to the uppers. It features a steel shank and padded tongue and ankles.

Avg. Wt: 50 oz. **Sizes:** 4-16
Width: M, W **Price:** 29.95

FABIANO 35

Similar to the 90, but slightly lighter with a single layer over the toe, and hooks instead of eyelets for lacing. Constructed of blue reversed leather, leather lined with a one piece Roccia sole and heel. The 35 features a padded ankle, padded tongue, and a steel shank.

Avg. Wt: 48 oz. **Sizes:** 4-10
Width: M **Price:** 29.95

VASQUE SEQUOIA II

The Sequoia is a lightweight boot of brown split leather with a padded leather-lined tongue, a stretchy scree top, and a leather-lined, padded ankle. It features a tempered steel shank, and a Vibram lug sole.

Avg. Wt: 46 oz. **Sizes:** 5-13
Width: M **Price:** 32.95

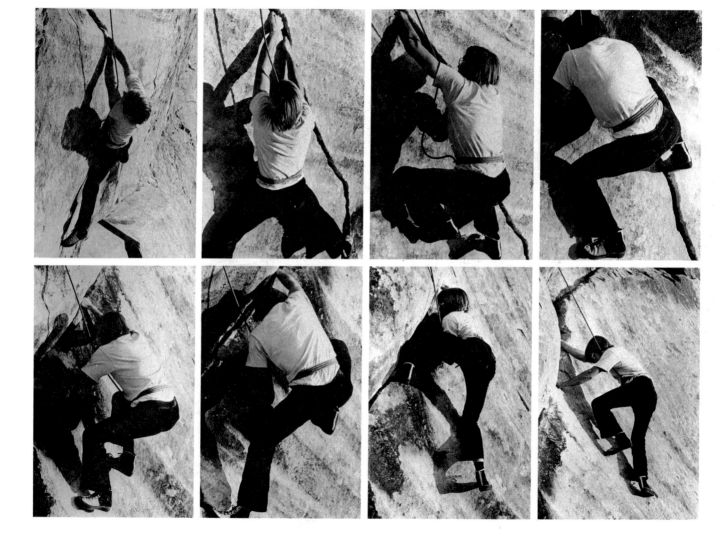

GOLDLINE

American made, nylon rope of continuous three-strand, hard-lay construction. Retains over 90 percent of its strength when wet and has excellent abrasion resistance. Breaking strength is 5,500 pounds.

7/16" x 120'	**Price:** 24.00	**Wt:** 6 lbs.
7/16" x 150'	**Price:** 30.00	**Wt:** 7.5 lbs.
7/16" x 165'	**Price:** 33.00	**Wt:** 8.25 lbs.
Bulk rate	**Price per ft:** .20	**Wt/ft:** 2/3 oz.

CHOUINARD ROPE

A kernmantle type rope, consisting of continuous Perlon fibers braided into one unit. Somewhat stiffer than the Edilrid, with excellent handling characteristics. Average breaking strengths are 9 mm - 4300 pounds; 11 mm - 5900 pounds.

Colors: Purple, fantasia, red.

9 mm x 120'	**Wt:** 4 lbs. 12 oz.	**Price:** 56.25
9 mm x 150'	**Wt:** 5 lbs. 1 oz.	**Price:** 69.75
9 mm x 165'	**Wt:** 5 lbs. 10 oz.	**Price:** 76.50
11 mm x 120'	**Wt:** 7 lbs. 2 oz.	**Price:** 71.50
11 mm x 150'	**Wt:** 7 lbs. 8 oz.	**Price:** 88.50
11 mm x 165'	**Wt:** 7 lbs. 14 oz.	**Price:** 97.50

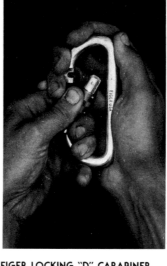
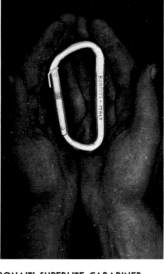

EIGER ALUMINUM OVAL CARABINER

A fine, oval, aluminum-alloy carabiner, smoothly polished with a notched gate. Rated strength of 3000 pounds.

Dimensions: 2" x 4"
Weight: 2 oz.
Price: 2.25

EIGER "D" CARABINER

A high quality "D" shaped carabiner.

Test: 5500 lbs.
Dimensions: 2" x 4-5/16"
Weight: 2-3/8 oz.
Price: 2.50

EIGER LOCKING "D" CARABINER

A "D" shaped aluminum alloy carabiner with a locking screw collar.

Test: 5500 lbs.
Weight: 2-3/8 oz.
Price: 3.50

BONAITI SUPERLITE CARABINER

An extremely light yet strong 'biner, with an asymmetrical shape for easy side opening.

Test: 4400 lbs.
Weight: 1-3/4 oz.
Price: 3.25

PROCESSED
Images that have a bold treatment applied to them.

Contribution by Kimou Meyer (p. 113)

These days, it's not uncommon for photographers to use computer software to process their images, adjusting the brightness, contrast and colour to make the photo just how they want it. Smartphones, too, are increasingly capable of pretty powerful image correction and manipulation. Consider the use (or overuse, depending on your perspective) of social-media filters, which have become the method by which most people interact with image processing. Here, users can give their holiday photos a dreamy vintage effect or even transform their face into a cartoon character with a simple tap.

While it's easy to imagine processed photography as a recent phenomenon, brands have been using it on the covers of outdoor catalogues for more than fifty years. Whether it was making an image black and white, adding a colour overlay, removing parts of the image or otherwise altering it, these effects often reflected the technology of the time. Simple, low-fi treatments gave way to more elaborate effects as the years passed, serving to strip away detail or intensify it for impact. Sometimes, the approach serves to highlight the gear, as seen in the 1992 Walrus catalogue (p. 122), where an illuminated tent in the foreground contrasts sharply with the darker background of the sepia-toned image. In other examples, it makes a person stand out, like many of the *Summit* magazine covers featuring a silhouetted figure against a brightly coloured background. And then there are treatments, like overlaying a heat map and using negative film effects, which are just fun ways to grab the viewer's attention by transforming otherwise ordinary photographs into something out of this world.

Moss Tent Works	
YEAR:	1994
DIMS:	22 × 28 CM
	8.75 × 11 IN
PAGES:	5
TEAM:	UNKNOWN

Kirtland Tour Pak	
YEAR:	1980
DIMS:	28 × 15 CM
	11 × 5.75 IN
PAGES:	9
TEAM:	UNKNOWN

Quality Packs
for the Serious
Outdoor
Enthusiast

Hine
SNOWBRIDGE

Hine Snowbridge		YEAR:	1980
DIMS:	23 × 15 CM (9 × 5.75 IN)	TEAM:	UNKNOWN
PAGES:	16		

SPRING / SUMMER

Lowa		YEAR:	2005
DIMS:	30 × 21 CM (11.75 × 8.25 IN)	TEAM:	BERND RITSCHEL, KAI PAUSELIUS, MICHAEL VOGELEY, PETER ROHRMOSER, KLAUS FENGLER, MARKUS ZIMMERMAN
PAGES:	112		

ASOLO	
YEAR:	1998
DIMS:	23 × 11 CM
	9 × 4.25 IN
PAGES:	22
TEAM:	UNKNOWN

ASOLO	
YEAR:	2000
DIMS:	29 × 22 CM
	11.25 × 8.75 IN
PAGES:	44
TEAM:	LORENZO TRENTO

ASOLO	
YEAR:	2000
DIMS:	28 × 21 CM
	11 × 8.25 IN
PAGES:	5
TEAM:	UNKNOWN

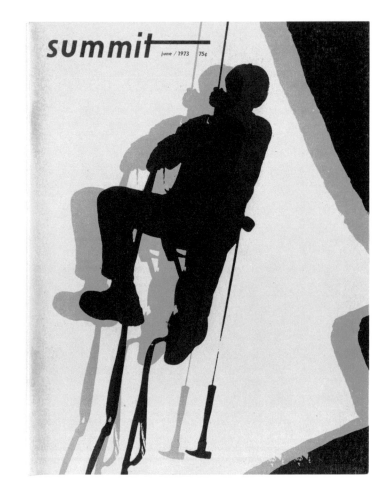

Summit	
YEAR:	1973
DIMS:	28 × 22 CM
	11 × 8.75 IN
PAGES:	44
TEAM:	BILL STEER

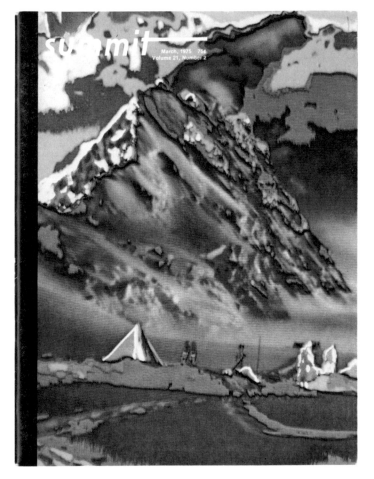

Summit	
YEAR:	1975
DIMS:	28 × 22 CM
	11 × 8.75 IN
PAGES:	44
TEAM:	GERALD A. ROACH

WITH HERMANN BUHL 1957 ■ FIRST ASCENT OF BROAD PEAK, GERMAN DIAMIR EXPEDITION 1961 ■ GERMAN ANDEAN EXPEDITION 1962 ■
EXPEDITION 1962 ■ AUSTRIAN HINDUKUSCH EXPEDITION 1963 ■ AMERICAN HINDUKUSCH EXPEDITION 1964 ■ BAVARIAN KARAKORUM EXPE-
PAL EXPEDITION 1964 ■ IRISH HIMALAYAN EXPEDITION 1964 ■ AUSTRIAN KARAKORUM EXPEDITION 1964 ■ YUGOSLAVIAN HIMALAYAN EX-
ER ASCENT OF THE DIRETISSIMA THROUGH THE GROSSE ZINNE NORTH FACE 1961 ■ FIRST WINTER ASCENT OF THE EIGER NORTH FACE 1961
WINTER ASCENT OF THE SUPER DIRETISSIMA THROUGH THE GROSSE ZINNE NORTH FACE 1963 ■ WINTER ASCENT OF THE PIZ BADILLE NORTH
ENT OF MALY DOMBAI ULGEN NORTH FACE, CAUCASUS MOUNTAINS (ICEWALL HEIGHTS OF 3,000 FEET) 1968 ■ AUSTRIAN PAMIR VIENNA EX-
USCH EXPEDITION 1962 ■ FIRST STEIRISCHE KARAKORUM-HIMALAYAN EXPEDITION 1964 ■ BAMBERGER HINDUKUSCH EXPLORATION 1962
ND EXPEDITION 1962 ■ MÜNCHNER HINDUKUSCH EXPLORATION 1963 ■ THE NETHERLANDS HIMALAYAN EXPEDITION 1964 ■ GERMAN HIMALAYAN
AVARIAN EXPLORATION CAUCASUS MOUNTAINS, CENTRAL AFRICA 1965 ■ EISENERZ HINDUKUSCH EXPEDITION 1965 ■ ROSENHEIMER HINDU-
DIRETISSIMA 1966 ■ HINDUKUSCH EXPEDITION 1967 ■ HINDUKUSCH JOURNEY, DAV SCHRONDORF 1967 ■ HINDUKUSCH EXPLORATION ÖAV
USTRIAN HINDUKUSCH EXPEDITION ÖAV FOR NASHAQ ■ FIRST ASCENT EAST FACE PIK-LENIN 1969 ■ FIRST JAPANESE DIRETISSIMA WINTER
MOUNT EVEREST DIRETISSIMA UNDER THE LEADERSHIP OF NORMAN DYHRENFURTH ■ FIRST EUROPEAN MOUNT EVEREST EXPEDITION 1972 ■
ORATION 1972 ■ AUSTRIAN HIMALAYAN EXPEDITION OF DHALAGIRI IV ■ AMERICAN K2 EXPEDITION 1975

Lowa		YEAR:	UNKNOWN
DIMS:	26 × 18 CM (10.25 × 7 IN)	TEAM:	UNKNOWN
PAGES:	14		

summit

may / 1969 60¢

KIMOU MEYER
Artist, co-founder and creative director

Growing up in Switzerland, I was surrounded by active types — being outdoors in nature is ingrained in Swiss heritage and culture. My grandfather was a seasoned climber. During my youth, my interests revolved around counterculture: skateboarding, hip-hop and punk music. These diversions shared common threads and spin offs, including DIY zines, fashion, logo mashups, revolutionary visual aesthetics, coded slang and a distinct 'underground' attitude. At that time, The North Face Nuptse was just a New York hip-hop winter puffer for me, not an outdoor jacket.

When I moved to New York City in 1999, I met Chris Gentile, owner of brilliant Brooklyn brand and shop Pilgrim Surf Supplies. He unveiled the visual world and counterculture of the outdoors to me, offering up stories of Yvon Chouinard and the origins of Patagonia, and sharing old psychedelic climbing catalogues with 'punk-like' illustrations. Pilgrim also had pop-ups with amazing vintage outdoor pieces — by the likes of L. L. Bean, Chouinard, *Summit*, The North Face and Rei — curated by Monroe Garden, a Japanese store in a Brooklyn basement. The design, colours and graphics all caught my attention.

What captivated me most about these vintage pieces, brochures and artefacts was their freshness, conceptualism and modernity. Swiss outdoor brands and catalogues felt sterile and official-looking with mundane photos. In contrast, many US catalogues and magazines from the 60s, 70s and 80s were radical, an unconventional medley of experimental design. You could tell it was a rebellious and anti-establishment movement.

The endless and enigmatic coded language inspired me too: the 'for us by us' attitude and unlocking of this anti-social, radical, hippie and underground visual world. Discovering the Utah State University Outdoor Recreation Archive triggered an emotional response for me. It emanated a unique aesthetic — graphics created for the climbing and outdoor nerd community, not the masses. You can tell the catalogues and magazines were designed from the heart, infused with creativity, humour and modernity, imbibed with an almost anti-consumer commercial approach.

This *Summit* cover is from May 1969. But remove the year and brand associations, and it could easily pass for a 2024 hip-hop album cover. In fact, the climber looks so much like The Alchemist, one of my favourite hip-hop producers, they could be doppelgängers! It's hard to believe the artwork is from 1969 — it's so modern. From the duotone colour approach and cropping to the model's facial expression, the image piques the curiosity. Is the man at high altitude? Is he in pain? Is he reading a map? Who knows. That's what I appreciate: this cover makes you wonder, eager to turn the page and explore.

Summit, 1969, 28 × 22 cm (11 × 8.75 in), 44 pages
Team: Chris Wren

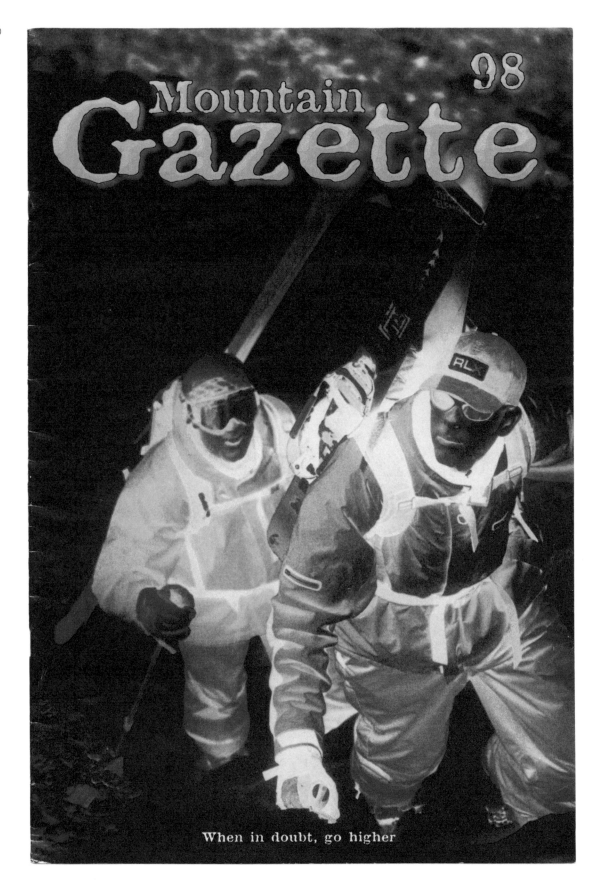

Mountain Gazette		YEAR:	2003
DIMS:	38 × 26 CM (15 × 10.25 IN)	TEAM:	GARY SOLES
PAGES:	42		

Mountain Gazette	
YEAR:	1976
DIMS:	38 × 26 CM
	15 × 10.25 IN
PAGES:	36
TEAM:	GALEN A. ROWELL

Mountain Gazette	
YEAR:	1977
DIMS:	38 × 26 CM
	15 × 10.25 IN
PAGES:	36
TEAM:	JAMES THRESHER

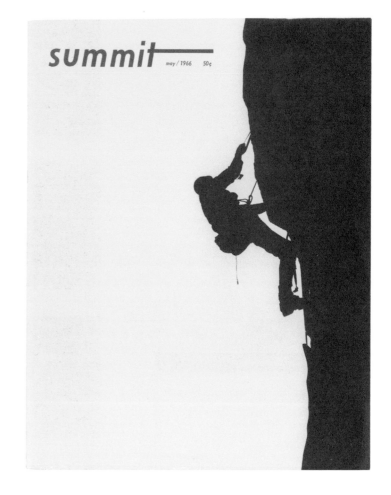

Summit	
YEAR:	1966
DIMS:	28 × 22 CM
	11 × 8.75 IN
PAGES:	32
TEAM:	UNKNOWN

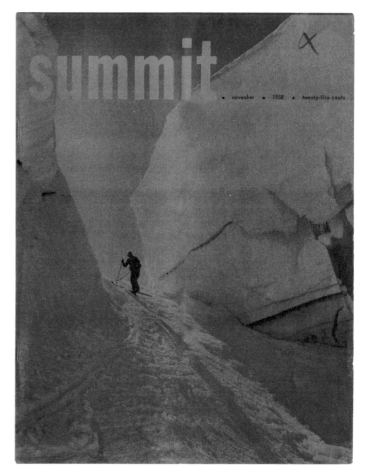

Summit	
YEAR:	1958
DIMS:	28 × 21 CM
	11 × 8.25 IN
PAGES:	24
TEAM:	BOB SPRING
	IRA SPRING

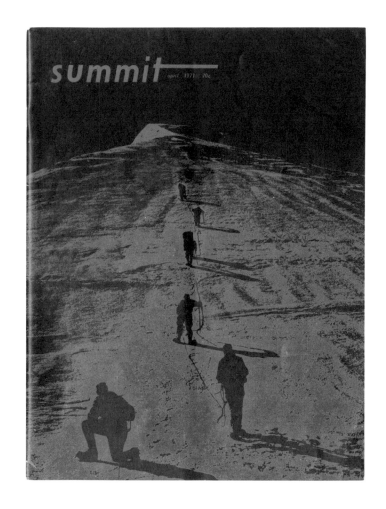

Summit	
YEAR:	1971
DIMS:	28 × 22 CM
	11 × 8.75 IN
PAGES:	44
TEAM:	ED COOPER

Summit	
YEAR:	1967
DIMS:	28 × 22 CM
	11 × 8.75 IN
PAGES:	36
TEAM:	UNKNOWN

SIERRA DESIGNS 69/70

Sierra Designs		YEAR:	1969	This cover image was derived from a photo of Bob Swanson, who co-founded Sierra Designs with George Marks in 1965.
DIMS:	26 × 17 CM	PAGES:	24	
	10.25 × 6.75 IN	TEAM:	UNKNOWN	

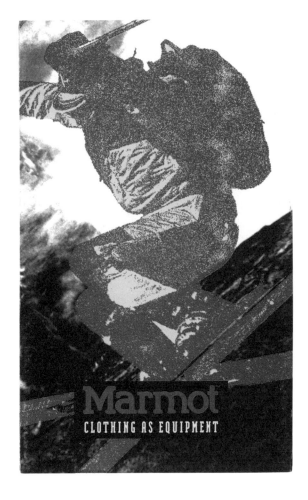

Marmot	
YEAR:	UNKNOWN
DIMS:	21 × 13 CM
	8.25 × 5.25 IN
PAGES:	7
TEAM:	UNKNOWN

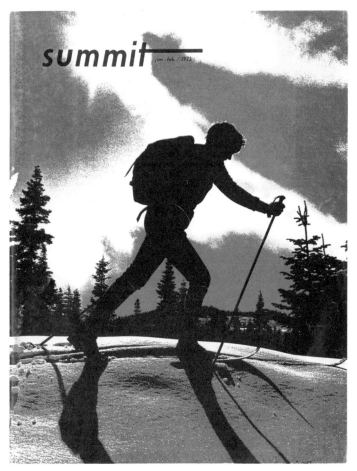

Summit	
YEAR:	1973
DIMS:	28 × 22 CM
	11 × 8.75 IN
PAGES:	36
TEAM:	KEITH GUNNAR

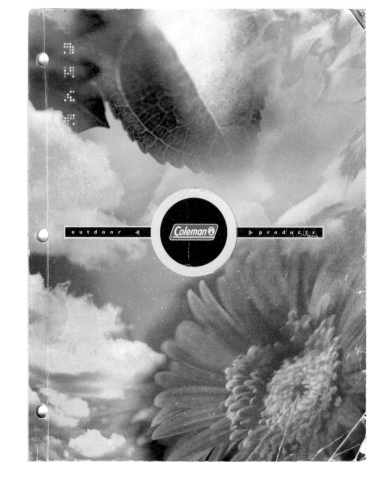

Coleman	
YEAR:	2003
DIMS:	28 × 22 CM
	11 × 8.75 IN
PAGES:	163
TEAM:	UNKNOWN

Marmot	
YEAR:	1999
DIMS:	28 × 22 CM
	11 × 8.75 IN
PAGES:	64
TEAM:	UNKNOWN

Kayaks for the Connoisseur

Eddyline		YEAR:	UNKNOWN
DIMS:	29 × 23 CM (11.25 × 9 IN)	TEAM:	UNKNOWN
PAGES:	2		

Walrus	
YEAR:	1992
DIMS:	15 × 22 CM
	5.75 × 8.75 IN
PAGES:	7
TEAM:	EUGENE FISHER

Vasque	
YEAR:	2010
DIMS:	28 × 22 CM
	11 × 8.75 IN
PAGES:	27
TEAM:	ROBERT MEYER
	CHAPPY ACHEN

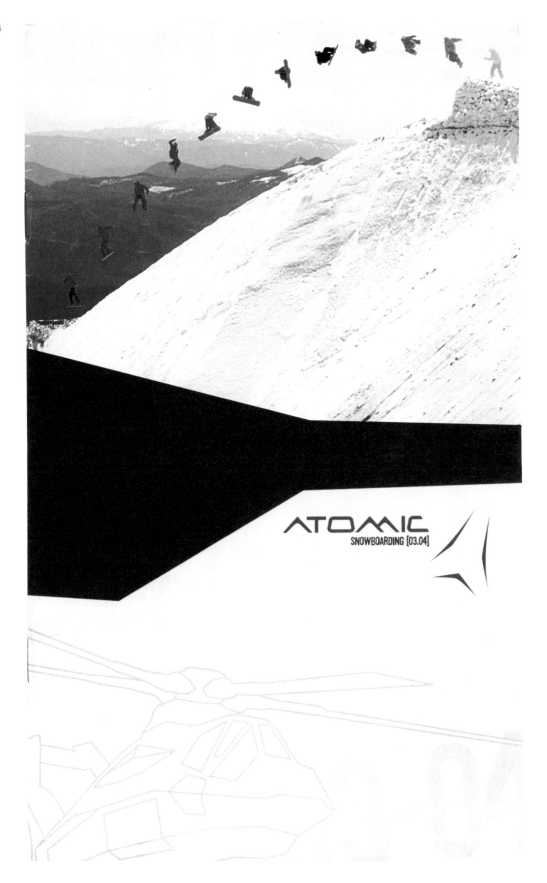

ATOMIC
SNOWBOARDING [03.04]

Atomic		YEAR:	2003
DIMS:	22 × 14 CM (8.75 × 5.5 IN)	TEAM:	UNKNOWN
PAGES:	18		

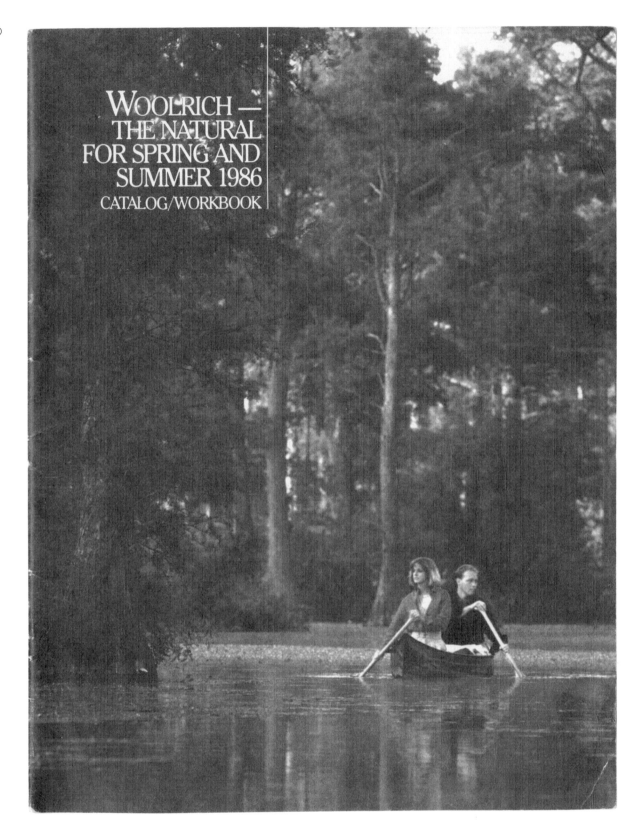

WOOLRICH —
THE NATURAL
FOR SPRING AND
SUMMER 1986
CATALOG/WORKBOOK

Woolrich		YEAR:	1986
DIMS:	28 × 22 CM (11 × 8.75 IN)	TEAM:	UNKNOWN
PAGES:	28		

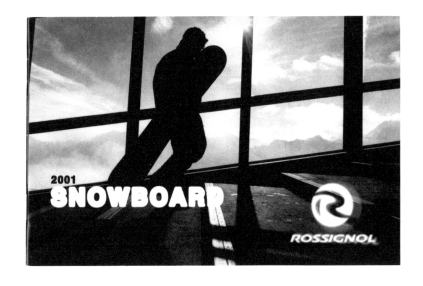

Rossignol	
YEAR:	2001
DIMS:	14 × 21 CM
	5.5 × 8.25 IN
PAGES:	39
TEAM:	KEVIN ZACHER

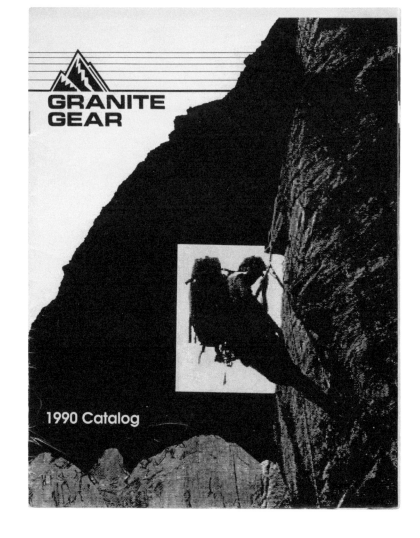

Granite Gear	
YEAR:	1990
DIMS:	28 × 22 CM
	11 × 8.75 IN
PAGES:	10
TEAM:	UNKNOWN

ON SET
Heavily directed images involving the use of models.

Contribution by Dr Julie Lamarra (p. 143)

The sun, perched on the horizon, casts a warm glow on a family camped beside a pristine alpine lake. Smiling children sit patiently at the picnic table, eagerly awaiting the plentiful food sizzling on the stove. The idyllic scene raises the question: who *wouldn't* like camping?

This is the goal of directed photography; to communicate the ideal outdoor adventure in a way that makes the viewer want to take part in it, too. The images are highly aspirational, often using models who appear happy and comfortable to demonstrate activities that seem approachable and fun. They typically look at or face the camera, perhaps in an effort to better connect with the viewer, humanizing the outdoors and making it more inviting. The setting is carefully curated to exclude bugs, rain, cold weather, boredom, exhaustion — or any other condition that could ruin the experience.

Central to this idealized version of the outdoors is the gear, which promises to make any activity easier and more enjoyable. This connection is perfectly reflected on the 1997 Cascade Designs catalogue cover, which features a man reclined in a camp chair taking in the view from atop a mountain (p. 155). 'Comfort ... between you and the earth' reads the tagline across the top. By this reasoning, the gear makes the outdoors so accessible that anyone can see themselves in it. Coleman embraces this angle to the point of absurdity in its series of catalogues from the 1960s and 1970s, which feature a menagerie of characters, from airplane pilots and falconers to chefs and cowboys, all experiencing the outdoors with their products. But for those who have been outdoors, who know that things are seldom perfect, perhaps these covers remind them of the unforgettable moments when everything was, in fact, just right.

Woolrich	
YEAR:	1982
DIMS:	22 × 30 CM
	8.75 × 11.75 IN
PAGES:	23
TEAM:	UNKNOWN

Woolrich	
YEAR:	1988
DIMS:	31 × 24 CM
	12.25 × 9.5 IN
PAGES:	24
TEAM:	UNKNOWN

1 9 9 2 P E A K 1® P R O D U C T C A T A L O G

Coleman		YEAR:	1992
DIMS:	28 × 22 CM (11 × 8.75 IN)	TEAM:	UNKNOWN
PAGES:	23		

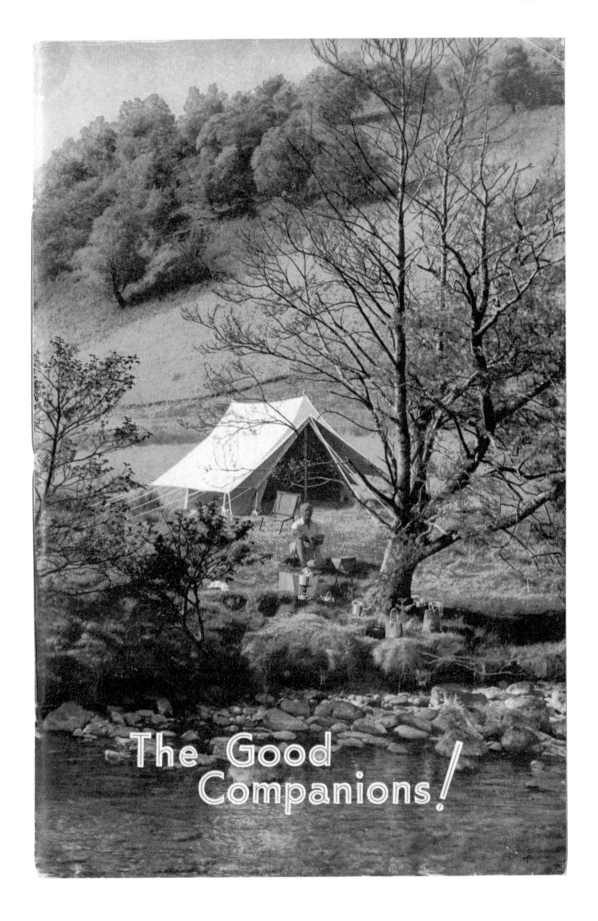

The Good
Companions!

Blacks		YEAR:	1952
DIMS:	22 × 15 CM (8.75 × 5.75 IN)	TEAM:	UNKNOWN
PAGES:	51		

Blacks	
YEAR:	1960
DIMS:	22 × 15 CM
	8.75 × 5.75 IN
PAGES:	88
TEAM:	UNKNOWN

Blacks	
YEAR:	1961
DIMS:	22 × 15 CM
	8.75 × 5.75 IN
PAGES:	49
TEAM:	UNKNOWN

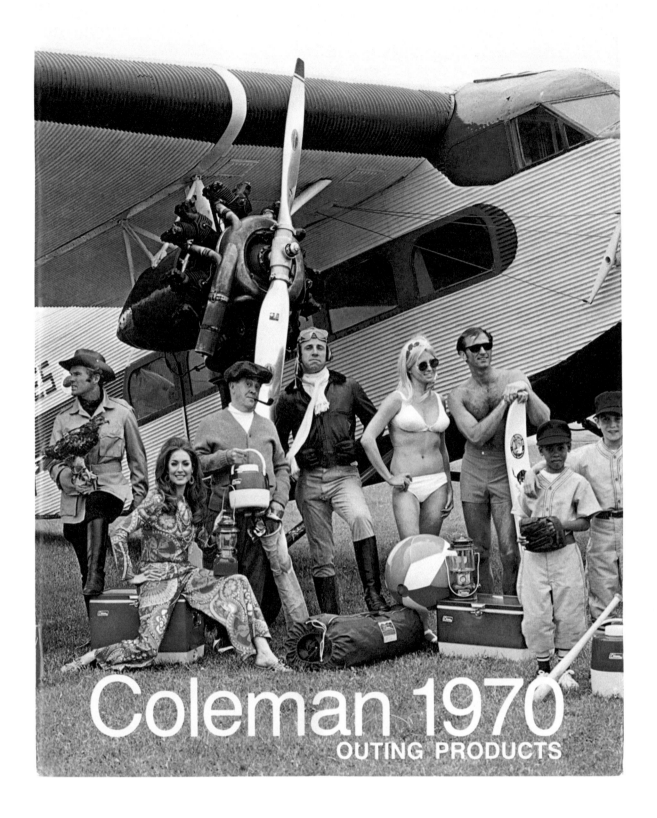

Coleman 1970
OUTING PRODUCTS

Coleman		YEAR:	1970
DIMS:	28 × 22 CM (11 × 8.75 IN)	TEAM:	UNKNOWN
PAGES:	35		

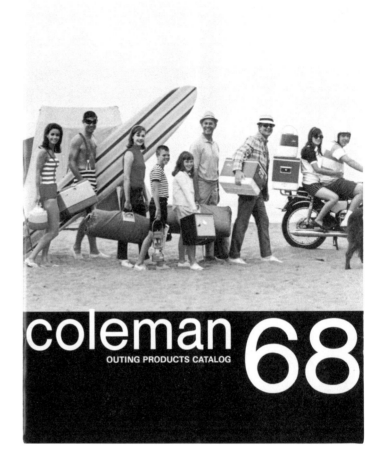

Coleman	
YEAR:	1968
DIMS:	28 × 22 CM
	11 × 8.75 IN
PAGES:	30
TEAM:	UNKNOWN

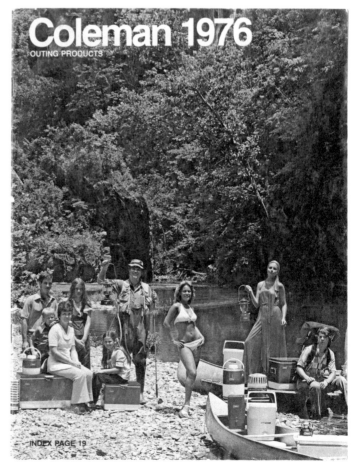

Coleman	
YEAR:	1976
DIMS:	28 × 22 CM
	11 × 8.75 IN
PAGES:	19
TEAM:	UNKNOWN

133

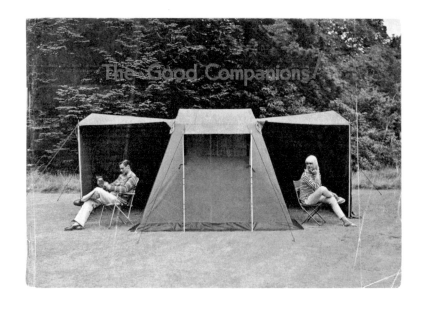

Blacks	
YEAR:	1964
DIMS:	16 × 23 CM
	6.25 × 9 IN
PAGES:	72
TEAM:	UNKNOWN

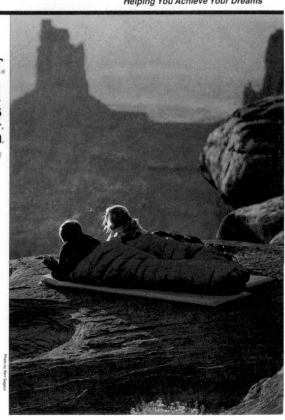

Cascade Designs	
YEAR:	1991
DIMS:	29 × 22 CM
	11.25 × 8.75 IN
PAGES:	4
TEAM:	BERT SAGARA

134

Coleman 1971
OUTING PRODUCTS

Coleman		YEAR:	1971
DIMS:	28 × 22 CM (11 × 8.75 IN)	TEAM:	UNKNOWN
PAGES:	48		

Vasque	
YEAR:	UNKNOWN
DIMS:	16 × 20 CM
	6.25 × 7.75 IN
PAGES:	21
TEAM:	UNKNOWN

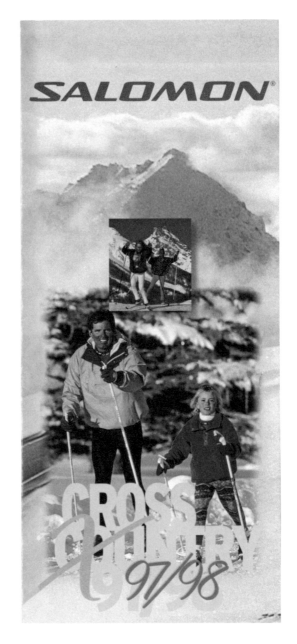

Salomon	
YEAR:	1997
DIMS:	23 × 11 CM
	9 × 4.25 IN
PAGES:	7
TEAM:	UNKNOWN

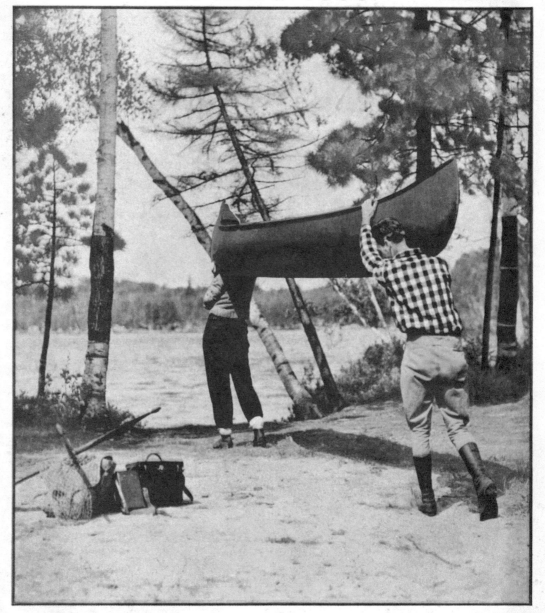

SPRING 1938

L.L.BEAN Inc. MANUFACTURER FREEPORT MAINE

L. L. Bean		YEAR:	1938
DIMS:	23 × 20 CM (9 × 7.75 IN)	TEAM:	UNKNOWN
PAGES:	60		

"THE MOTHER OF ALL ADVERTISING CAMPAIGNS."

—Tim Boyle, President, Columbia Sportswear

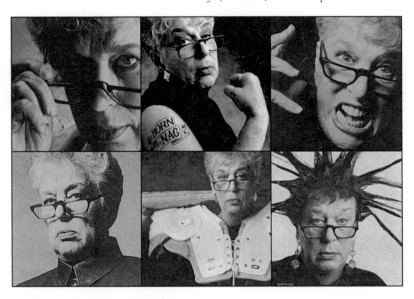

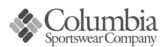

Columbia
Sportswear Company

Columbia Sportswear Co.	YEAR:	1994	In 1984, agency Borders Perrin Norrander pitched an advertising campaign to Columbia Sportswear based on something they felt set the company apart: its female president, Gert Boyle. Boyle continues to appear in Columbia's marketing today.	
DIMS:	30 × 18 CM	PAGES:	29	
	11.75 × 7 IN	TEAM:	UNKNOWN	

138

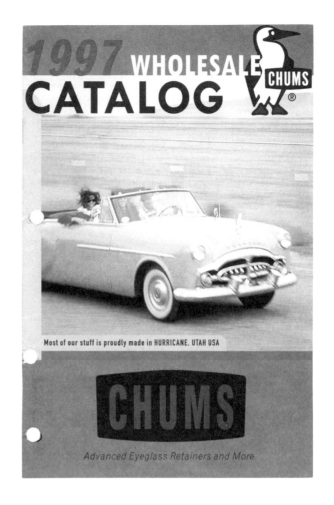

Chums	
YEAR:	1997
DIMS:	23 × 16 CM
	9 × 6.25 IN
PAGES:	14
TEAM:	CAROLINE WOOD

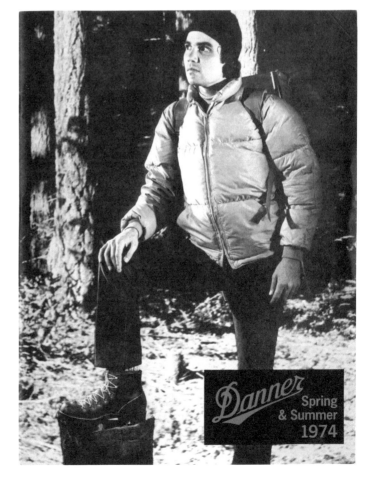

Danner	
YEAR:	1974
DIMS:	28 × 22 CM
	11 × 8.75 IN
PAGES:	27
TEAM:	UNKNOWN

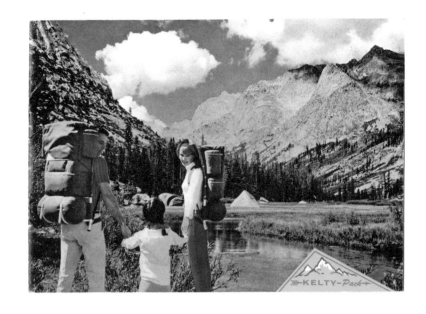

Kelty	
YEAR:	1965
DIMS:	18 × 26 CM
	7 × 10.25 IN
PAGES:	11
TEAM:	JOSEF MUENCH

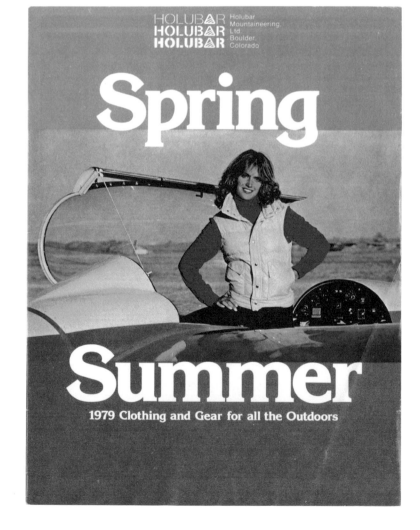

Holubar	
YEAR:	1979
DIMS:	28 × 22 CM
	11 × 8.75 IN
PAGES:	31
TEAM:	GEOFFREY WHEELER

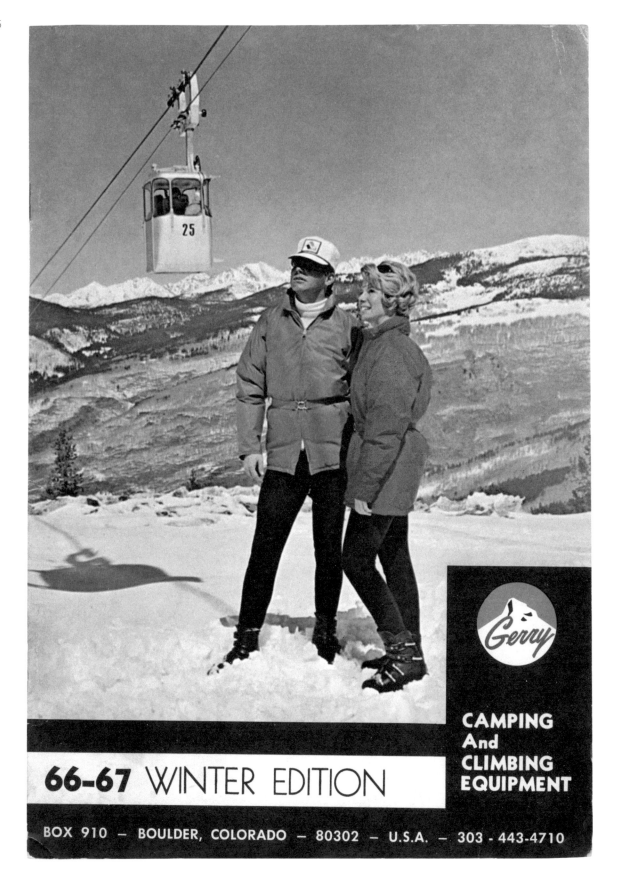

66-67 WINTER EDITION

CAMPING And CLIMBING EQUIPMENT

BOX 910 — BOULDER, COLORADO — 80302 — U.S.A. — 303 - 443-4710

Gerry		YEAR:	1966
DIMS:	26 × 18 CM (10.25 × 7 IN)	TEAM:	UNKNOWN
PAGES:	40		

Coleman 1974
OUTING PRODUCTS

DR JULIE LAMARRA
University professor

A dance of storytelling and character placement takes centre stage on the Coleman 1974 catalogue cover, weaving narratives with meticulous precision and imbuing the image with cinematic flair. Like a carefully composed frame, a well-crafted brand story possesses the power to captivate audiences and breathe life into products.

The essence of brand equity — the social value of a brand, determined by consumer perception rather than straight financial gains — lies in storytelling. Positive associations are built by narratives that go beyond the mere description of a product's features and benefits. These tales, reminiscent of whimsical adventures, infuse campaigns with quirky charm and unexpected twists. The goal is not just to sell a product, but to invite consumers into a world where transactions become enchanting escapades.

At the heart of this particular escapade is an element of unpredictability — a space for the viewer to insert themselves — a key ingredient in creating brand equity. Crucially, consumers must be able to see themselves within the story. Successful brands therefore offer narratives that transcend the ordinary and pursue the extraordinary. A profound connection forms when the narrative reflects the consumer's experiences, idiosyncrasies and dreams. The brand transforms from a mere commodity into a steadfast companion, a co-conspirator through life.

Imagine being part of this delightful tableau. Consider the clever placement of characters: each becomes an avatar, a vessel through which consumers embark on a vicarious journey. They mirror the attributes and aspirations of the target audience, offering a sense of familiarity and connection, each embodying a unique facet of the brand's identity. Like the brand itself, the bus becomes a trusty vehicle on the viewer's personal journey, promising an adventure filled with laughter and memorable detours. Transported into another world, it's easy to forget that all this contributes to a healthy bottom line; it helps establish customer loyalty, leading consumers to repurchase from recognized and admired brands.

In this beguiling world of advertising, the goal is to craft a narrative that lingers in the hearts of consumers. Whether you're the bikini-clad adventurer, the double-decker dreamer, the tweed-blazer explorer or part of the camping crew, the story unfolds with you as the protagonist. When artfully constructed, a brand becomes not just a product or service but a shared story, creating a bond beyond the transactional. After all, in this fun bus brand-advertising adventure, the orange cooler is your pedestal, and the journey is yours to embrace.

Coleman, 1974, 28 × 22 cm (11 × 8.75 in), 52 pages

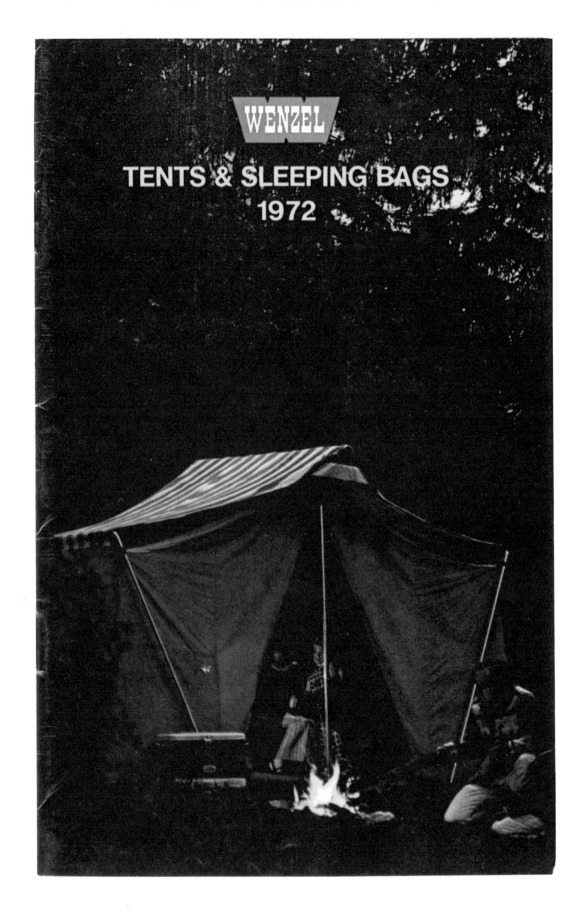

WENZEL

TENTS & SLEEPING BAGS
1972

Wenzel		YEAR:	1972
DIMS:	22 × 14 CM (8.75 × 5.5 IN)	TEAM:	UNKNOWN
PAGES:	12		

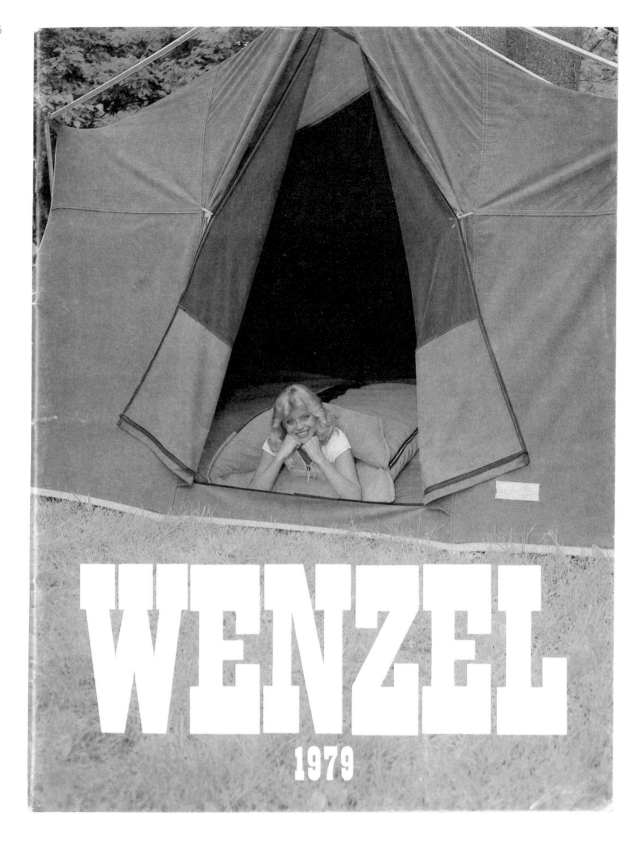

Wenzel		YEAR:	1979
DIMS:	28 × 22 CM (11 × 8.75 IN)	TEAM:	UNKNOWN
PAGES:	47		

KIRTLAND TOUR PAK, 1982

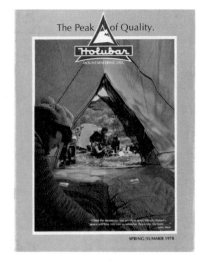

HOLUBAR, 1978

MOSS TENT WORKS, 1997

MILLETS, 1971

SHELTER SYSTEMS, 1996

TITLE NINE, 2002

ULTIMATE DIRECTION, 1992

WOOLRICH, 1979

WENZEL, 1967

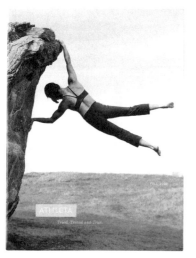

ATHLETA, 2000

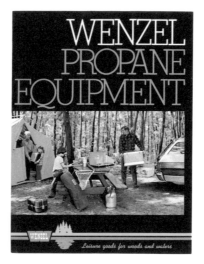

WENZEL, 1974

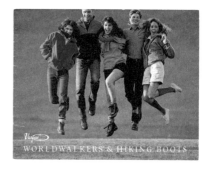

VASQUE, 1987

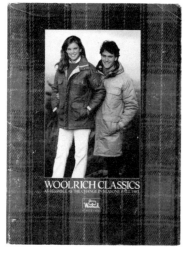

WOOLRICH, 1983

WILDERNESS EXPERIENCE, 1985

LOWE ALPINE SYSTEMS, 1979

BLACKS, 1967

SIERRA DESIGNS, 1989

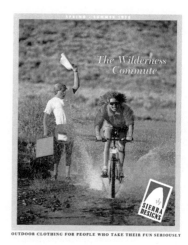

SIERRA DESIGNS, 1990

147

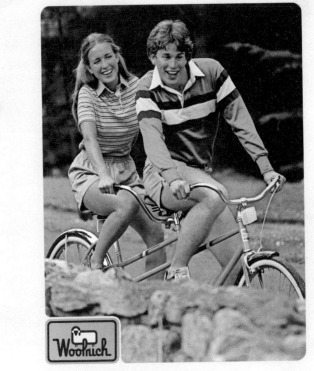

Spring 1981: Woolrich classics.

Woolrich	
YEAR:	1981
DIMS:	30 × 22 CM
	11.75 × 8.75 IN
PAGES:	11
TEAM:	UNKNOWN

Woolrich	
YEAR:	1989
DIMS:	28 × 22 CM
	11 × 8.75 IN
PAGES:	12
TEAM:	UNKNOWN

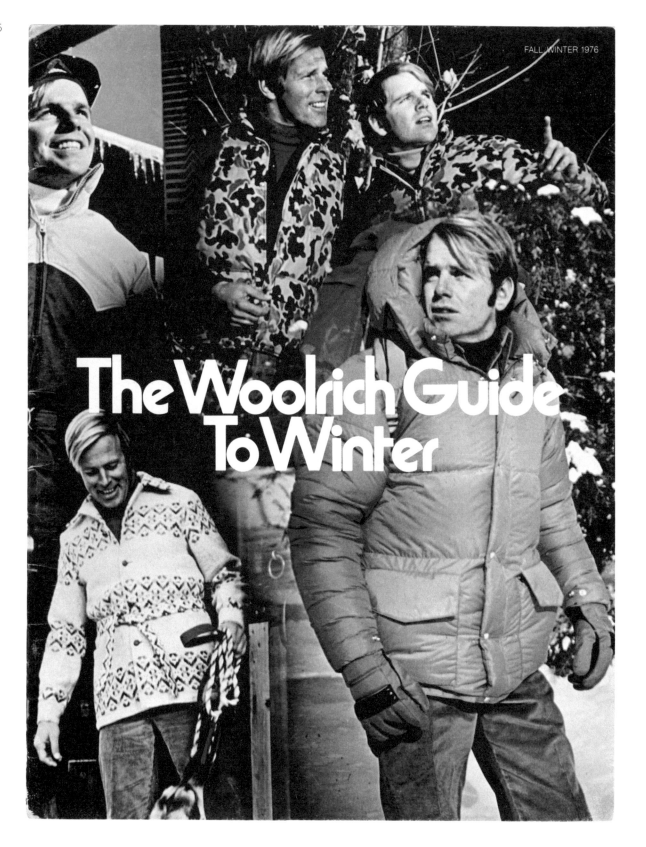

FALL WINTER 1976

The Woolrich Guide To Winter

Woolrich		YEAR:	1976
DIMS:	29 × 22 CM (11.25 × 8.75 IN)	TEAM:	UNKNOWN
PAGES:	41		

How to be sure of your bindings before you hit the slopes.

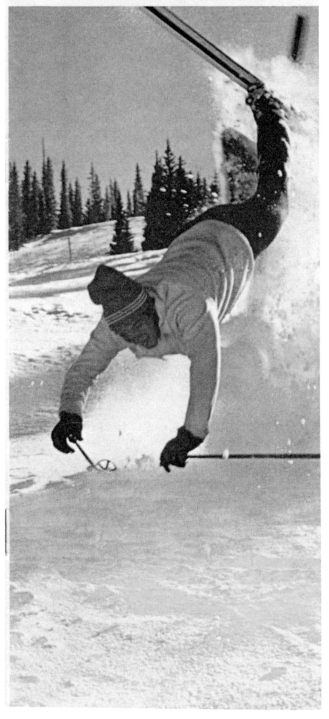

Salomon		YEAR:	UNKNOWN
DIMS:	24 × 10 CM (9.5 × 3.75 IN)	TEAM:	UNKNOWN
PAGES:	18		

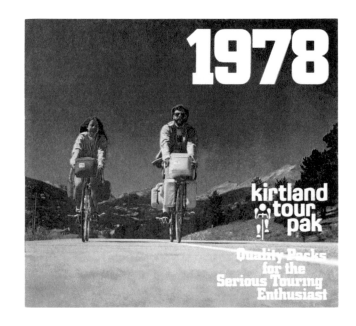

Kirtland Tour Pak	
YEAR:	1978
DIMS:	20 × 22 CM
	7.75 × 8.75 IN
PAGES:	14
TEAM:	UNKNOWN

Kirtland Tour Pak	
YEAR:	1979
DIMS:	20 × 22 CM
	7.75 × 8.75 IN
PAGES:	14
TEAM:	UNKNOWN

Kirtland Tour Pak	
YEAR:	1976
DIMS:	21 × 17 CM
	8.25 × 6.75 IN
PAGES:	18
TEAM:	UNKNOWN

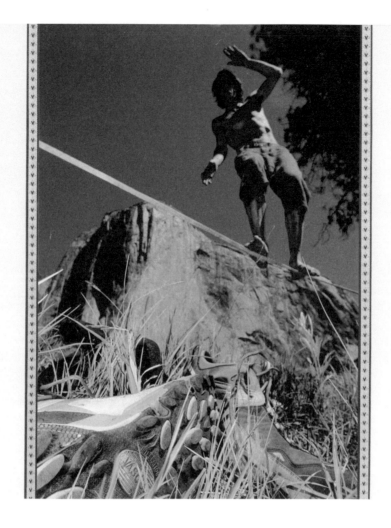

SEEK
CLIMB
HIKE
RUN

2005

Vasque		YEAR:	2005
DIMS:	22 × 28 CM (8.75 × 11 IN)	TEAM:	KRISTOFFER ERICKSON
PAGES:	35		

Holubar		YEAR:	1978
DIMS:	28 × 22 CM (11 × 8.75 IN)	TEAM:	COMMUNICATION ARTS, INC., BOULDER, CO
PAGES:	47		

Mountain House		YEAR:	1981
DIMS:	28 × 22 CM (11 × 8.75 IN)	TEAM:	UNKNOWN
PAGES:	3		

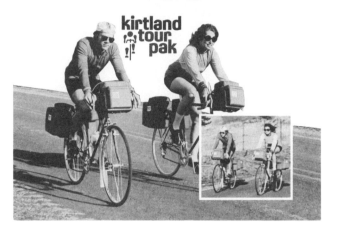

Kirtland Tour Pak	
YEAR:	1974
DIMS:	21 × 23 CM
	8.25 × 9 IN
PAGES:	4
TEAM:	UNKNOWN

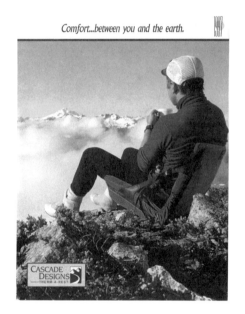

Cascade Designs	
YEAR:	1997
DIMS:	28 × 22 CM
	11 × 8.75 IN
PAGES:	31
TEAM:	JOHN BOLIVAR AND OTHERS

Coleman	
YEAR:	1980
DIMS:	22 × 28 CM
	8.75 × 11 IN
PAGES:	19
TEAM:	UNKNOWN

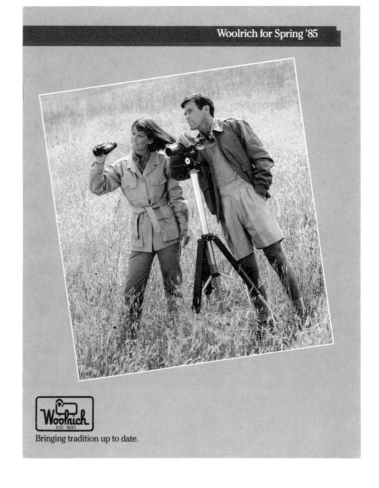

Woolrich	
YEAR:	1985
DIMS:	28 × 22 CM
	11 × 8.75 IN
PAGES:	20
TEAM:	UNKNOWN

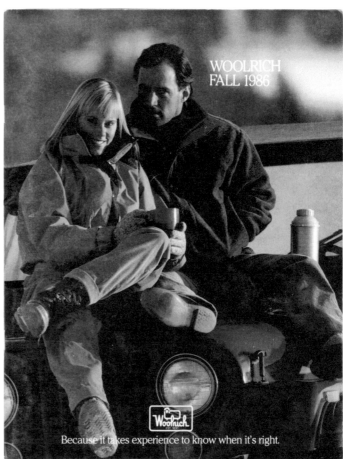

Woolrich	
YEAR:	1986
DIMS:	28 × 22 CM
	11 × 8.75 IN
PAGES:	58
TEAM:	UNKNOWN

SUMMIT

25¢

March, 1957

"I will lift up mine eyes to the Hills."

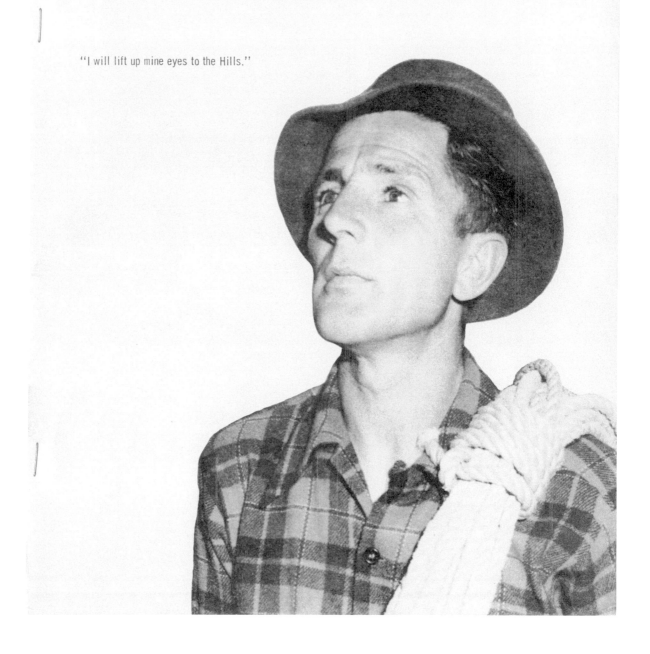

Summit		YEAR:	1957
DIMS:	27 × 21 CM (10.75 × 8.25 IN)	TEAM:	GEORGIA ENGLEHARD
PAGES:	24		KEITH BRIGHT

Springbar Tents
Finest Quality Tents Made in the U.S.A.

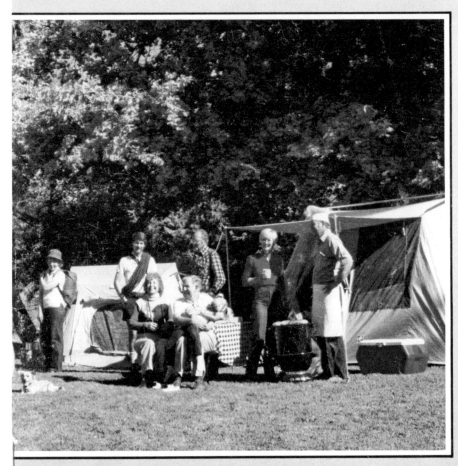

Kirkham's Outdoor Products
1983

Springbar Tents		YEAR:	1983
DIMS:	29 × 22 CM (11.5 × 8.75 IN)	TEAM:	UNKNOWN
PAGES:	37		

Coleman® Outing Products 1982

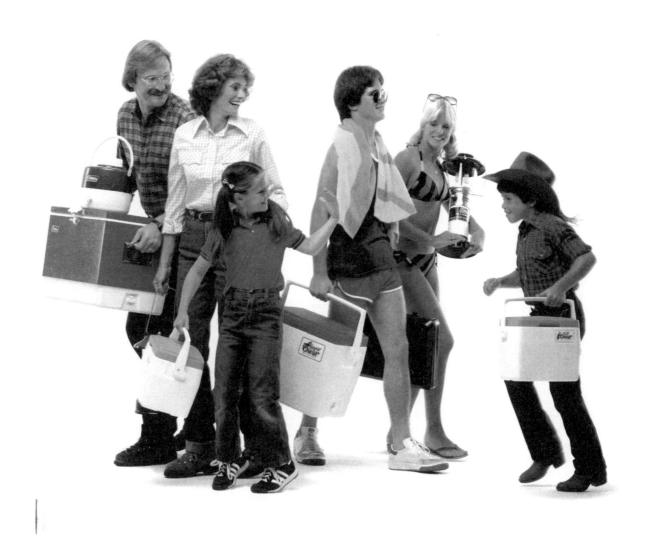

"Good Times Outdoors"

Coleman		YEAR:	1982
DIMS:	28 × 22 CM (11 × 8.75 IN)	TEAM:	UNKNOWN
PAGES:	23		

L. L. Bean, 1927, 23 × 20 cm (9 × 7.75 in), 24 pages
Team: Edwin Bolenbaugh

FALL
CATALOGUE
1927

Edwin
Bolenbaugh

L. L. BEAN, Manufacturer
FREEPORT, MAINE

Our New 1927 Shoe is lighter weight, better fitting and has a low, broad heel as shown above.

1927 Maine Cruising Shoe

This shoe is in a class by itself, as there is nothing yet produced in rubber footwear that will compare with it for hard service. The vamps and soles are dark red, pure gum rubber, same as used in high grade automobile tires. The top is the toughest oil-tanned leather money will buy [treated to make as near waterproof as leather can be made] cut on the same close fitting pattern as our Maine Hunting Shoe.

We guarantee this shoe to outwear two pairs of ordinary leather top rubbers, and will give a new pair to any dissatisfied customer.

This shoe is intended for Lumber Cruisers, Guides and Choppers, who want a good fitting shoe that will stand the hardest kind of usage, and don't mind a little extra weight. See guarantee tag on page 13 that is attached to every pair. For boys it is the best winter shoe made for hard service.

Delivered free east of Mississippi River. If west add 25c.

Send for free sample of rubber and leather

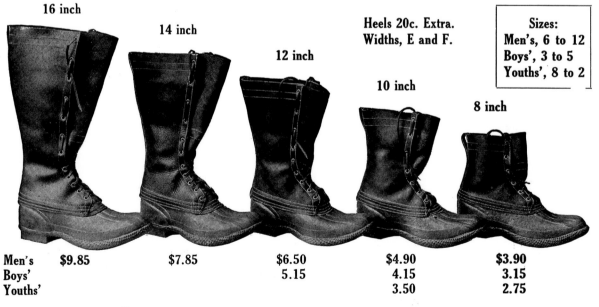

16 inch 14 inch 12 inch 10 inch 8 inch

Heels 20c. Extra.
Widths, E and F.

Sizes:
Men's, 6 to 12
Boys', 3 to 5
Youths', 8 to 2

	16 inch	14 inch	12 inch	10 inch	8 inch
Men's	$9.85	$7.85	$6.50	$4.90	$3.90
Boys'			5.15	4.15	3.15
Youths'				3.50	2.75

(Sept. 1, 1927)

MANUFACTURED AND SOLD BY
L. L. BEAN, FREEPORT, MAINE

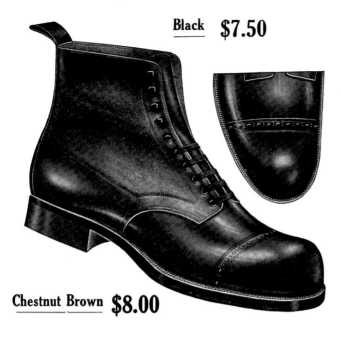

Black **$7.50**

Chestnut Brown **$8.00**

Bean's Comfort Shoe

The present style of footwear makes it next to impossible to get a practical shoe for wide tender feet.

There are plenty of wide unsightly shoes that are comfortable, also lots of stylish shoes that are uncomfortable.

Bean's Comfort Shoe is made on a combination last having an eight wide ball and a five wide instep with a medium width toe, which not only makes a perfect fitting shoe for wide, tender feet but a very good looking shoe as well.

The uppers are highest grade vici kid with best oak tanned soles, Goodyear Welt, also special stiff shank, long counter and orthopedic rubber heel that is especially adapted to those with a tendency towards weak arches. This construction is a big improvement over the ordinary arch support.

These shoes cannot be fully appreciated until tried on. Send for free samples and guarantee tag that is attached to every pair. Sizes, 5½ to 12. Width, EEE only. Price: Black $7.50; Chestnut Brown $8.00. Delivered free anywhere in the United States.

$2.35 Postpaid

Sure Grip Gunning Glove

Will operate rifle or shot gun accurately as with bare hands.

Back is made of buckskin chamois that hugs the hand, but does not bind in the least. Front is high grade cape leather with ribbed palm and thumb that will grip a gun better than the bare hand. Light weight, close fitting with ample protection for fall hunting. For auto driving they cannot be beaten.

An occasional application of Bean's Waterproof Dressing keeps them in perfect condition.

Slippery woolen or poor fitting, stiff leather gloves are sure to lose you some good shots. All sizes in men's and cadets'. If not sure of size, send outline of hand. Price $2.35 Postpaid.

"Beaver" Lamb Trimmed Camp Slipper

The same as our regular Camp Slipper as shown on page 2, except it has a Lamb Skin Innersole and "Beaver" Lamb trimmed. It also has a rubber counter that allows it to be flattened without breaking. A warm Slipper that is comfortable even without stockings.

MADE AND SOLD BY
L. L. BEAN, FREEPORT, MAINE

Price $2.35 Postpaid

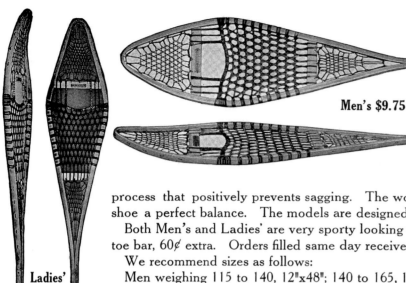

Men's $9.75

Ladies' $9.50

The Maine Snow-shoe

If there is a better Snow-shoe made we certainly would like to see it. The frames are especially selected State of Maine second growth white ash butts, seasoned so they will not warp.

The filling is the very best cowhide, cured by a secret process that positively prevents sagging. The workmanship is so well done that it gives the shoe a perfect balance. The models are designed especially for New England winter sports.

Both Men's and Ladies' are very sporty looking shoes. Wool tassels, 60¢ extra. Initials on toe bar, 60¢ extra. Orders filled same day received.

We recommend sizes as follows:

Men weighing 115 to 140, 12"x48"; 140 to 165, 13"x48"; 165 to 225, 14"x48". Ladies weighing 80 to 120, 10"x50"; 120 to 160, 11"x50".

Price, Men's $9.75. Ladies' $9.50. Delivered free in the United States.

Bean's Ski Boots

$9.50

Postpaid

Believing there is a demand for a high grade Ski Boot at a reasonable price, we are offering a first class shoe within reach of all.

Made of very best grade dark Chocolate water-proof leather, hand sewed vamp, concaved heel, long heavy inside sole leather toe box, two full soles, Goodyear welt, felt top facing. Has strap that buckles over backstay for holding rigging.

Height, 8". Price, $9.50. Delivered free in the U. S.

(Sept. 1 1927)

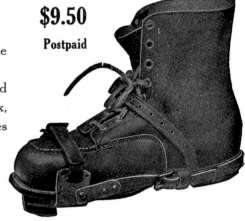

Men's and Ladies'
$1.25. Postpaid

Bean's Snow-shoe Rigging

After experimenting with different Snow-shoe Riggings for over two seasons, we have settled on this one as the best and most practical for both men and ladies.

As we use waste pieces that are too small for our Hunting Shoes, we are able to make a light weight, high-grade rigging at the low price of $1.25.

MANUFACTURED AND SOLD BY

L. L. BEAN. FREEPORT, MAINE

Winter Sport Cap

Showing Cap with ear protectors and visor up

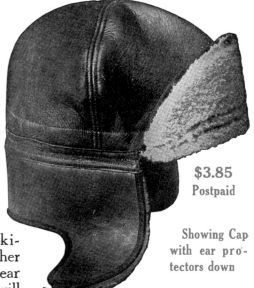

$3.85 Postpaid

Showing Cap with ear protectors down

Is made of high grade Mahogany glove leather, trimmed with the very best white lamb-skin, that looks and feels like fur. Sateen lined.

Visor can be worn up or down.

A very practical, sporty looking cap for Snow-shoeing, Ski-ing, Skating and other winter sports. With ear protectors down it looks like a high grade aviator's cap and will keep head, neck and ears warm in the very coldest weather.

Outside of our Hunting Shoe, Leather Caps are the biggest sellers we manufacture.

Weight only 6 oz. Price, $3.85, delivered. Send for free sample of leather and lamb-skin.

Bean's Deer Hunting Cap

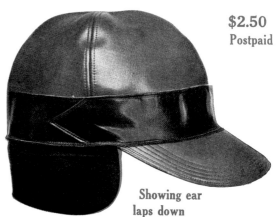

$2.50 Postpaid

Showing ear laps down

Cap at right is made of best Mahogany Elk Leather with red leather band and wool ear laps. Gives better protection than a cloth cap. Will not catch or brush off in thick bushes. Is water-proof and will last a lifetime.

Do not take chances hunting big game without red Cap or Coat.

We want you to see this cap. Order one and return it after your trip if you are not more than satisfied.

Weight, 5 ounces. Send for free sample of leather.

$2.00 Postpaid

Boys' Winter Sport Cap

Has the same general appearance of our Men's Sport Cap as shown above except the ear laps do not tie.

This Cap was gotten out to use up pieces of leather and lamb skin that are too small for our Men's Cap. We also make the same Cap of dark brown corduroy, lamb trimmed. Price, $1.50. Send for free samples of leather, lamb skin and corduroy.

Manufactured and sold by **L. L. BEAN, FREEPORT, MAINE**

Bean's New Tan Duck Hunting Boot

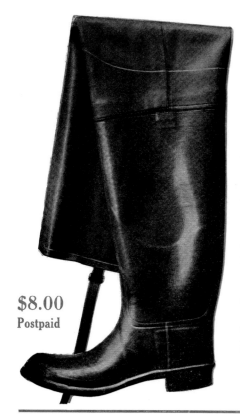

$8.00
Postpaid

Is a much more desirable color for Duck Hunting than Black. The rubber is a special compound that is extra tough and very elastic. It is heavier and more durable than our 1926 Boot. In fact, the weight, color and last is designed especially for Duck Hunting.

Top is so elastic that it will almost stay up without using the special snap fastener strap.

I am so anxious that all our Duck Hunting customers see this new Boot that we will gladly pay carrying charges both ways and refund purchase price if boots are returned.

35" high, 24" around at top and widths to fit all feet. Send for free sample of rubber showing color and quality.

Sizes, 5 to 12. Price, $8.00, delivered free anywhere in the United States. We also have our regular black Duck Hunting Boot same as last Season. Price, $7.65.

New No. 112 Stocking

New #112, $1.00

All wool, Hand Knit, Medium Weight, Color Gray, 14" to 16" Length.

The best value we have ever offered in Stockings. Correct weight for Fall Hunting. You can buy no stocking better adapted for wear with our Duck Hunting Boot, Indian Moccasin or Guide Shoe. Sizes 9½ to 12. Price $1.00. Postpaid.

Bean's New Leather Hat

$3.65
Postpaid

Designed especially for hunting and fishing. Made of mahogany elk leather same as our winter Sports Cap. The brim is 2½" wide with green under that relieves eye strain and keeps snow and rain from back of neck.

Has windshield sweat band, also red ear laps same as hunting cap on page 16. Weighs only 5½ ounces and can be rolled for packing. Will stand all kinds of abuse and rough wear.

For months we have been testing and perfecting this hat so that we think it is now about 100% perfect.

Made with red or mahogany band. Price, $3.65. Postpaid. Send for free sample of hat, band and earlaps.

MANUFACTURED AND SOLD BY L. L. BEAN, FREEPORT, MAINE

New Plaid Hunting Pant

Is the best and most up-to-date odd pant we ever offered. Made roomy through hips, with lace bottom, as shown in cut, so as to fit smoothly under stockings or leggings. Are extra strong and very nearly water-proof.

For tucking into shoes they are a big improvement over the ordinary hem bottom pants.

Strictly all wool, medium weight, Oxford Gray with Black and Dark Red over plaid that goes well with any coat or blouse.

Send for free sample as we are sure you will want a pair when you see the cloth. Price, $8.85. Delivered free in the United States.

$8.85
Delivered

WHITE RED-TOP STOCKING, #31, $1.10

A new Number that we consider extra good value. The red top is a protection against accidental shooting.

Made of fine, soft all wool. 20" long, factory knit.

Black and White Check
Black and Brown Check

Maine Outing Shirt

Is the very best, fine, all wool shirt that can be made. They are roomy and long, tailored and trimmed to suit the most particular.

Be sure and send for free samples of these shirts as we cannot do them justice on paper.

Four patterns: Two checks as shown at left. Two plain, one dark tan and one light fawn.
Sizes; 14½ to 19.
Price, $5.50, delivered free in the United States.

$5.50

Bean's Leatherette Shirt

I have personally been testing this Shirt on my hunting and fishing trips for over two years and prefer it to any woolen shirt ever tried.

The fabric will not shrink and is much more durable than woolen.

Closed front only.
Color; Olive Drab.
Send for free sample.
Sizes; 14½ to 19.
Price, $4.00. Postpaid.

$4.00

L. L. BEAN, FREEPORT, MAINE

Bean's Hunting Stockings

Made especially to be worn with Maine Hunting Shoes. Good woolen Stockings and plenty of [them are a very important part of a hunter's outfit. Sizes: Medium, Small and Large except No. 24 and 28 which come 9½ to 12.

Hand Knit

#12	#27	#7
$1.25	$2.25	$1.75

Factory Knit

#28	#24	#29	#18
.68	.65	$1.85	.70

The three Stockings shown above are strictly pure virgin wool and hand knit.

No. 7 and No. 27 are heavy weight with legs so elastic that they can be worn over pants well up to knee and not slip down. No. 12 is a medium weight 16" stocking designed especially for all-around hunting and fishing.

No. 28 is heavy silk and lisle to be worn under woolen stockings, tan only.

No. 24. Extra fine cashmere under stocking, light gray with white toe and heel.

No. 29. High grade, medium weight golf hose, three colors: Light gray, dark gray and dark tan with striped top as shown.

No. 18. Heavy weight, wool, knee length, two colors: Gray and White.

(REDUCED) No. 3

Bean's Disk Screw Calks

Are easily inserted or removed and insure absolute protection against slipping Every camper and hunter should have a set of these calks in his outfit. Put up in boxes of 50 any size with awl and key for inserting as shown in cut Price 50¢ per box. Postpaid.

No. 1 No. G No. 2B

Drag Line and Emergency Cord

Guides and experienced hunters will appreciate this little outfit. Besides dragging and hanging up big game, this cord is invaluable in case of accident. It is no more bother to carry than a jack knife and is just as important.

The cord is eight feet long and tests three hundred pounds. The wood handle will not cut or sore the hands. Both in leather case that makes a neat package and weighs only four and one-half ounces.

MADE AND SOLD BY L. L. BEAN, FREEPORT. ME·

Price 75¢ Postpaid

DOCUMENTARY
Captures the everyday experience of outdoor activities.

Contributions by Katie Hargrave and Meredith Laura Lynn (p. 177), Saeed Al-Rubeyi (p. 181), Lei Takanashi (p. 185), Charles Ross (p. 197)

Documenting outdoor activities is probably one of the most relatable ways that brands use photography on catalogue covers. After all, what is more universal than the desire to take pictures of an adventure to share with friends and family? In this type of imagery, a hiker stops for a moment to capture their companion gazing out over a sweeping vista or traversing a bridge across a raging mountain stream. Campers take a moment after pitching their tent to photograph the setting where they'll bed down or the view as seen from their sleeping bag. While there may be some intention to these images, they don't feel heavily posed or staged. Subjects may be aware of the camera, but their actions aren't beholden to it. These are simply photographs people take to document their ordinary – or perhaps extraordinary – outdoor pursuits.

Because this type of photography is characterized by its depiction of outdoor activities, people and the gear are a natural focus. A successful example of this framing is on the Spring 2006 Mountain Hardwear catalogue cover, where climber Sue Nott clinches a wiregate carabiner in her teeth before placing a cam (p. 200). Backpacks, worn by hikers pausing to discuss their route, feature prominently on the 1984 Coleman Peak 1 catalogue (p. 186). A furry friend makes an appearance, too, on the cover of the November–December 1980 issue of *Summit* magazine (p. 170). Showing a dog decked out in climbing gear and sunglasses, the image documents the lighter side of being outdoors. By depicting these kinds of activities, from the skilful and serious to the mundane and silly, documentary photography allows brands to use a familiar medium to connect with their consumers.

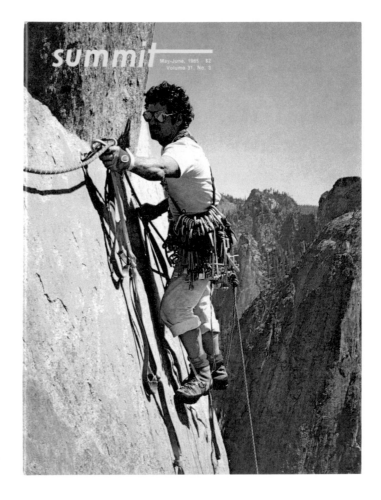

Summit	
YEAR:	1985
DIMS:	28 × 22 CM
	11 × 8.75 IN
PAGES:	36
TEAM:	UNKNOWN

Summit	
YEAR:	1980
DIMS:	28 × 22 CM
	11 × 8.75 IN
PAGES:	36
TEAM:	DWIGHT KROLL

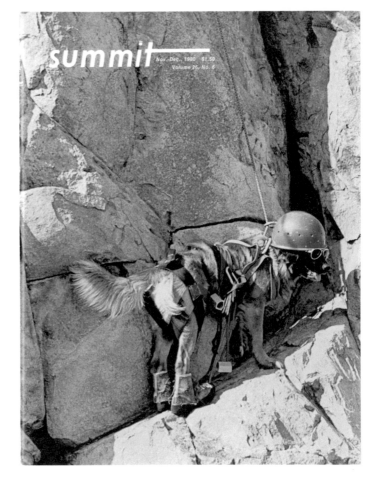

EMS
The Outdoor Specialists

1982 Fall Catalog

Eastern Mountain Sports		YEAR:	1982
DIMS:	28 × 22 CM (11 × 8.75 IN)	TEAM:	PACK MONADNOCK
PAGES:	83		

Moss Tent Works

1984

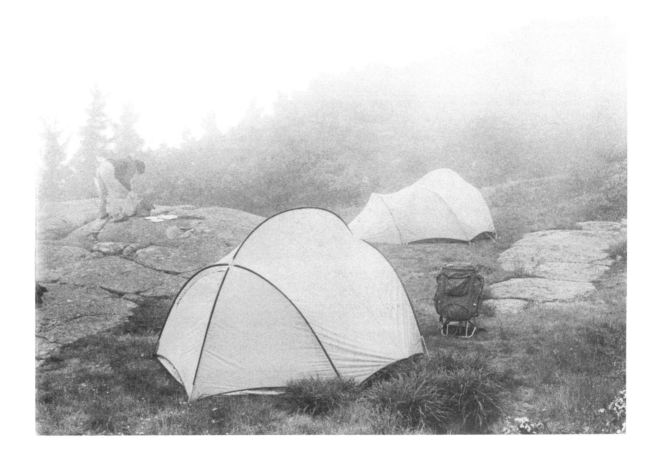

Moss Tent Works		YEAR:	1984
DIMS:	28 × 22 CM (11 × 8.75 IN)	TEAM:	UNKNOWN
PAGES:	14		

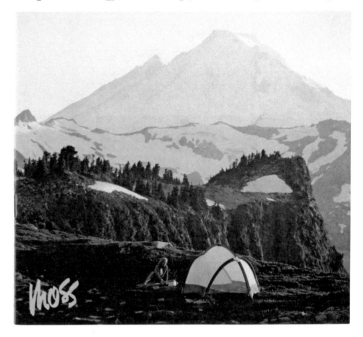

Moss Tent Works	
YEAR:	1989
DIMS:	28 × 22 CM
	11 × 8.75 IN
PAGES:	15
TEAM:	BERT SAGARA

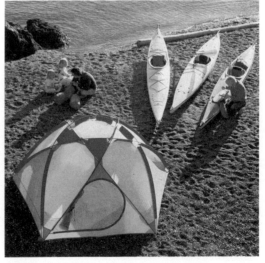

Moss Tent Works	
YEAR:	1990
DIMS:	28 × 22 CM
	11 × 8.75 IN
PAGES:	15
TEAM:	BERT SAGARA

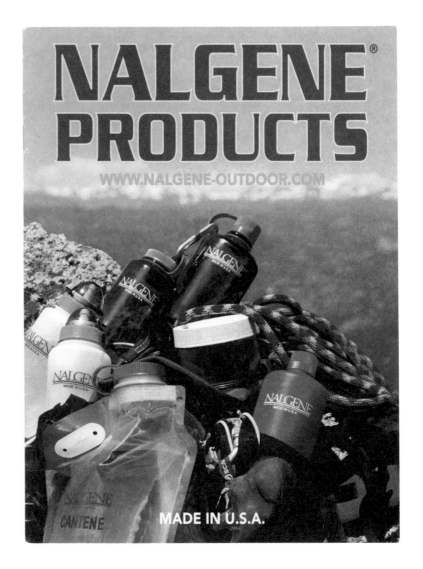

Nalgene	
YEAR:	1999
DIMS:	26 × 20 CM
	10.25 × 7.75 IN
PAGES:	19
TEAM:	SCOTT B. BROWER

Mountain Hardwear	
YEAR:	1998
DIMS:	22 × 28 CM
	8.75 × 11 IN
PAGES:	64
TEAM:	UNKNOWN

FALL 2002

Mountain Hardwear		YEAR:	2002
DIMS:	44 × 29 CM (17.25 × 11.25 IN)	TEAM:	ERIC PHILIPS
PAGES:	63		

SHELTER SYSTEMS Box 1294, Capitola, CA 95010

KATIE HARGRAVE AND MEREDITH LAURA LYNN
Artists and educators

Bob Gillis, the founder and inventor behind Shelter Systems, deserves to be a legend in the history of tent design. One of the three masterminds of the Oval Intention, The North Face's iconic geodesic dome tent, Gillis is a primary innovator of tents that rely on tensional integrity, or tensegrity. Championed by the prominent US architect and visionary Buckminster Fuller, a wide range of structures utilize tensegrity, from two-person camping tents to sports arenas. This system of tension and compression keeps the sturdy domes designed and manufactured by Shelter Systems upright and resilient.

Even more than for his design and engineering accomplishments, we admire Bob Gillis and Shelter Systems for the approach to outdoor recreation that the company exemplifies in their aesthetic. The tents are unfussy and multi-use, equally equipped for a beach party or supporting a greenhouse. The catalogues are sparse and casual — just a few folded sheets printed on regular paper with basic information on how to order. You can technically buy a tent from their website, but you can also find instructions on how to build your own kayak out of sticks and a tarp.

We had the opportunity to learn more about Gillis from reading through his sketchbooks and correspondence. It is clear that Gillis was never comfortable with the commercialization of the outdoor experience. Bruce Hamilton, one of The North Face's in-house designers who collaborated on the Oval Intention with Gillis, chided Gillis for his 'need to live in the woods and to avoid working a job' as well as his reliance on trying things out with his own hands. As artists, these qualities resonate with us. We too are wary of the capitalist drives of the outdoor recreation industry, and we also come to understand things by making them ourselves. Gillis's notes show how uneasy corporate demands made him even after he started Shelter Systems: he tries to psych himself up for meetings and phone calls, apprehensively testing different sales pitches and motivational tricks.

Bob Gillis pulled up to The North Face headquarters in the early 1970s as an independent designer with a 'bundle of poles and cloth', and although his Tent Flatables were not suited for the mass market, his creativity and skill as a designer were undeniable. From Shelter Systems' advertisements, one gets the sense that Gillis remained true to himself. Selling tents was coincidental; making reliable, easy products that people could use to escape the stresses of modern life was always the point.

Shelter Systems, 1993, 15 × 22 cm (5.75 × 8.75 in), 7 pages

Lowe Alpine Systems	
YEAR:	1978
DIMS:	28 × 22 CM
	11 × 8.75 IN
PAGES:	29
TEAM:	WES KRAUSE AND OTHERS

Marmot	
YEAR:	1988
DIMS:	26 × 26 CM
	10.25 × 10.25 IN
PAGES:	31
TEAM:	ERIC REYNOLDS

Sierra Designs 73

Sierra Designs		YEAR:	1973
DIMS:	28 × 22 CM (11 × 8.75 IN)	TEAM:	NICK LAWRENCE
PAGES:	79		ROBERT SWANSON

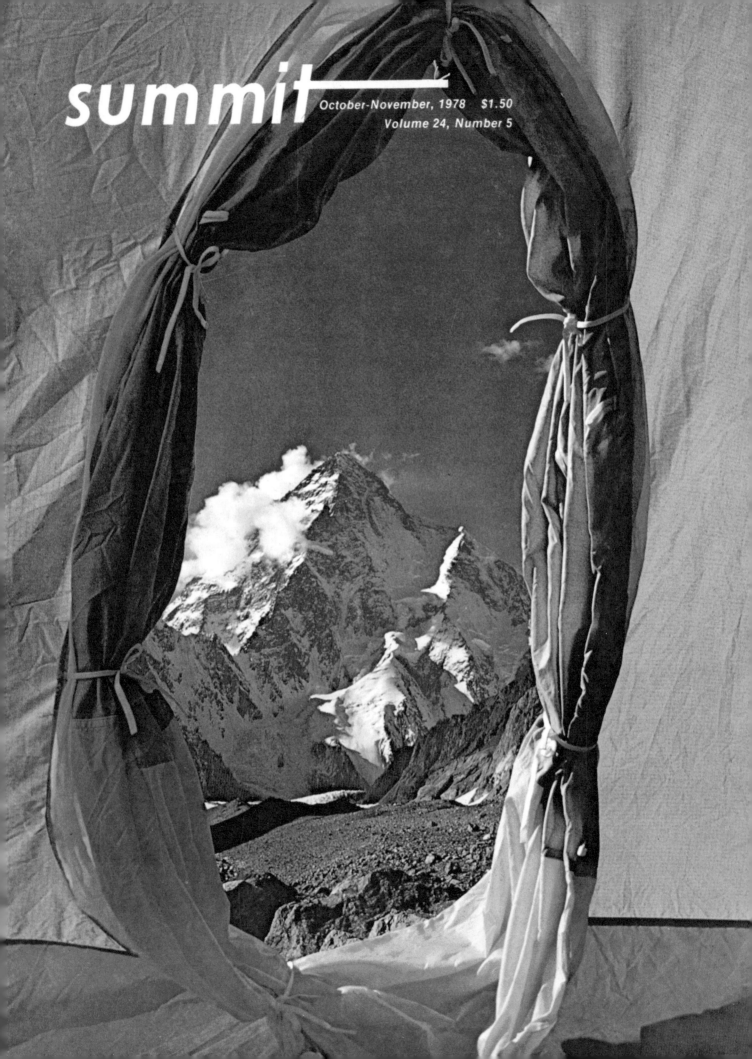

summit

October-November, 1978 $1.50
Volume 24, Number 5

SAEED AL-RUBEYI
Designer and co-founder

Aside from the colours in this issue of *Summit* from 1978, which are superb — strong synthetic manmade colours against natural hues — the image also does something I love and respect.

Outdoor brands in general do an outstanding job of contextualizing products, showing them in the natural world. This imbues authenticity, speaks to the function of the object and underlines the idea that 'we make things to do stuff in'. It sometimes seems to make little sense commercially, and can go so far the other way that it can be hard to work out what product they're even trying to show you.

Clothing especially can suffer both from being fashionable ('gross', 'posers') or unfashionable ('gross', 'is that last year's?'), but outdoor shoppers and brands understand that the outdoors has a kind of democratizing effect — and if you make an item people love to take out with them, none of the rest matters. Stuff just has to make you feel good, do a job and not fall apart. If a product can do those things, people will choose it to be part of their next adventure (even if it's just walking the dog around a park).

Taken literally, this cover is a reversal of that idea — a vista framed with a piece of outdoor equipment — but really, it's just a purer telling of the same story. The mountain is why you're there, but the equipment is part of the adventure too. A reliable necessity, sure, but also a friend that has looked after you and deserves to be shown off.

Summit, 1978, 28 × 22 cm (11 × 8.75 in), 44 pages
Team: Galen Rowell

Granite Stairway Mountaineering	
YEAR:	1974
DIMS:	20 × 25 CM
	7.75 × 9.75 IN
PAGES:	96
TEAM:	JOE BAKKETUN, DAN B. WRIGHT, PETER BENJAMIN, BILL SIMON, STEPHEN TUCKER, GARY WALKER, RICHARD KELTY, GALEN A. ROWELL

Sierra Designs	
YEAR:	1991
DIMS:	28 × 12 CM
	11 × 4.75 IN
PAGES:	14
TEAM:	DAN GRANT PROJECT RAFT

1993 PEAK 1 PRODUCT CATALOG

PEAK 1

Coleman The Future OUTDOOR EQUIPMENT

183

Coleman		YEAR:	1993
DIMS:	28 × 22 CM (11 × 8.75 IN)	TEAM:	UNKNOWN
PAGES:	27		

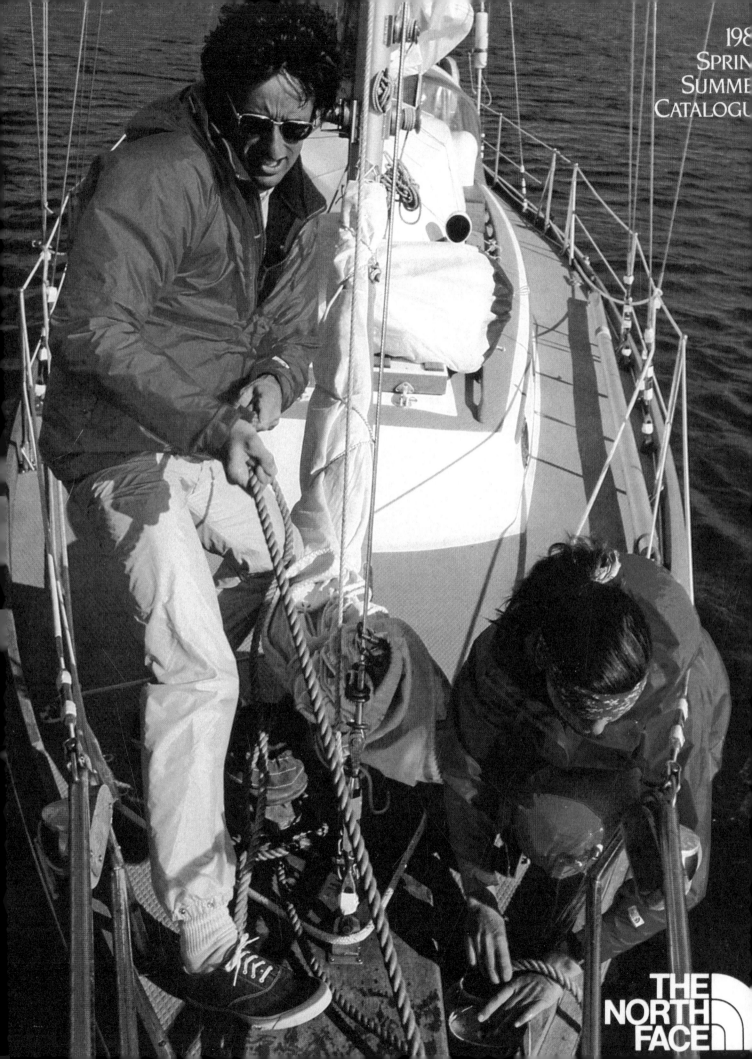

THE
NORTH
FACE

LEI TAKANASHI
Fashion journalist and writer

Sailing is a sport so entrenched in the trappings of luxury that it can be used to market a $15 Nautica polo and an $800 pair of Prada trainers. It's funny that this catalogue cover by The North Face could have easily been flipped into an ad for Polo Ralph Lauren with just a quick wardrobe change. This cover truly reminds me of my earliest perception of what The North Face was while growing up in New York.

When I saw that half dome logo as a kid, it felt akin to walking by the scant boat docks and marinas along Manhattan's public waterfronts, a sight that my parents would quickly deem 'too expensive'. The actual sport of sailing is the last thing anyone thinks of when a private boat goes past in New York City. Instead, one wonders how a New Yorker could even afford a sailboat in the first place. Likewise, I wasn't thinking about the outdoors when I first encountered The North Face; I felt both these things co-existed in the same realm of luxurious and aspirational purchases.

For many years, that embroidered North Face logo only served as a constant reminder that my L. L. Bean backpack and Columbia jacket (while functional) were not stylish enough to impress my peers. When I finally began building my own personal style as a young adult with expendable income, I discovered that many other New Yorkers actually positioned The North Face as a luxury brand as well. Instead of sailing, they participated in the urban sport of graffiti. Instead of Petzl headlamps, they styled their North Face jackets with fine garments from Polo Ralph Lauren.

Traditional luxury connotations aside, what sailing represents at its core is an innate human desire to explore our world. And while any outdoor brand can aid you on that journey, it comes as no surprise that The North Face became my most trusted outfitter for such endeavours. This could be interpreted as a testament to brand marketing, but I see it more as an indication of what truly defines luxury. It's to find solace in any passion that you'll go the extra distance for. Those journeys could unfold on the high seas, in the concrete jungles of New York or on the highest peaks of our beloved national parks. Regardless of what that luxury is, you will always be the captain of your own ship.

The North Face, 1984, 28 × 22 cm (11 × 8.75 in), 47 pages
Team: Roland Dare

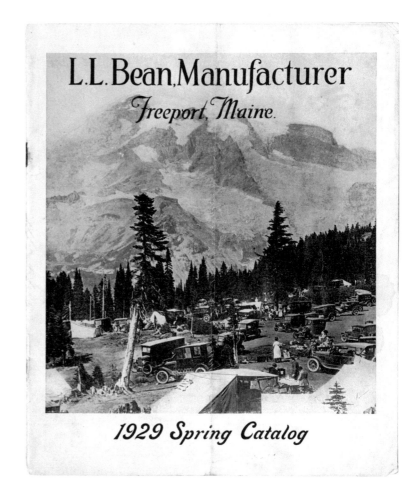

L. L. Bean	
YEAR:	1929
DIMS:	23 × 20 CM
	9 × 7.75 IN
PAGES:	24
TEAM:	UNKNOWN

Coleman	
YEAR:	1984
DIMS:	29 × 22 CM
	11.25 × 8.75 IN
PAGES:	23
TEAM:	UNKNOWN

CLOTHING / CAMPING / OUTDOOR EQUIPMENT · FALL / WINTER 1967

Gerry		YEAR:	1967
DIMS:	26 × 18 CM (10.25 × 7 IN)	TEAM:	UNKNOWN
PAGES:	44		

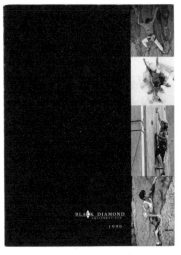

BLACK DIAMOND EQUIPMENT, 1990

COLEMAN, 1994

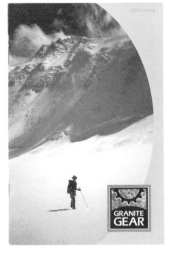

GRANITE GEAR, 2002

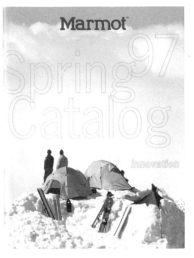

MARMOT, 1997

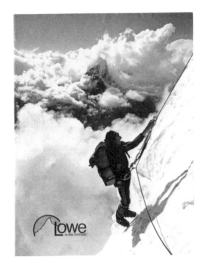

LOWE ALPINE SYSTEMS, 1981

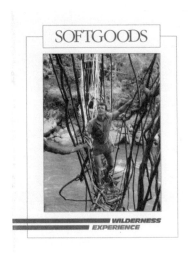

WILDERNESS EXPERIENCE, 1986

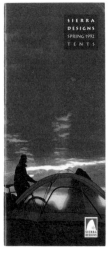

SIERRA DESIGNS, 1992

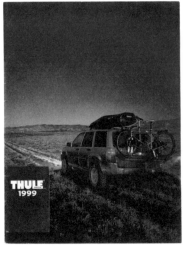

THULE, 1999

ULTIMATE DIRECTION, 1993

GRANITE GEAR, 2007

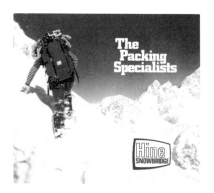

HINE SNOWBRIDGE, 1979

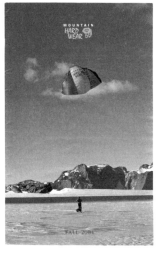

MOUNTAIN HARDWEAR, 2004

ROSSIGNOL, 2000

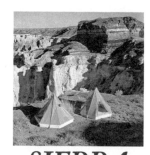

SIERRA DESIGNS, 1974

SIERRA DESIGNS, 1989

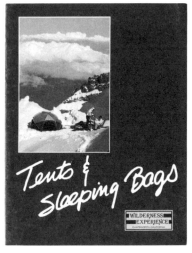

WILDERNESS EXPERIENCE, 1984

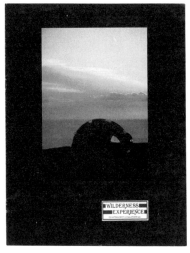

WILDERNESS EXPERIENCE, UNKNOWN

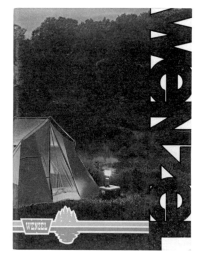

WENZEL, 1980

189

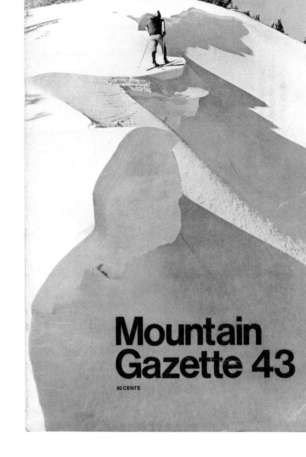

Mountain Gazette	
YEAR:	1976
DIMS:	38 × 26 CM
	15 × 10.25 IN
PAGES:	36
TEAM:	FLETCHER MANLEY

Kelty Pack/Sierra Designs Spring/Summer 1978

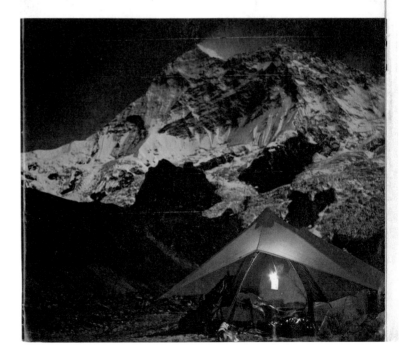

Sierra Designs	
YEAR:	1978
DIMS:	28 × 24 CM
	11 × 9.5 IN
PAGES:	55
TEAM:	LANNY JOHNSON

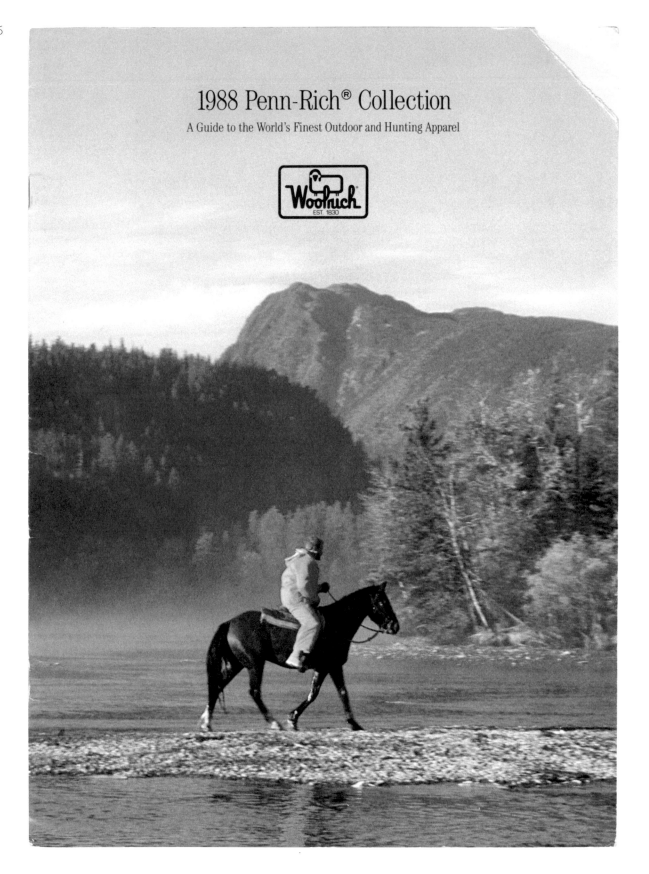

1988 Penn-Rich® Collection

A Guide to the World's Finest Outdoor and Hunting Apparel

Woolrich		YEAR:	1988
DIMS:	31 × 23 CM (12.25 × 9 IN)	TEAM:	UNKNOWN
PAGES:	17		

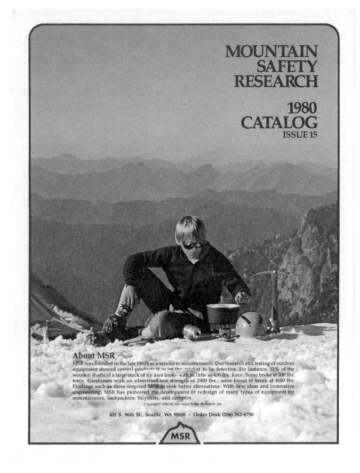

Mountain Safety Research (MSR)	
YEAR:	1980
DIMS:	28 × 22 CM
	11 × 8.75 IN
PAGES:	7
TEAM:	UNKNOWN

Mountain Safety Research (MSR)	
YEAR:	1995
DIMS:	29 × 22 CM
	11.25 × 8.75 IN
PAGES:	24
TEAM:	SCOTT FISCHER

1983-84 FALL-WINTER CATALOGUE

THE NORTH FACE

The North Face		YEAR:	1983
DIMS:	29 × 22 CM (11.25 × 8.75 IN)	TEAM:	ROLAND DARE
PAGES:	47		

ASOLO	
YEAR:	1999
DIMS:	23 × 10 CM
	9 × 3.75 IN
PAGES:	13
TEAM:	UNKNOWN

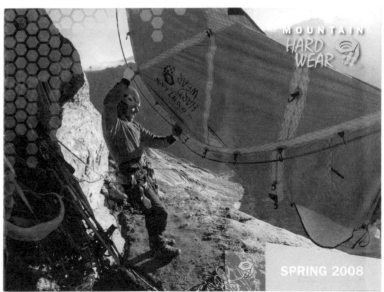

Mountain Hardwear	
YEAR:	2008
DIMS:	21 × 28 CM
	8.25 × 11 IN
PAGES:	31
TEAM:	JONATHAN COPP

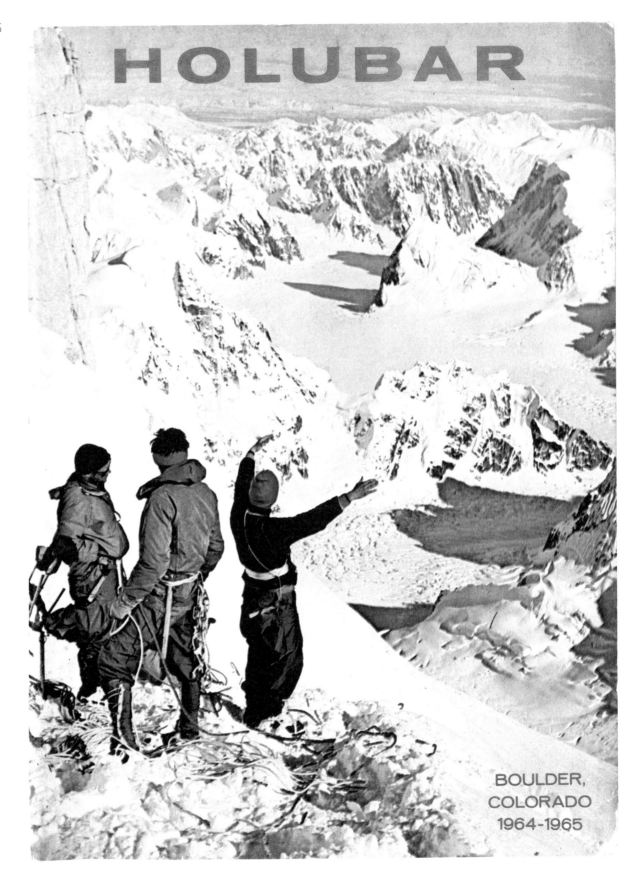

HOLUBAR

BOULDER,
COLORADO
1964-1965

Holubar		YEAR:	1964
DIMS:	26 × 19 CM (10.25 × 7.25 IN)	TEAM:	UNKNOWN
PAGES:	35		

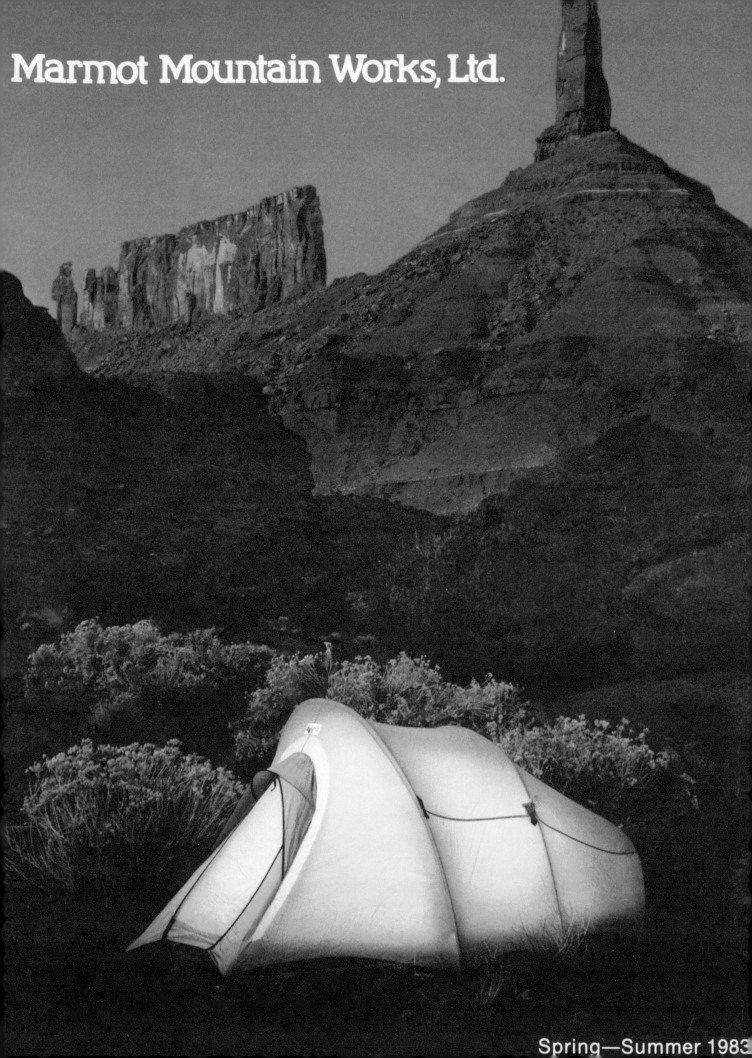

Marmot Mountain Works, Ltd.

Spring—Summer 1983

CHARLES ROSS
University lecturer

The early 1980s was when I caught the outdoor bug, which has been the thread of my career for the last half-century. At the time, I was finishing school, having grown up in a strong outdoor environment. As a Brit, living on an island, I dreamt of travel — getting one of the first round-the-world generation air tickets allowed me to explore so much of the beauty and serenity of North America (my ticket had unlimited flight coupons). This catalogue cover sums up so much of the pull I felt. It's a fantastic image that just makes you want to be there!

This style of picture has typically been used by brands to inspire you to be better. You fall in love with the romance of the imagery and then buy into whatever they're communicating (normally the product, though brands like Patagonia have also used campaigns to raise the profile of causes and issues). Images like this offered a more candid form of marketing — brands sold values before products. Users are invited to step up and adopt the same vision.

In the 1980s, brands connected directly with consumers using printed matter (it was the virtual of the day), but direct sales channels had not been developed. The aim was to drive the customer into the shops to make a purchase by creating desire. The catalogue also allowed for a clear message to be communicated.

The detail of this image has been carefully composed: it is a stunning (and original for the 1980s) photograph; then you notice the association with outdoor equipment; then (if you are geeky enough), you identify the silhouette of a Marmot tent. I think this is a set-up photo — the minor details have clearly been considered (you can just read the brand name on the porch) — but by the time you notice, you've already been won over. Creativity like this makes me proud to have joined the outdoor industry and to be part of a rich legacy of innovation.

Marmot, 1983, 28 × 22 cm (11 × 8.75 in), 27 pages

BLACKS
CAMPING EQUIPMENT

1971

Specialists
in
lightweight
camping
equipment

Blacks		YEAR:	1971
DIMS:	20 × 21 CM (7.75 × 8.25 IN)	TEAM:	UNKNOWN
PAGES:	21		

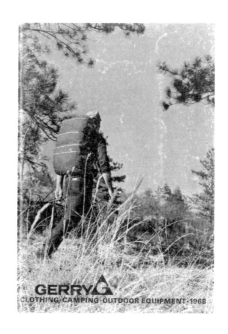

Gerry	
YEAR:	1968
DIMS:	26 × 18 CM
	10.25 × 7 IN
PAGES:	52
TEAM:	UNKNOWN

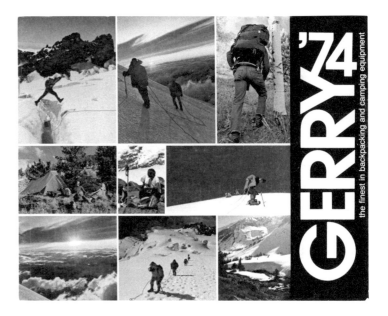

Gerry	
YEAR:	1974
DIMS:	22 × 28 CM
	8.75 × 11 IN
PAGES:	35
TEAM:	UNKNOWN

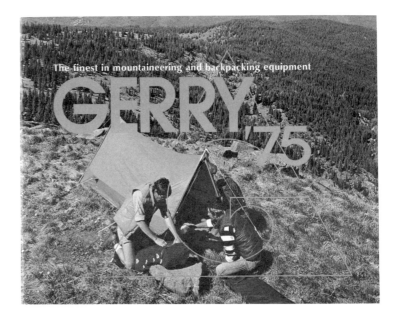

Gerry	
YEAR:	1975
DIMS:	22 × 28 CM
	8.75 × 11 IN
PAGES:	20
TEAM:	RICHARD VAN PELT

Coleman	
YEAR:	1995
DIMS:	28 × 24 CM
	11 × 9.5 IN
PAGES:	120
TEAM:	UNKNOWN

Mountain Hardwear	
YEAR:	2006
DIMS:	21 × 30 CM
	8.25 × 11.75 IN
PAGES:	49
TEAM:	CAMERON LAWSON

200

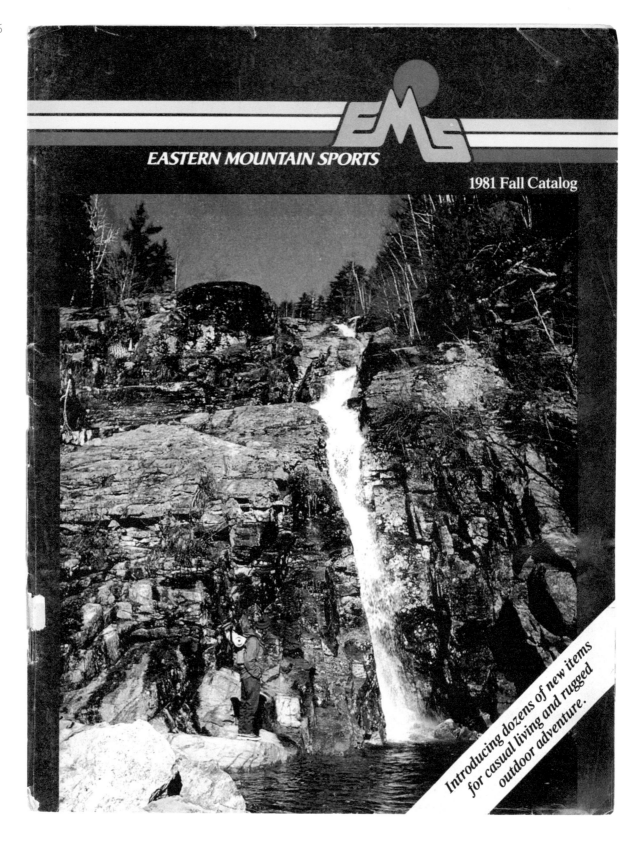

EASTERN MOUNTAIN SPORTS

1981 Fall Catalog

Introducing dozens of new items for casual living and rugged outdoor adventure.

Eastern Mountain Sports		YEAR:	1981
DIMS:	28 × 22 CM (11 × 8.75 IN)	TEAM:	UNKNOWN
PAGES:	97		

LIVE
Action photography that features dynamic movement.

Contribution by Conrad Anker (p. 211)

What better way to visually communicate the excitement of outdoor activities than through action photography. In this genre, athletes and weekend warriors are captured at the peak of movement: hikers and runners leaping between rocks, skiers launching through the air and climbers dynoing from one rock hold to another. Photographers often communicate motion in these images by blurring the subject, but they may use other methods as well. Skiers are often shot as they blast through banks of powder, demonstrating the impact their manoeuvres have on the snow around them. Though images of climbers may not appear dynamic in the same way, their positioning suggests upward movement against the relentless pull of gravity. They are all going somewhere, and the viewer is along for the ride.

Movement evokes the aspects of outdoor pursuits that so many love, including struggle, speed, adrenaline and achievement. Embodying this physicality, subjects in action photography show what the human body can do, challenging viewers to move faster, push harder and climb higher to see things they've never been able to witness. It also demonstrates what the gear is capable of, generating enthusiasm for shoes and skis even if they ultimately never see more action than a walk around the block or some wide turns on the slopes. In this sense, the imagery is highly aspirational, communicating to consumers what the gear can help you achieve and where it can take you — if you're willing to put in the effort.

Columbia Sportswear Co.	
YEAR:	2001
DIMS:	28 × 22 CM
	11 × 8.75 IN
PAGES:	40
TEAM:	UNKNOWN

Columbia Sportswear Co.	
YEAR:	2002
DIMS:	28 × 22 CM
	11 × 8.75 IN
PAGES:	41
TEAM:	UNKNOWN

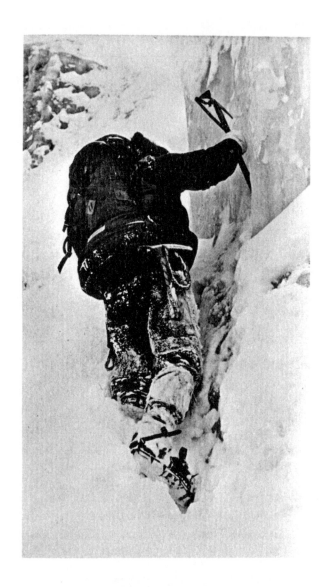

P.O. Box E, Snoqualmie, Washington 98065
P. O. Box 198, Victor, Idaho 83455

Rivendell Mountain Works		YEAR:	1974
DIMS:	22 × 10 CM (8.75 × 3.75 IN)	TEAM:	UNKNOWN
PAGES:	5		

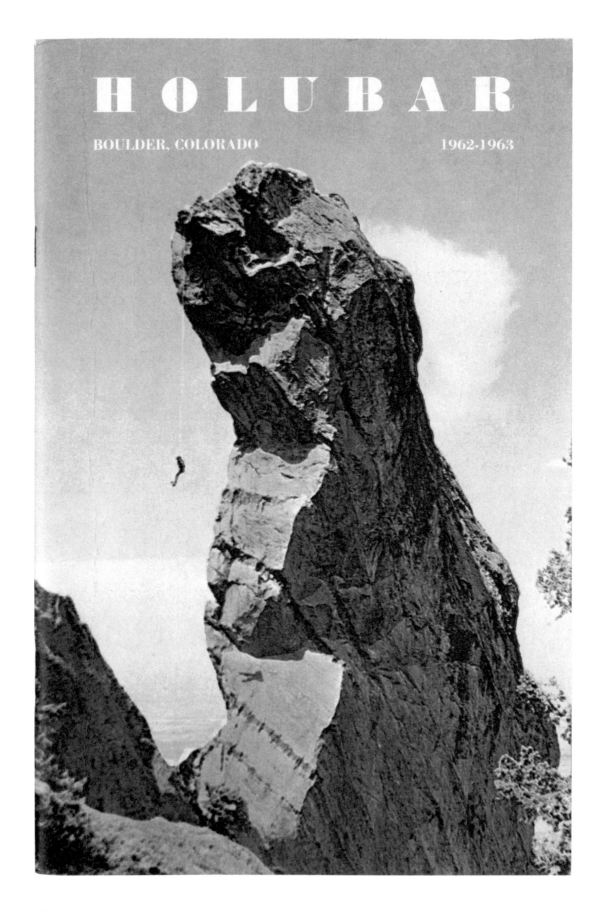

Holubar		YEAR:	1962
DIMS:	23 × 15 CM (9 × 5.75 IN)	TEAM:	UNKNOWN
PAGES:	35		

Voilé	
YEAR:	UNKNOWN
DIMS:	28 × 22 CM
	11 × 8.75 IN
PAGES:	5
TEAM:	JOHN LAPTAD

207

Voilé	
YEAR:	UNKNOWN
DIMS:	30 × 21 CM
	11.75 × 8.25 IN
PAGES:	3
TEAM:	UNKNOWN

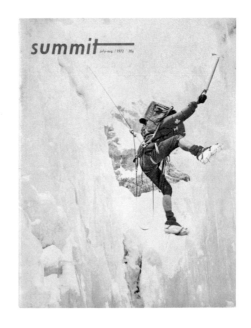

Summit	
YEAR:	1972
DIMS:	28 × 22 CM
	11 × 8.75 IN
PAGES:	44
TEAM:	UNKNOWN

Summit	
YEAR:	1974
DIMS:	28 × 22 CM
	11 × 8.75 IN
PAGES:	36
TEAM:	JIM WICKWIRE

Summit	
YEAR:	1979
DIMS:	28 × 22 CM
	11 × 8.75 IN
PAGES:	32
TEAM:	BRIAN SMOOT

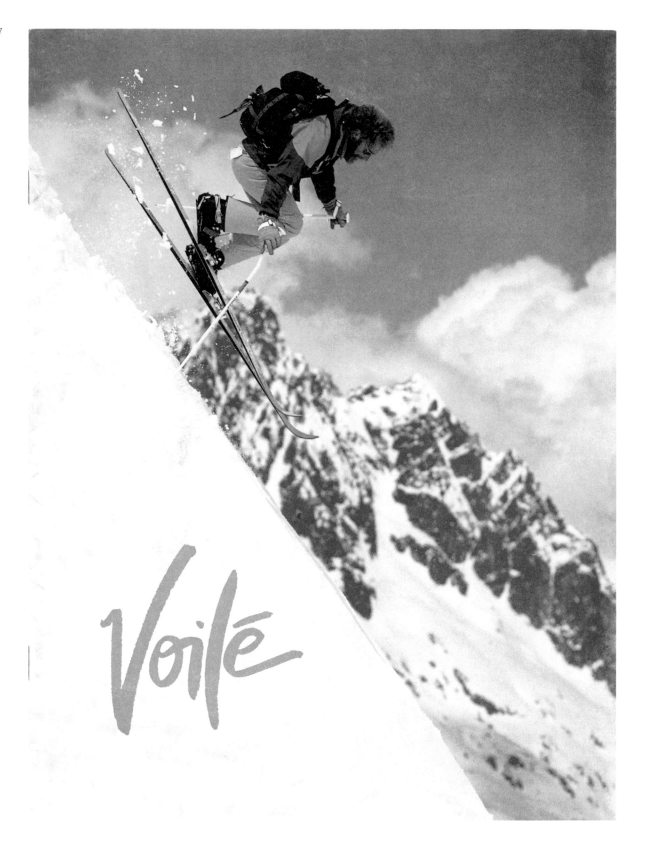

Voilé		YEAR:	UNKNOWN
DIMS:	28 × 22 CM (11 × 8.75 IN)	TEAM:	JOHN LAPTAD
PAGES:	11		

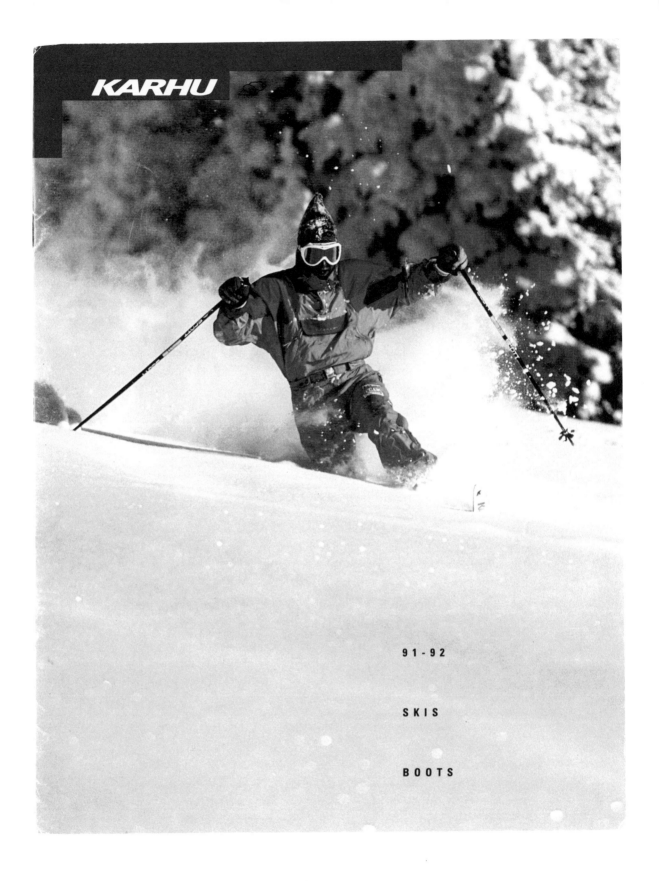

KARHU

91-92

SKIS

BOOTS

Karhu		YEAR:	1991
DIMS:	29 × 22 CM (11.25 × 8.75 IN)	TEAM:	JOHN KELLY
PAGES:	10		

CONRAD ANKER
Climber, mountaineer and author

The North Face Spring 1985 catalogue featured Yosemite legend Ron Kauk on his eponymous route 'Kauk-kulator'. Established a decade earlier on the shady side of the Rostrum in Yosemite National Park, the 5.11c crack starts thin and finishes wide. It has the aura of a valley test-piece yet, due to the hidden and obscure start, it remains a relatively unknown route.

The black-and-white treatment of Roland Dare's image highlights the nuances of the granite and builds upon the foundation of tonal photography in Yosemite. The silhouette of the oak, the glossy rhododendron and the reflective leaves, which frame the action, create a garden of calm and timelessness.

Inside all the catalogues in this book one finds the latest in clothing and equipment. The gear is one thing, but the covers set the tone. Dreams, after all, are fuel for adventures. Nearly forty years later, this cover stands the test of time. It still motivates. While the painter's trousers are a timestamp, they are much less so than neon or Lycra, brief trends in 1980s climbing. The image welcomes viewers to the outdoors with its ethereal location. It's a flywheel for imagination. Marketing within the climbing community that connects to dreams and imagination is enduringly powerful.

The North Face, 1985, 28 × 22 cm (11 × 8.75 in), 55 pages
Team: Roland Dare
This image, taken by Roland Dare in Yosemite in October 1984, is one of the photographer's favourites. 'Aesthetically, I love the lines and shapes of the photo … and that human inching up the line', Dare reflected.

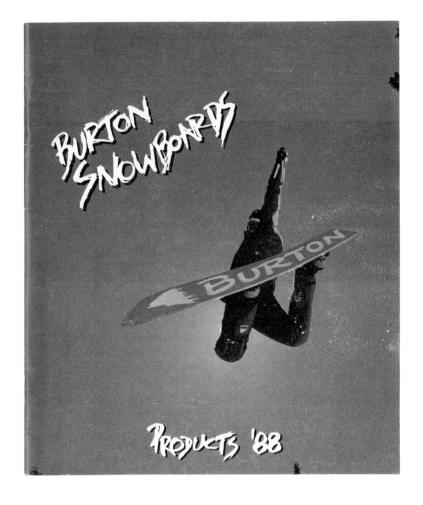

Burton	
YEAR:	1988
DIMS:	22 × 19 CM
	8.75 × 7.25 IN
PAGES:	35
TEAM:	JAMES CASSIMUS

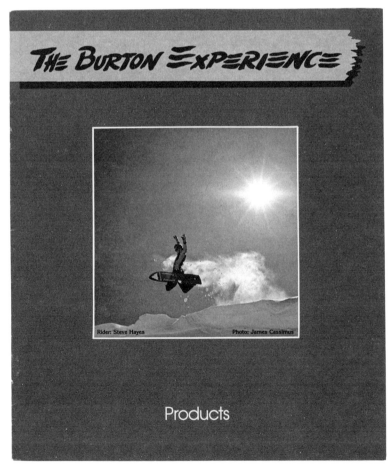

Burton	
YEAR:	1986
DIMS:	22 × 19 CM
	8.75 × 7.25 IN
PAGES:	17
TEAM:	JAMES CASSIMUS

advanced

SNOWBOARD

SCIENCE

BURTON 🅑 1993

Burton		YEAR:	1993
DIMS:	20 × 14 CM (7.75 × 5.5 IN)	TEAM:	JON FOSTER
PAGES:	99		

Title Nine	
YEAR:	2005
DIMS:	27 × 16 CM
	10.75 × 6.25 IN
PAGES:	63
TEAM:	JOSS4.COM, MARTIN SUNDBERG, PATITUCCI PHOTO, JOHN KELLY, DENNIS WELSH, BELDA PHOTOGRAPHY, MARK ESTES

Title Nine	
YEAR:	2003
DIMS:	27 × 16 CM
	10.75 × 6.25 IN
PAGES:	63
TEAM:	JOHN KELLY, DENNIS WELSH, JOSS, MARK ESTES

Title Nine		YEAR:	1998	
DIMS:	28 × 16 CM (11 × 6.25 IN)	TEAM:	DAPHNE HOUGARD	MARK ESTES
PAGES:	47		DENNIS WELSH	TODD POWELL

Buttermilk Mountain Works

Buttermilk Mountain Works		YEAR:	1985
DIMS:	22 × 15 CM (8.75 × 5.75 IN)	TEAM:	GORDON WILTSIE
PAGES:	11		

Black Diamond Equipment		YEAR:	1991
DIMS:	25 × 18 CM (9.5 × 7 IN)	TEAM:	GLENN ROBBINS
PAGES:	71		

Osprey		YEAR:	1992
DIMS:	28 × 22 CM (11 × 8.75 IN)	TEAM:	CHUCK NICHOLS
PAGES:	18		

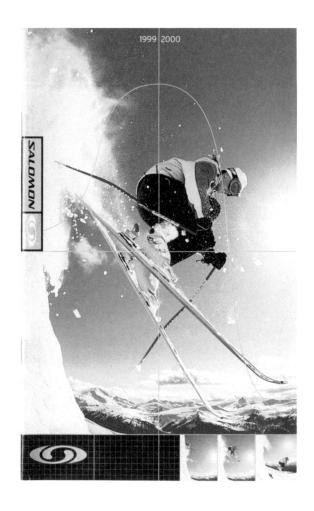

Salomon	
YEAR:	1999
DIMS:	22 × 14 CM
	8.75 × 5.5 IN
PAGES:	22
TEAM:	MARK FREDERICKS
	GARY LAND
	JOE MCBRIDE

Salomon	
YEAR:	2001
DIMS:	22 × 14 CM
	8.75 × 5.5 IN
PAGES:	30
TEAM:	UNKNOWN

ATOMIC, 1995

ASOLO, 2001

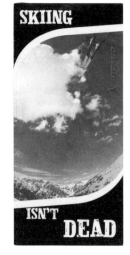

ATOMIC, UNKNOWN

ULTIMATE DIRECTION, 1997

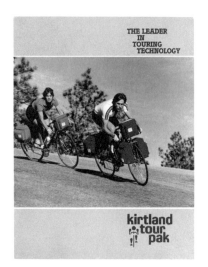

KIRTLAND TOUR PAK, 1981

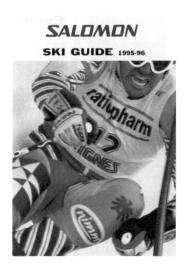

SALOMON, 1995

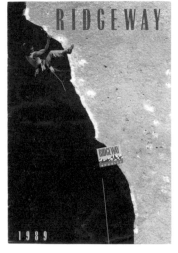

KELTY, 1989

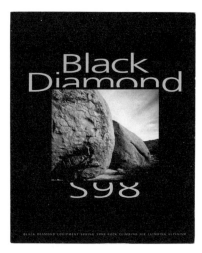

BLACK DIAMOND EQUIPMENT, 1998

VOILE, UNKNOWN

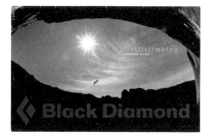

BLACK DIAMOND EQUIPMENT, 2002

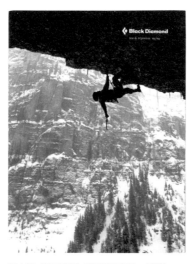

BLACK DIAMOND EQUIPMENT, 2003

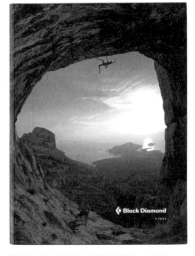

BLACK DIAMOND EQUIPMENT, 2003

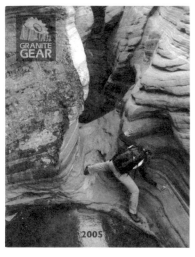

GRANITE GEAR, 2005

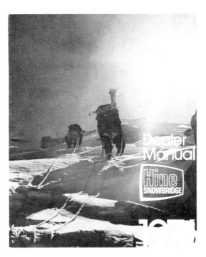

HINE SNOWBRIDGE, 1976

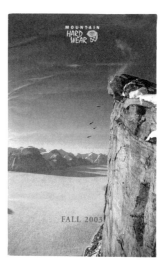

MOUNTAIN HARDWEAR, 2003

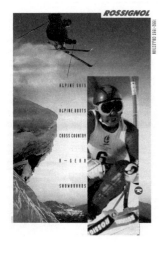

ROSSIGNOL, 1992

MOUNTAIN SAFETY RESEARCH (MSR), 1994

ROSSIGNOL, 1993

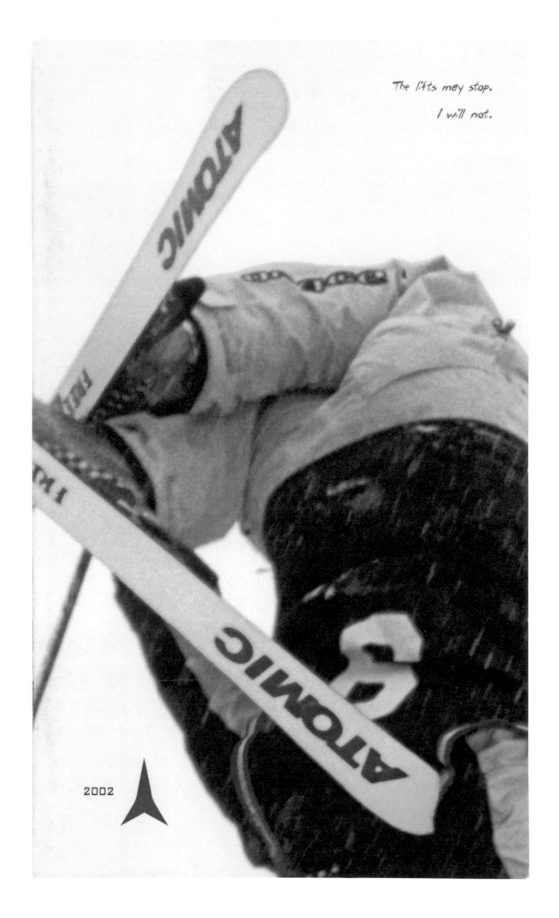

The lifts may stop.

I will not.

2002

Atomic		YEAR:	2002
DIMS:	22 × 14 CM (8.75 × 5.5 IN)	TEAM:	BUTCH ADAMS, BO BRIDGES, SHAYNE LYNN, TOM PATTON, JONATHAN SELKOWITZ, GREG VON DOERSTEN
PAGES:	22		

Black Diamond Equipment	
YEAR:	2005
DIMS:	18 × 22
	7 × 8.5 IN
PAGES:	49
TEAM:	KENNAN HARVEY

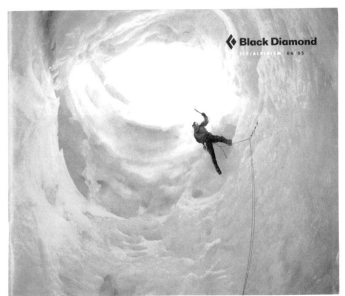

Black Diamond Equipment	
YEAR:	2004
DIMS:	18 × 22
	7 × 8.5 IN
PAGES:	49
TEAM:	TYLER STABLEFORD

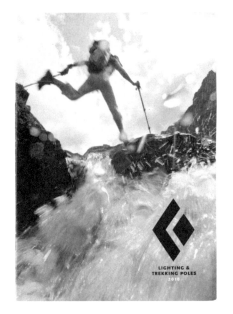

Black Diamond Equipment	
YEAR:	2010
DIMS:	22 × 16
	8.75 × 6.25 IN
PAGES:	14
TEAM:	MATT HAGE

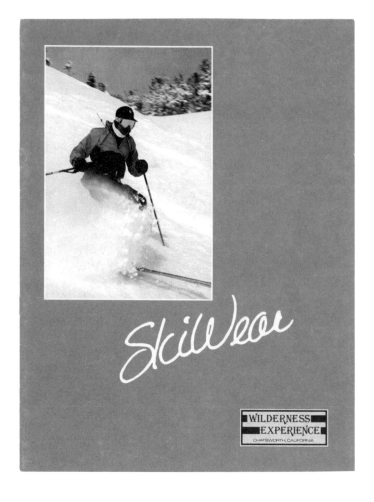

Wilderness Experience	
YEAR:	1984
DIMS:	28 × 21 CM
	11 × 8.25 IN
PAGES:	6
TEAM:	UNKNOWN

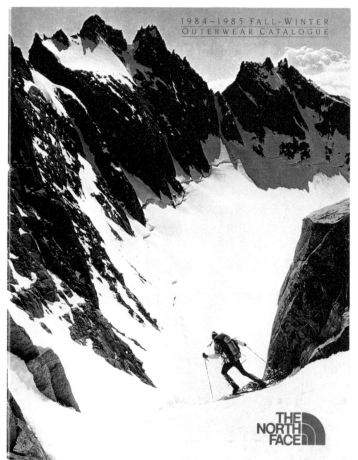

224

The North Face	
YEAR:	1984
DIMS:	28 × 22 CM
	11 × 8.75 IN
PAGES:	27
TEAM:	ALLAN BARD

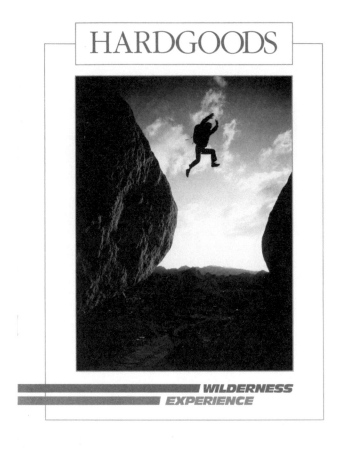

Wilderness Experience	
YEAR:	1986
DIMS:	28 × 21 CM
	11 × 8.25 IN
PAGES:	11
TEAM:	UNKNOWN

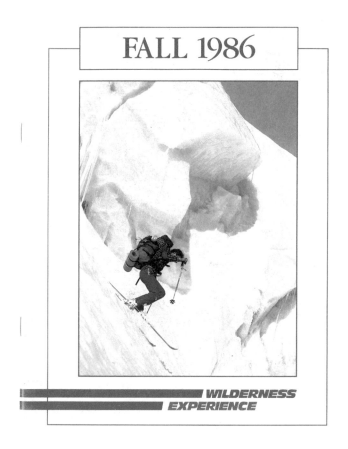

Wilderness Experience	
YEAR:	1986
DIMS:	28 × 21 CM
	11 × 8.25 IN
PAGES:	27
TEAM:	UNKNOWN

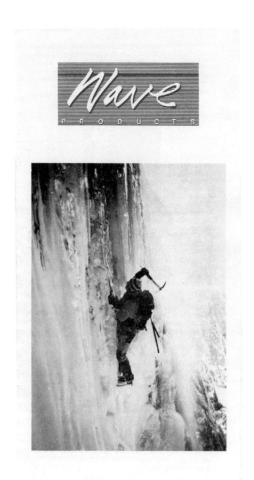

Wave Products	
YEAR:	UNKNOWN
DIMS:	28 × 15 CM
	11 × 5.75 IN
PAGES:	10
TEAM:	UNKNOWN

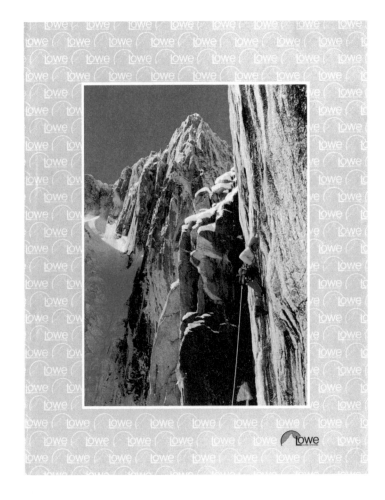

Lowe Alpine Systems	
YEAR:	1985
DIMS:	28 × 22 CM
	11 × 8.75 IN
PAGES:	10
TEAM:	MARK WILFORD

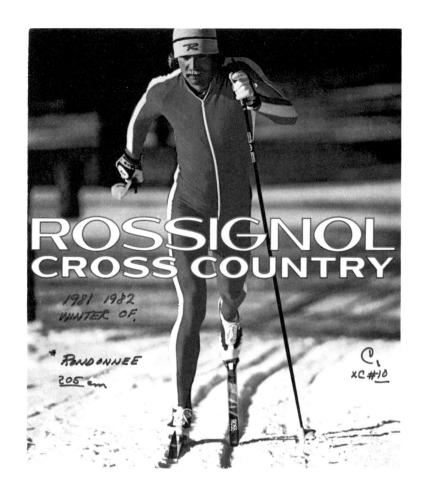

Rossignol	
YEAR:	1981
DIMS:	22 × 19 CM
	8.75 × 7.25 IN
PAGES:	5
TEAM:	UNKNOWN

Rossignol	
YEAR:	1999
DIMS:	14 × 14 CM
	5.5 × 5.5 IN
PAGES:	22
TEAM:	UNKNOWN

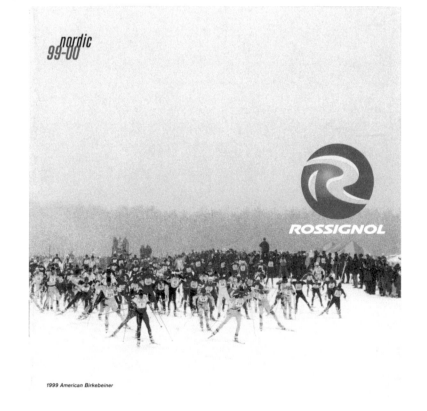

1999 American Birkebeiner

Athleta	
YEAR:	2000
DIMS:	28 × 21 CM
	11 × 8.25 IN
PAGES:	39
TEAM:	UNKNOWN

Athleta	
YEAR:	2003
DIMS:	27 × 21 CM
	10.75 × 8.25 IN
PAGES:	43
TEAM:	UNKNOWN

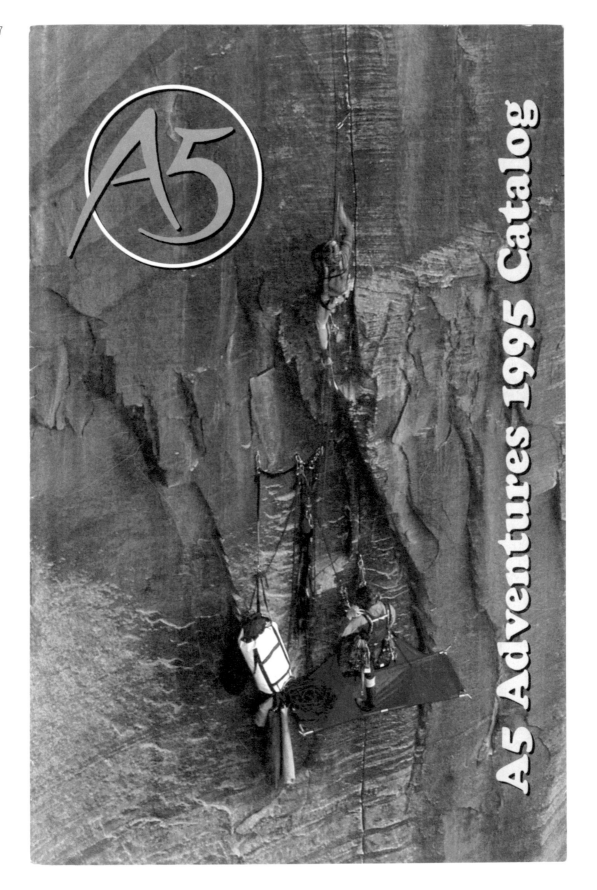

A5 Adventures		YEAR:	1995
DIMS:	23 × 16 CM (9 × 6.25 IN)	TEAM:	BILL HATCHER
PAGES:	21		

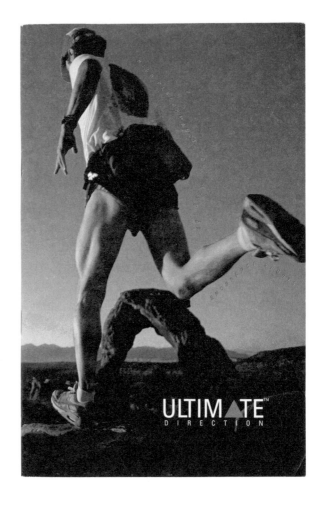

Ultimate Direction	
YEAR:	1991
DIMS:	22 × 15 CM
	8.75 × 5.75 IN
PAGES:	23
TEAM:	HUGHES MARTIN

Ultimate Direction	
YEAR:	1996
DIMS:	22 × 14 CM
	8.75 × 5.5 IN
PAGES:	20
TEAM:	GREGG ADAMS

230

Winterstick	
YEAR:	UNKNOWN
DIMS:	21 × 21 CM
	8.25 × 8.25 IN
PAGES:	6
TEAM:	PETER MILLER

231

Burton	
YEAR:	1985
DIMS:	14 × 22 CM
	5.5 × 8.75 IN
PAGES:	14
TEAM:	CHRIS NOBLE

CHAPTER 8

REMIXED
Collaged layering of imagery and/or text to create compositions.

Contributions by Elizabeth Goodspeed (p. 241), Chris Burkard (p. 250)

Sometimes brand designers create catalogue and magazine covers using layered compositions of imagery, text and other elements to achieve an effect they cannot realize with photography or illustration alone. These covers can lean heavily on one element, like 1998 Vasque catalogue, in which several photographs, carefully arranged, communicate where and how their products may be used (p. 234). The 1992 Dana Design catalogue, on the other hand, balances different elements, including an outdoor photograph and gradient text-block 'tab', seemingly tied together with bright-pink webbing and a yellow buckle (p. 261). The catalogue's quirkiest detail has nothing to do with the imagery at all: it is cut and bound so that the cover opens right at the buckle to reveal the products within. A review of all the covers using this medium generates a long list of other design treatments, including embossing, embroidery, texture, mosaics and just about any type of photography and illustration a person can imagine.

Combining various elements into a new creation affords brand creatives a number of novel design opportunities. Photographers can create attention-grabbing mashups that depict scenes that aren't possible in reality. Fun examples include the 1984 Caribou Mountaineering (p. 247) and 2001 Vasque catalogues (p. 255), which feature tiny hikers perched atop a sleeping bag and boot, respectively. This medium also allows companies to include more branding elements, as demonstrated by the 1994 Rossignol brochures (p. 269). The combination of prominent logos, branded products, narrative text and taglines creates a feel more akin to traditional advertising than a catalogue cover. No matter the elements, the eclectic nature of these compositions makes them an engaging way to connect with readers and consumers.

Vasque	
YEAR:	1998
DIMS:	22 × 28 CM
	8.75 × 11 IN
PAGES:	41
TEAM:	BRUCE AUSE-RED WING ELC, GLEN GELHLAR, LEON ,JENSEN, PEGGY PROFANT, RICHARD HAMILTON SMITH, KIRK SHIMEALL, PHIL STONE

Lowa	
YEAR:	2002
DIMS:	22 × 30 CM
	8.75 × 11.75 IN
PAGES:	59
TEAM:	UNKNOWN

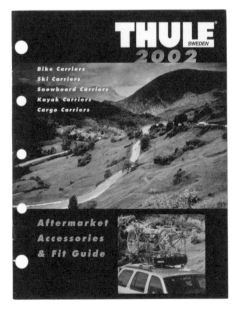

Thule	
YEAR:	2002
DIMS:	28 × 22 CM
	11 × 8.75 IN
PAGES:	18
TEAM:	UNKNOWN

Prana		YEAR:	2000
DIMS:	21 × 23 CM (8.25 × 9 IN)	TEAM:	HILL & OTHERS
PAGES:	35		

**NEW
FROM VASQUE**

**THE LATEST
TECHNOLOGY
IN MOUNTAINEERING
BOOTS**

SAN MARCO

Vasque
the mountain boots

Vasque		YEAR:	UNKNOWN
DIMS:	30 × 22 CM (11.75 × 8.75 IN)	TEAM:	UNKNOWN
PAGES:	14		

ASOLO	
YEAR:	2010
DIMS:	28 × 22 CM
	11 × 8.75 IN
PAGES:	8
TEAM:	UNKNOWN

ASOLO	
YEAR:	2003
DIMS:	23 × 15 CM
	9 × 5.75 IN
PAGES:	4
TEAM:	UNKNOWN

ASOLO	
YEAR:	1981
DIMS:	28 × 22 CM
	11 × 8.75 IN
PAGES:	3
TEAM:	UNKNOWN

ASOLO	
YEAR:	1981
DIMS:	28 × 22 CM
	11 × 8.75 IN
PAGES:	3
TEAM:	UNKNOWN

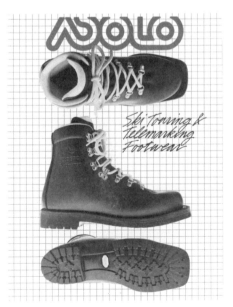

ASOLO	
YEAR:	1981
DIMS:	28 × 22 CM
	11 × 8.75 IN
PAGES:	3
TEAM:	UNKNOWN

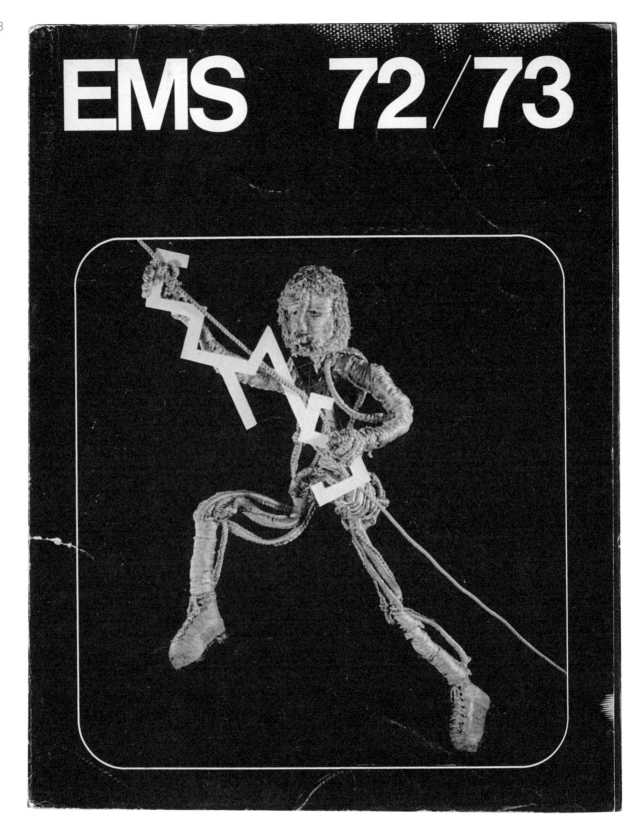

Eastern Mountain Sports		YEAR:	1972
DIMS:	28 × 22 CM (11 × 8.75 IN)	TEAM:	ROBERT GUARALDI
PAGES:	240		FRANK GLICKMAN

SUMMIT

SEPTEMBER 1956

25¢

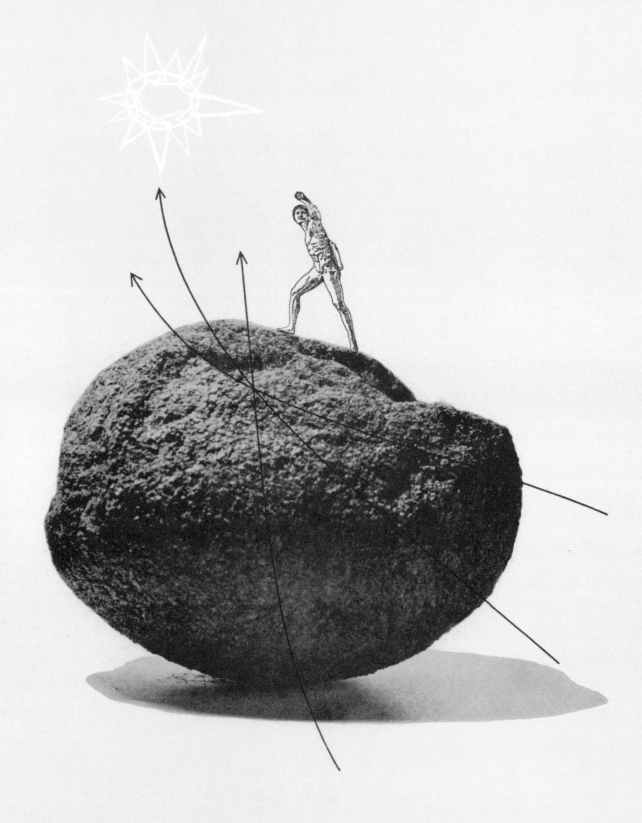

25¢

ELIZABETH GOODSPEED
Graphic designer and writer

I've never been a nature person. I grew up in a suburb of New York City where 'going outside' usually consisted of walking a few paved blocks to a manicured park with a handful of gazebos. Being outdoors always felt like it required some kind of secret knowledge — what to watch out for, what to bring, where to go — so, for a long time, I tried to get into nature the only way an indoor girl knows how: by reading about it. But no matter how many books I flipped through, nature remained static and unresponsive to me, like a stuffed mammoth in a dusty museum.

A few years ago, I moved from my tidy, antiseptic Brooklyn apartment to an almost one hundred-year-old colonial house in Rhode Island. For the first time since my childhood, I had a backyard. I also had birds nesting in my roof, puddles in my basement and ants in my kitchen. I hated it. But, somehow, despite myself, I've started to grow fond of the fat squirrels I see gobbling up our birdseed and the paltry apples that grow on a gnarled tree outside my kitchen window every spring. I've even started to look forward to making the ten-minute drive to the nearby 240-hectare (600-acre) state for-est, and I'm learning what to watch out for, what to bring and where to go just by the very act of doing.

This cover feels like a homage to the more playful and personal way of interacting with nature that I am slowly — so slowly — develop-ing. Visually, the cover reminds me of the work of one of my favourite Mid-Century graphic designers, Alvin Lustig, whose book covers for icons like James Joyce and Gertrude Stein (most of which were made from 1945–55, pre-dating this *Summit* cover only slightly) embraced an unexpected mélange of scribbly lines, rigid geometry and bold colour. Here, the *Summit* designer similarly experiments with mixed styles of mark-making, from the rough, childlike lines of the sun to the precisely inked arrows and human figure. While the slab serif typography and bright yellow background are bold and joyful, the exaggeration in scale between the oversized stone and the small man is a bit surreal; a nod to our own corporeal insignificance against the breadth of nature, and the beauty of even the smallest pebble. Getting to know the out-doors still feels a bit embarrass-ing to me at times, but at least it's mine.

Summit, 1956, 27 × 21 cm (10.75 × 8.25 in), 24 pages
Team: Keith Bright, Fred Swift

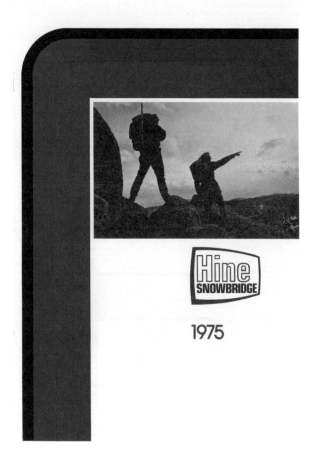

1975

Hine Snowbridge	
YEAR:	1975
DIMS:	28 × 18 CM
	11 × 7 IN
PAGES:	6
TEAM:	P. HARRIS PHOTO

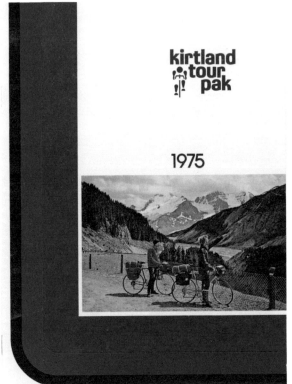

1975

Quality packs for the
serious touring enthusiast

Kirtland Tour Pak	
YEAR:	1975
DIMS:	28 × 18 CM
	11 × 7 IN
PAGES:	6
TEAM:	G.S. HINE PHOTOS

Eastern Mountain Sports	
YEAR:	1976
DIMS:	28 × 22 CM
	11 × 8.75 IN
PAGES:	128
TEAM:	INTRAMEDIA ASSOCIATES

Eastern Mountain Sports	
YEAR:	1977
DIMS:	28 × 22 CM
	11 × 8.75 IN
PAGES:	97
TEAM:	INTRAMEDIA

Blacks	
YEAR:	1963
DIMS:	17 × 23 CM
	6.75 × 9 IN
PAGES:	72
TEAM:	UNKNOWN

Blacks	
YEAR:	1968
DIMS:	18 × 23 CM
	7 × 9 IN
PAGES:	16
TEAM:	UNKNOWN

Chums	
YEAR:	UNKNOWN
DIMS:	16 × 23 CM
	6.25 × 9 IN
PAGES:	18
TEAM:	UNKNOWN

Mountain Hardwear		YEAR:	1995
DIMS:	23 × 23 CM (9 × 9 IN)	TEAM:	LOCKLIN ADVERTISING & DESIGN, BERKELEY
PAGES:	51		

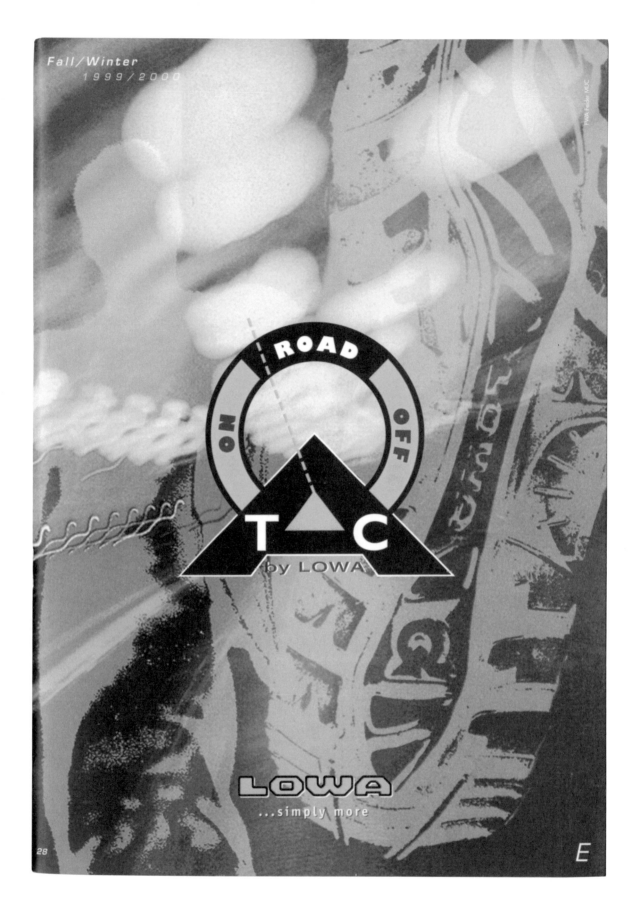

Fall/Winter
1999/2000

28

E

Lowa		YEAR:	1999
DIMS:	30 × 22 CM (11.75 × 8.75 IN)	TEAM:	UNKNOWN
PAGES:	28		

246

Caribou	
YEAR:	1984
DIMS:	29 × 22 CM
	11.5 × 8.75 IN
PAGES:	5
TEAM:	MIKE AGLIOLO STUDIOS

Caribou	
YEAR:	1984
DIMS:	28 × 22 CM
	11 × 8.75 IN
PAGES:	31
TEAM:	MIKE AGLIOLO STUDIOS

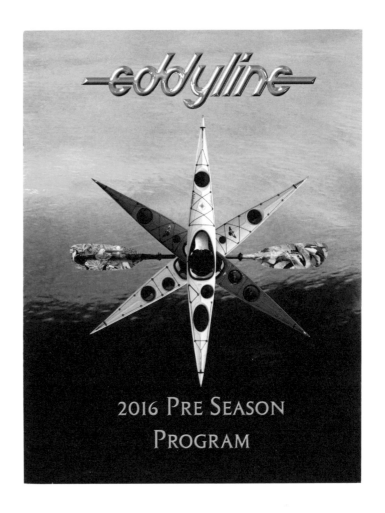

Eddyline	
YEAR:	2016
DIMS:	28 × 22 CM
	11 × 8.75 IN
PAGES:	6
TEAM:	UNKNOWN

Holubar	
YEAR:	1974
DIMS:	28 × 22 CM
	11 × 8.75 IN
PAGES:	79
TEAM:	AL MORGAN
	FELIX DUNBAR

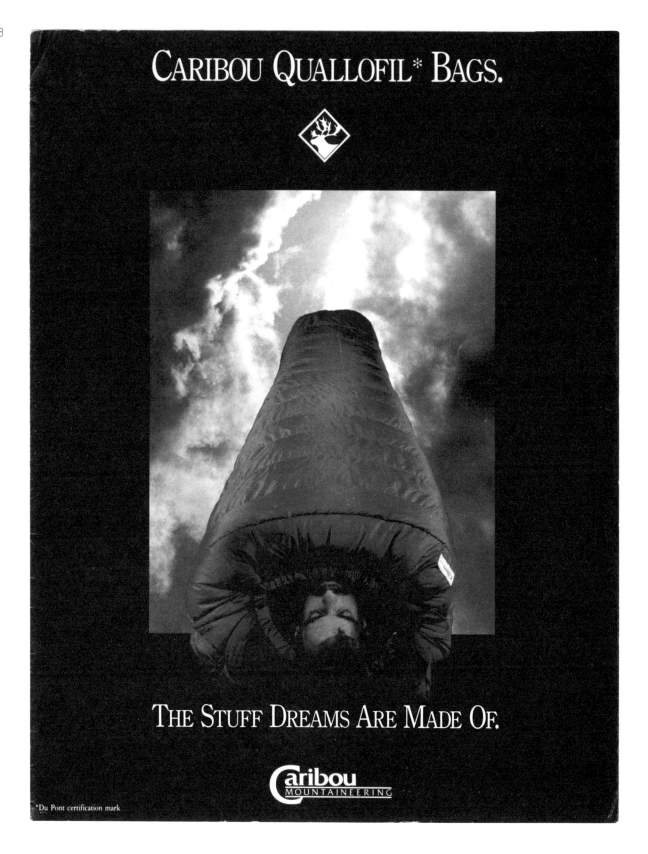

Caribou		YEAR:	UNKNOWN
DIMS:	28 × 22 CM (11 × 8.75 IN)	TEAM:	UNKNOWN
PAGES:	2		

CHRIS BURKARD
Outdoor photographer

As simple as this image may seem, it struck me in ways it's hard to explain.

Often, when I think about photography these days, and what really makes an image special, it boils down to simplicity. An image that is honest isn't trying to be more — or ask more — than it is. At its very essence, a great advertising photo is trying to instill a feeling or emotion in the viewer, connecting them to the ethos of the brand and its product.

In this case, the obvious hero of the image is Yosemite's hulking half dome. The tent in the foreground, which is obviously our point of sale, mirrors the half dome in an almost comical way. It's easy to overthink a composition and tease out much more of a scene, but oftentimes, in the act of trying to make things look perfect, we end up de-authenticating the very experience we're trying to represent.

But here, in this simple catalogue cover, we see a homage to one of the US' greatest ideas — its national parks — and more so, one of the parks' most famous icons. I love it. I love the boldness of allowing this midday, sepia-toned image to sit on the cover, as if to remind us what it's all really about. To find oneself in nature, in the places that you truly want to be. To me, that says more about the mission statement of this brand than anything else.

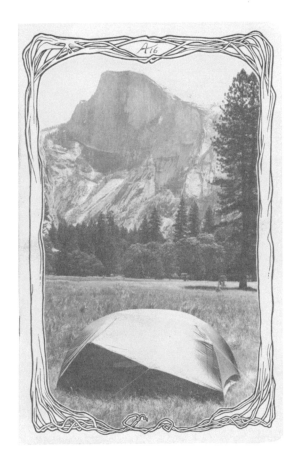

Adventure 16, 1976, 23 × 16 cm (9 × 6.25 in), 29 pages

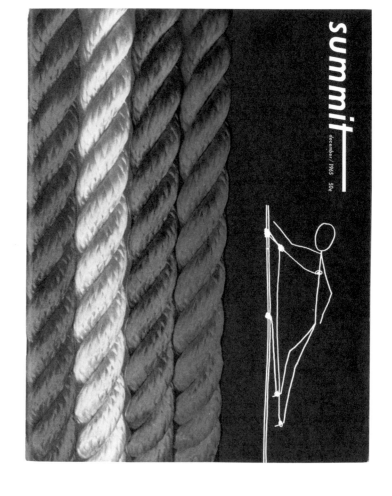

Summit	
YEAR:	1965
DIMS:	28 × 22 CM
	11 × 8.75 IN
PAGES:	32
TEAM:	JERRY LEBECK

Woolrich	
YEAR:	1984
DIMS:	30 × 22 CM
	11.75 × 8.75 IN
PAGES:	42
TEAM:	UNKNOWN

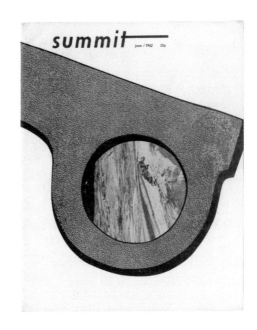

Summit	
YEAR:	1962
DIMS:	27 × 22 CM
	10.75 × 8.75 IN
PAGES:	28
TEAM:	ALLEN STECK

Summit	
YEAR:	1959
DIMS:	27 × 21 CM
	10.75 × 8.25 IN
PAGES:	24
TEAM:	KEITH BRIGHT

Summit	
YEAR:	1972
DIMS:	28 × 22 CM
	11 × 8.75 IN
PAGES:	44
TEAM:	ED COOPER
	S. SANSONETTI

Summit	
YEAR:	1960
DIMS:	27 × 21 CM
	10.75 × 8.25 IN
PAGES:	26
TEAM:	BOB AND IRA SPRING

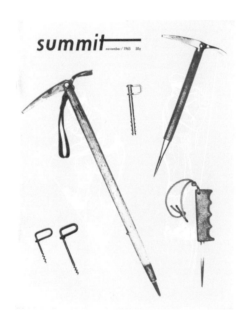

Summit	
YEAR:	1965
DIMS:	28 × 22 CM
	11 × 8.75 IN
PAGES:	34
TEAM:	UNKNOWN

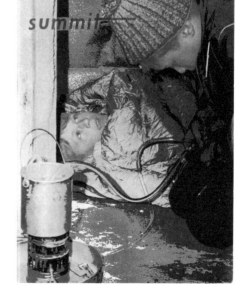

Summit	
YEAR:	1970
DIMS:	28 × 22 CM
	11 × 8.75 IN
PAGES:	36
TEAM:	UNKNOWN

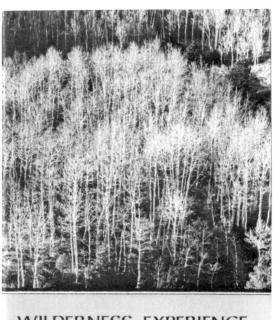

Wilderness Experience	
YEAR:	1976
DIMS:	23 × 14 CM
	9 × 5.5 IN
PAGES:	18
TEAM:	UNKNOWN

Wilderness Experience	
YEAR:	1974
DIMS:	28 × 17 CM
	11 × 6.75 IN
PAGES:	12
TEAM:	PHILIP L. WICK, PHOTO-UNIQUE

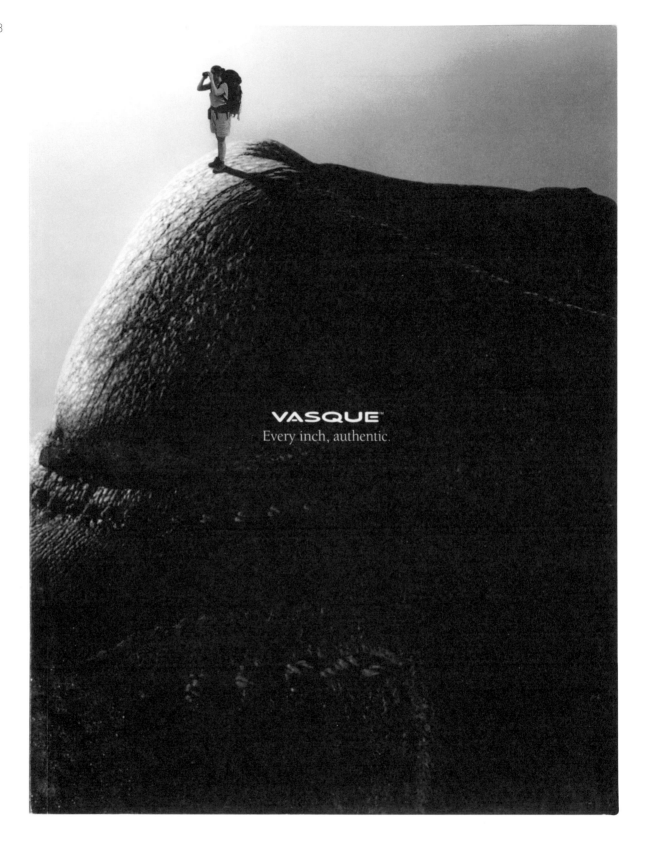

VASQUE™
Every inch, authentic.

Vasque		YEAR:	2001
DIMS:	28 × 22 CM (11 × 8.75 IN)	TEAM:	UNKNOWN
PAGES:	40		

Marmot	
YEAR:	1999
DIMS:	28 × 22 CM
	11 × 8.75 IN
PAGES:	48
TEAM:	GREG VON DOERSTEN, DAVE SHELDON, PETE TAKEDA, DANIEL H. BAILEY, JULIE-ANN CLYMA

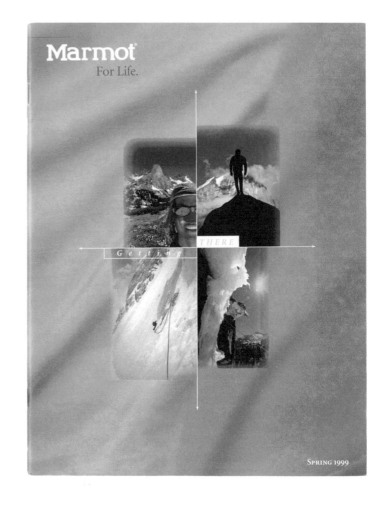

Marmot	
YEAR:	1994
DIMS:	28 × 22 CM
	11 × 8.75 IN
PAGES:	49
TEAM:	ROBERT ASCHENBRENNER

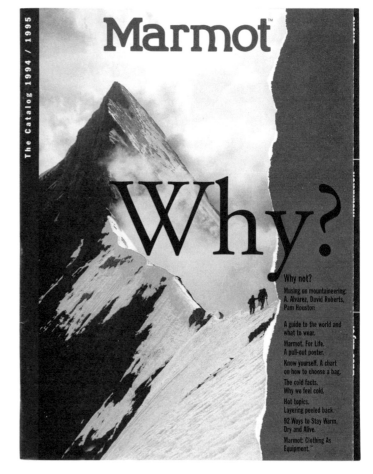

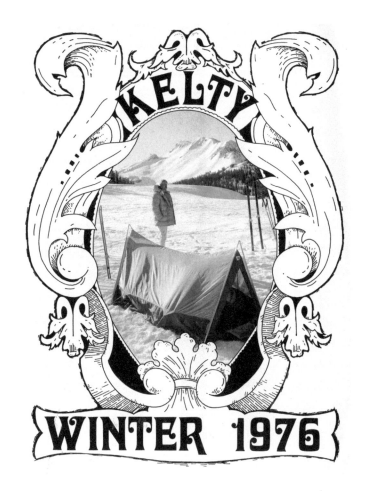

Kelty	
YEAR:	1976
DIMS:	28 × 22 CM
	11 × 8.75 IN
PAGES:	23
TEAM:	BORIS SAVIC
	TOM TERRY

1985

257

Kelty	
YEAR:	1985
DIMS:	23 × 22 CM
	9 × 8.75 IN
PAGES:	42
TEAM:	GORDON WILTSIE

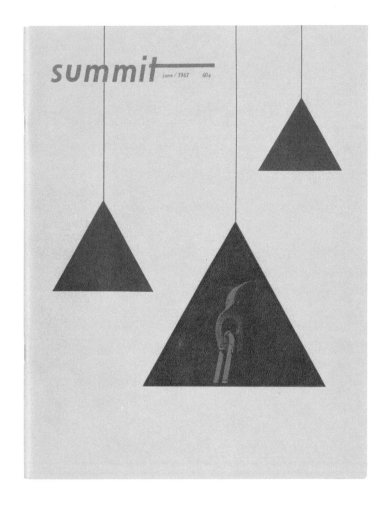

Summit	
YEAR:	1967
DIMS:	28 × 22 CM
	11 × 8.75 IN
PAGES:	36
TEAM:	UNKNOWN

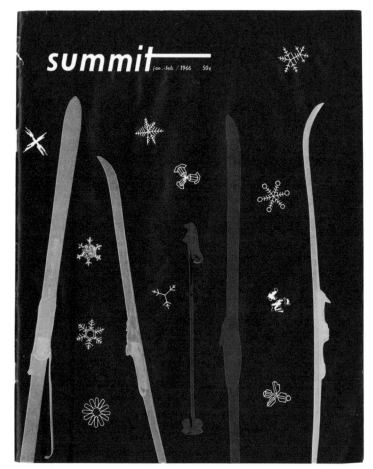

Summit	
YEAR:	1966
DIMS:	28 × 22 CM
	11 × 8.75 IN
PAGES:	32
TEAM:	UNKNOWN

When in doubt, go higher

Mountain Gazette		YEAR:	2001
DIMS:	38 × 26 CM (15 × 10.25 IN)	TEAM:	MIKE WILSON
PAGES:	70		

Spring/Summer 1976

Sierra Designs		YEAR:	1976
DIMS:	26 × 23 CM (10.25 × 9 IN)	TEAM:	GORDON HIRANO
PAGES:	51		GEORGE BRAUN

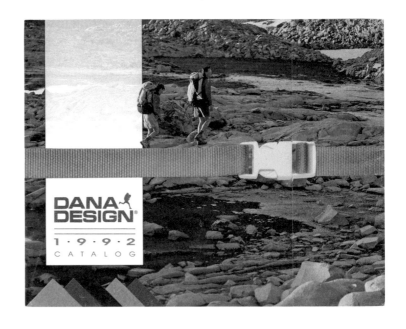

Dana Design	
YEAR:	1992
DIMS:	22 × 29 IN
	8.75 × 11.25 IN
PAGES:	27
TEAM:	BERT SAGARA

Dana Design	
YEAR:	1991
DIMS:	22 × 29 CM
	8.75 × 11.25 IN
PAGES:	21
TEAM:	BERT SAGARA

Dana Design	
YEAR:	1998
DIMS:	28 × 22 CM
	11 × 8.75 IN
PAGES:	30
TEAM:	JIM STIMSON

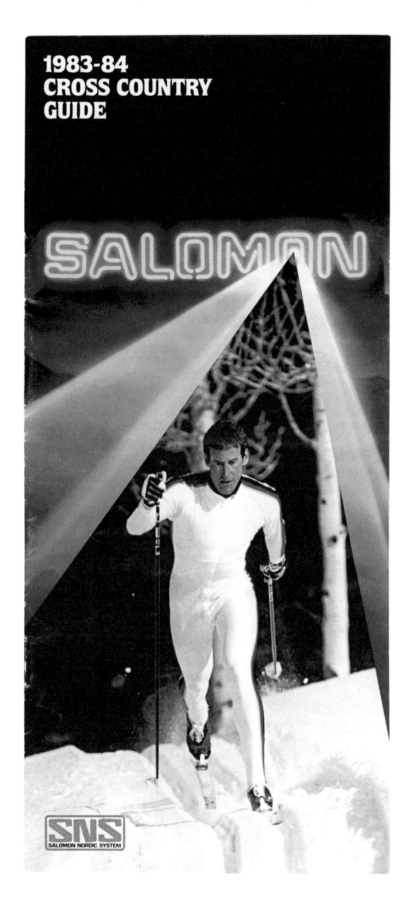

**1983-84
CROSS COUNTRY
GUIDE**

SALOMON

SNS
SALOMON NORDIC SYSTEM

Salomon		YEAR:	1983
DIMS:	23 × 11 CM (9 × 4.25 IN)	TEAM:	UNKNOWN
PAGES:	7		

Mountain House	
YEAR:	1978
DIMS:	28 × 22 CM
	11 × 8.75 IN
PAGES:	5
TEAM:	UNKNOWN

Ibex	
YEAR:	2000
DIMS:	23 × 16 CM
	9 × 6.25 IN
PAGES:	37
TEAM:	CHERMAYEFF & GEISMAR
	LORELEI GRAZIER

263

Rossignol	
YEAR:	1999
DIMS:	14 × 14 CM
	5.5 × 5.5 IN
PAGES:	46
TEAM:	SCOTT MARKEWITZ
	PAUL MORRISON

Kelty	
YEAR:	UNKNOWN
DIMS:	22 × 14 CM
	8.75 × 5.5 IN
PAGES:	19
TEAM:	JOHN ROSKELLEY

the ultimate
carving experience

ATOMIC
RESIST THE USUAL

Atomic		YEAR:	1996
DIMS:	22 × 10 CM (8.75 × 3.75 IN)	TEAM:	UNKNOWN
PAGES:	11		

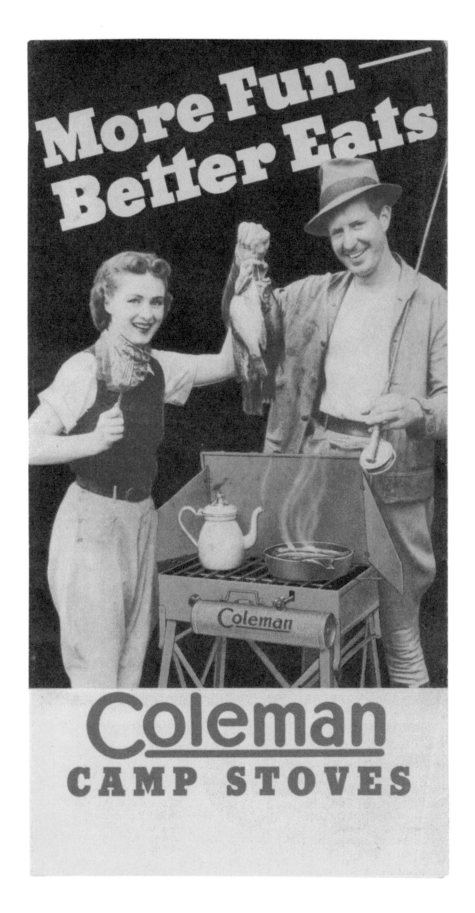

Coleman		YEAR:	UNKNOWN	
DIMS:	16 × 9 CM (6.25 × 3.5 IN)	TEAM:	UNKNOWN	
PAGES:	6			

Granite Gear	
YEAR:	1994
DIMS:	28 × 22 CM
	11 × 8.75 IN
PAGES:	15
TEAM:	BOB FIRTH, JEFF FREY, CHRIS CORKINS, LOIS HATFIELD, A. BANCROFT

Granite Gear	
YEAR:	1995
DIMS:	28 × 22 CM
	11 × 8.75 IN
PAGES:	14
TEAM:	GORDON WILTSIE

ADVENTURE 16, 2001

ADVENTURE 16, UNKNOWN

GRANITE GEAR, 1996

ADVENTURE 16, 1987

HINE SNOWBRIDGE, 1974

ATOMIC, 1995

ASOLO, 2005

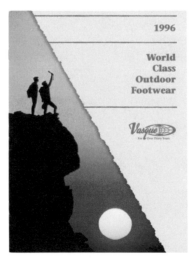

VASQUE, 1996

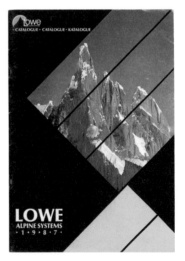

LOWE ALPINE SYSTEMS, 1987

268

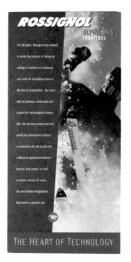

ROSSIGNOL, 1994

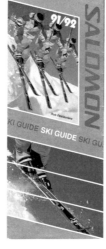

SALOMON, 1991

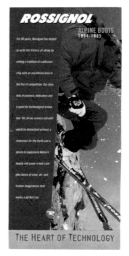

ROSSIGNOL, 1994

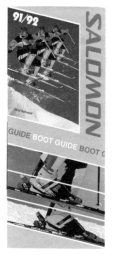

SALOMON, 1991

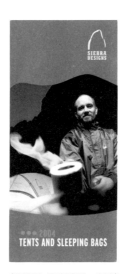

SIERRA DESIGNS, 2004

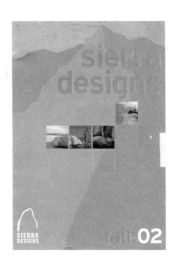

SIERRA DESIGNS, 2002

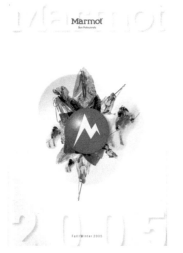

MARMOT, 2005

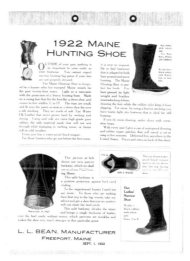

L. L. BEAN, 1922

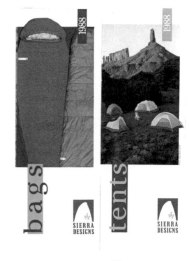

SIERRA DESIGNS, 1988

269

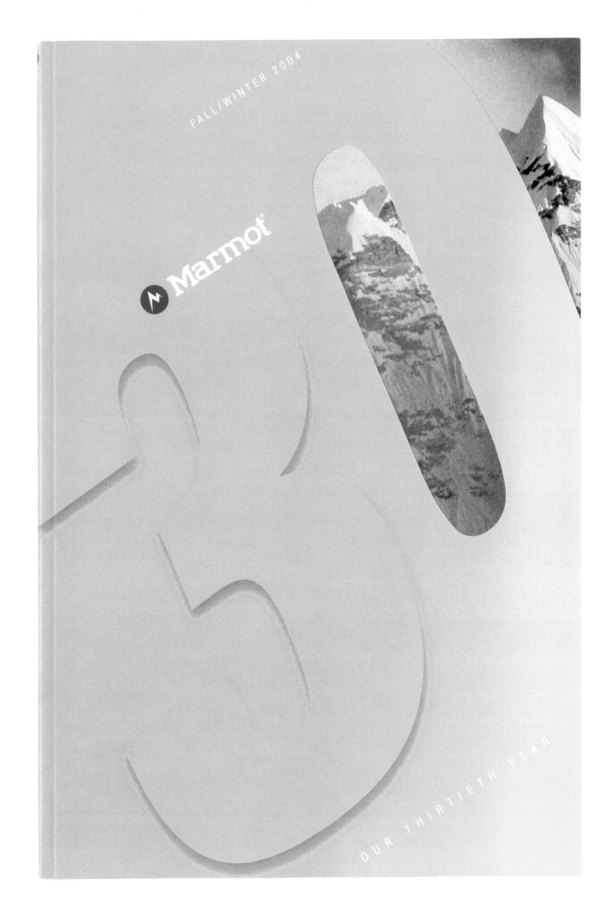

FALL/WINTER 2004

Marmot

OUR THIRTIETH YEAR

Marmot		YEAR:	2004
DIMS:	29 × 20 CM (11.25 × 7.75 IN)	TEAM:	ACE KVALE
PAGES:	81		

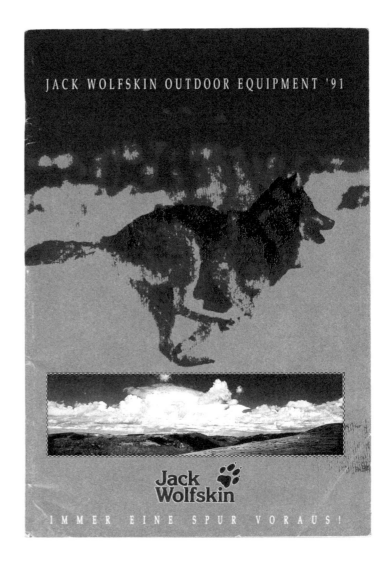

Jack Wolfskin Outdoor Equipment	
YEAR:	1991
DIMS:	30 × 22 CM
	11.75 × 8.75 IN
PAGES:	117
TEAM:	IMPACT WERBEAGENTUR GMBH, MANNHEIM

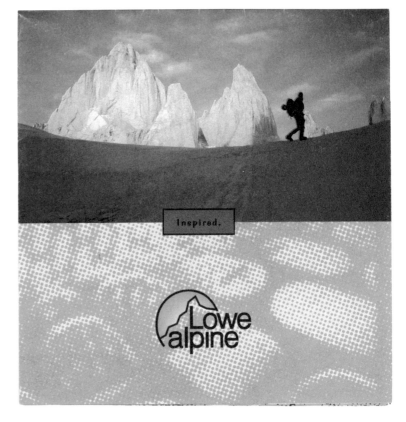

Lowe Alpine Systems	
YEAR:	1996
DIMS:	19 × 18 CM
	7.25 × 7 IN
PAGES:	5
TEAM:	GREG CROUCH

The North Face, 1966, 28 × 21 cm (11 × 8.25 in), 40 pages
Team: Jim Berryhill
Founder Doug Thompkins hired Jim Berryhill to produce TNF's first
mail-order catalogue in 1966. Berryhill's illustrations — inspired
by a series of climbing books at the company's San Francisco store
— feature throughout the catalogue.

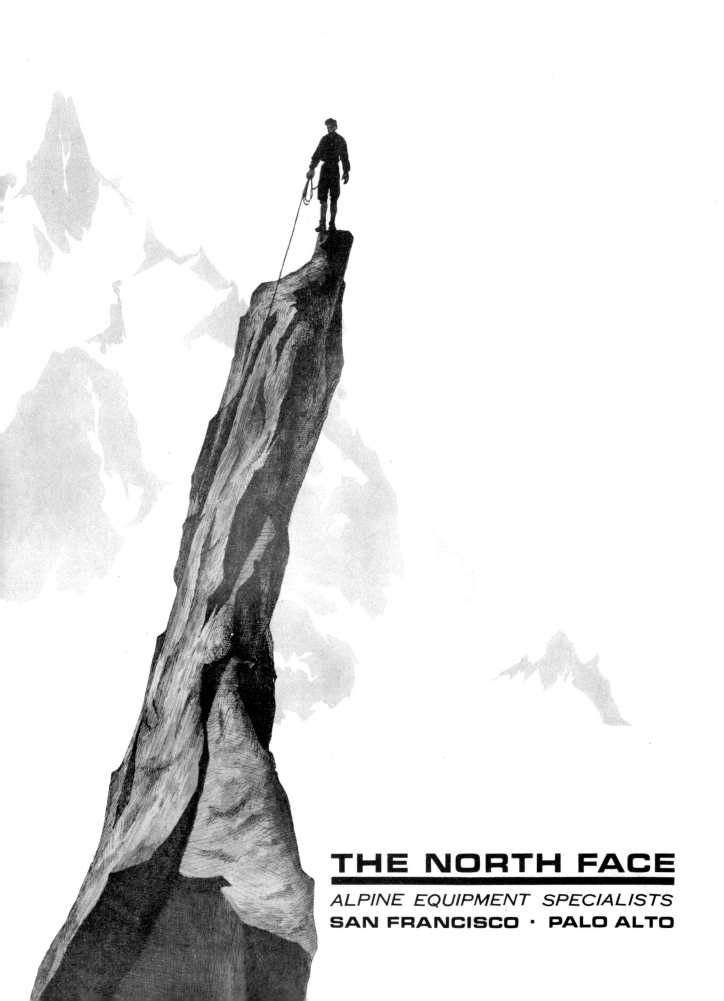

THE NORTH FACE

ALPINE EQUIPMENT SPECIALISTS

SAN FRANCISCO · PALO ALTO

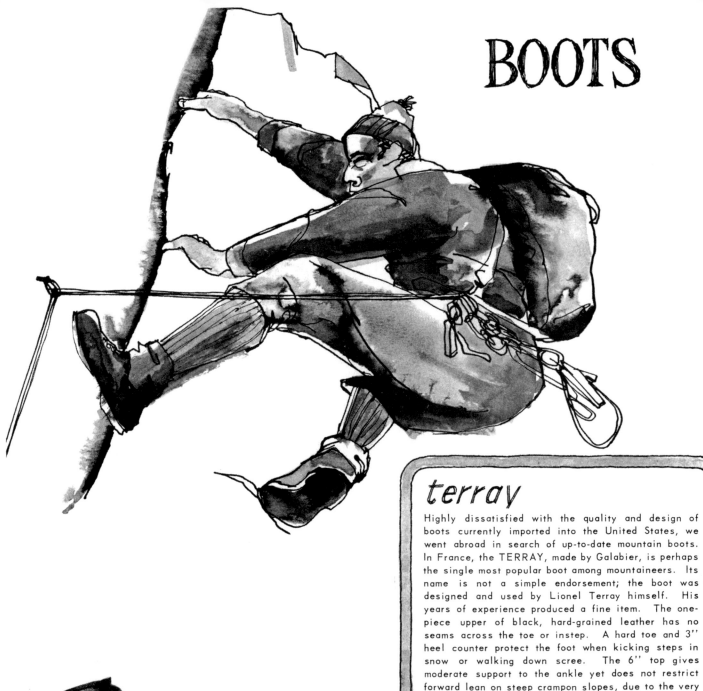

BOOTS

terray

Highly dissatisfied with the quality and design of boots currently imported into the United States, we went abroad in search of up-to-date mountain boots. In France, the TERRAY, made by Galabier, is perhaps the single most popular boot among mountaineers. Its name is not a simple endorsement; the boot was designed and used by Lionel Terray himself. His years of experience produced a fine item. The one-piece upper of black, hard-grained leather has no seams across the toe or instep. A hard toe and 3'' heel counter protect the foot when kicking steps in snow or walking down scree. The 6'' top gives moderate support to the ankle yet does not restrict forward lean on steep crampon slopes, due to the very thick, soft tongue. The TERRAY is laced to within 1½'' of the toe, providing full adjustment through five rings and four sturdy hooks on each side. The outer flaps lap securely over the tongue, which is gusseted up to the ankle. The inside of the boot is fully-lined with smooth, soft leather covering all irregularities which might chafe. The instep and ankle are exceptionally well padded to hold the heel in place. The leather midsole is double-stitched by hand to the upper; the resulting very narrow welt, which is sealed, allows a good crampon fit and proper feel on difficult rock. A 3/8'' lug sole is screwed and glued to the mid-sole, thus durably attached yet easily replaced. Our direct import affords a good price.

sizes: 5 through 13
widths: A-B, D-E (two only)
weight: 5 lbs. pair (size 9)
price: $37.50

Boot fitting

WHEN YOU ORDER

State your usual street shoe size and width, i.e., ''9-C.''

Put on exactly the socks you intend to wear in the boots. Stand with your weight evenly on both feet. Put a piece of cardboard or stiff paper under each foot. Have someone draw an outline of each foot. Be sure to hold the pencil vertically.

WHEN YOU RECEIVE YOUR BOOTS

1. Put them on and lace them firmly from bottom to top, especially across the instep. The boot may feel loose around the instep because it has been packed flat; do not make any judgments until you are through step 8.

2. Stand straight with your weight evenly on both feet. Have someone press hard on the toe of each boot about ¼'' back from the curve of the toe; your big toe should be at that point.

3. Wiggle your toes up and down and pull them back toward the foot. There should be enough room for free toe movement.

4. With the weight still evenly on both feet, the ball of your foot should not be pinched at point #4 in the drawing. Now have your companion hold the toe and the heel of the boot rigid while you stand on that foot and twist vigorously from side to side. The ball of the foot should fill the boot and barely move; the heel must not move at all from side to side.

5. Relace your boots firmly.

6. Walking is an important part of boot-fitting. You may test your fit on a clean, dry, paved road but we will not accept returned boots which have obviously been used in the field. Walk briskly uphill for 50 yards. If your heel moves up or down very loosely, the boot is too long for you (step 2) or too wide in the heel (step 4).

7. As you walk downhill, your foot should not slip forward and hit the front of the boot or pinch the toes. If either occurs, the boot is too short (step 2) or too narrow (step 3 or 4). Remember, the boots have been packed flat and must mold themselves to your foot.

8. If you are trying on Klettershoes or climbing boots, try the edge on a curb or thin board. You may want a narrower and/or shorter boot for climbing. Klettershoes must be tight—almost painfully narrow and very snug in length.

If, after these tests, you feel your boots do not fit, return them with your suggestions for a better size. We guarantee a fit or your money back.

Boot care

When you buy a new pair of boots to be used in water or snow, they should be thoroughly water-proofed immediately. Johnson's Shoe Saver, Sno-Seal and DRI are all excellent. Though the last is messy to apply, it is the most effective for snow and running water. We do not recommend animal fat or grease.

After each period of use, your boots should be cleaned with saddle soap before they are rewaterproofed. Adding more waterproofing without removing the old caked dirt will only break down the leather. When your boots need resoling, take them to a boot specialist who is used to working with lug soles and handmade boots.

cortina

The Italian CORTINA is the most popular hiking shoe in California. It is admirably suited to the well-packed dry trails throughout the Sierra. The soft suede upper is light, cool, and smoothly lined. The sole is a ¼'' Vibriam lug — thick enough for good traction and cushioning yet very flexible in front for enjoyable walking. The CORTINA takes no breaking in and can be worn immediately on long hikes. One caution must be issued: Improper use of the boot will find it unsatisfactory and inadequate. It is not designed for snow or off-trail use; it can be only moderately waterproofed. The CORTINA is easily fitted to a wide range of sizes and widths. One pair of thermal socks is usually sufficient for a comfortable fit.

sizes: 3 through 13
widths: AA – D
weight: 2 lbs. 10 oz.
price: $21.50

summit

The SUMMIT, from Italy, is an excellent compromise for people who want somewhat more waterproofness and durability in a boot as well fitting and finely crafted as the CORTINA. The SUMMIT is identical in cut but the upper is a very fine brown oiled leather which is nearly waterproof. The Roccia sole is screwed through an extra midsole, making the SUMMIT mildly stiffer and more durable in rough country. Again the same fine sizing as the CORTINA makes fitting easy.

sizes: 4 through 13
widths: AA – D
weight: 3 lbs. 10 oz.
price: $25.50

SLEEPING BAGS

The North Face

We have chosen to name our finest sleeping bag THE NORTH FACE bag because this single item, more than any other, epitomizes our general principle: to sell only the finest alpine equipment. The name NORTH FACE is derived from the traditional association of the great North Faces of the Northern Hemisphere with the highest challenge and standards of mountaineering—faces such as those of the Eiger, Mt. Robson, the Grandes Jorasses, the Matterhorn, the Grand Teton, the Piz Badile. We have no hesitation in presenting the NORTH FACE bag as the finest sleeping bag available. For ultimate and absolute protection from the cold, the NORTH FACE bag is peerless. We make no compromise in the design and construction of this bag.

The cut of the NORTH FACE is identical to the IBEX bag. Inside widths of 30'' at the shoulders and 16'' at the feet allow one to enter the bag before removing one's heavy outer clothing. The optional half or full-length zippers are a ¾'' wide #7 nylon chain with slider pulls inside and out. The zipper teeth are unbreakable and self-lubricating; they mesh closely yet their slipperiness prevents damage to snagged fabric. The 4'' down-filled zipper tube is lined with a stiff backing fabric to reduce snags. This tube is not sewn in a single line along the zipper closure; instead, on all bags we manufacture, the draft flap is attached at two points offset so that the flap forms a continuous thickness behind the zipper. The nylon zippers themselves will not freeze up or radiate heat at low temperatures. All these features combine to make the zipper a completely trouble-free closure with no loss of insulation and very little additional weight. The completely adjustable hood controls ventilation around the head and shoulders. It may be left flat, closed around the neck to stop drafts, or drawn up snugly to leave only a breathing hole. The separate nylon tape drawstrings for head and shoulders are sewn through the middle so they can not pull out. Leather friction sliders replace clumsy knots or plastic gadgets.

The shell of the NORTH FACE bag, as in all our bags, is 1.9 oz. Ripstop nylon which has proven more than tough enough for racing sails and parachutes. Every exposed fabric edge is turned and overlock stitched. The 4½'' radial differential expands to a staggering 9½'' of loft when filled with 2¾ to 3¼ pounds of WHITE NORTHERN GOOSE DOWN. For full control of so much thickness, we employ the continuous diaphragm method of baffling in which 1 oz. mosquito mesh baffles are attached every 6''. The block baffle along each side eliminates circumferential down shift and maintains the same loft at the sides as over the center—a unique achievement. The immense loft of the NORTH FACE bag is probably sufficient protection for most people at 30° to 40° below 0°F. More important, however, is the extra margin of insulation which may be vital at high altitudes or during prolonged periods of extreme effort and exposure. At such times the body's natural heat production is greatly lowered; consequently, less heat loss can be tolerated. The NORTH FACE bag is supplied with a 9''x21'' waterproof stuff sack.

colors: We have BLUE in stock; GREEN, YELLOW, and ORANGE are available on special request (allow 3 weeks). Give alternates when ordering.

comfort range: To −30°F.

loft: 9½''

down type: White northern goose down

fabric: 1.9 oz. Ripstop nylon

construction: 6'' diaphragm baffle

size:	Regular (to 5' 9'')	Large (to 6' 2'')	Extra Large (to 6' 9'')
down content: (no zipper)	42 oz.	47 oz.	52 oz.
total weight:	4 lb. 0 oz.	4 lb. 6 oz.	4 lb. 12 oz.
price:	$91.50	$98.00	$105.00
(½ zipper)			
total weight:	4 lb. 4 oz.	4 lb. 10 oz.	5 lb. 0 oz.
price:	$95.00	$101.50	$108.00
(full zipper)			
total weight:	4 lb. 8 oz.	4 lb. 14 oz.	5 lb. 4 oz.
price:	$97.50	$104.50	$110.50

Chamois

The CHAMOIS BAG is named for its close association with the lovely and nimble animal of the Alps and Pyrenees. Light, well-proportioned and ultimately efficient for its use, it bears good reasons for its name. The CHAMOIS is ideal for the lightweight specialist who carries the absolute minimum of gear. The very tapered shape of this bag follows body contours closely to yield the smallest insulating package possible. These advantages result: the body fills the inside of the bag almost completely so there is no excess space to be heated; the outside surface area, which loses heat to the air, is minimal; the bag is extremely light and compact. The CHAMOIS is 24'' wide at the shoulders and 12'' at the feet. These dimensions have proven adequate for people accustomed to sound sleep in narrow spaces. The fabric used throughout the CHAMOIS, and in all NORTH FACE sleeping bags, is an exceptionally tough, completely down-proof Ripstop nylon weighing 1.9 oz. per square yard. This material has a tear strength of 15 pounds, or approximately three times that of an equal weight nylon fabric without the Ripstop cross-weave. The shell is cut with a 2'' radial differential which allows the 1½ to 1¾ pounds of WHITE NORTHERN GOOSE DOWN to expand to a total loft of 6''. 6'' wide slant wall tubes and a 2'' block baffle at each side control the down completely to maintain even loft. The baffles in all NORTH FACE sleeping bags are constructed of 1 oz. nylon mosquito mesh which is lighter than woven fabric yet closed enough for baffling. The CHAMOIS is available with no zipper, a 32'' zipper, or a right or left opening 69'' separating zipper which may be joined to another bag. All zippers are #7 nylon and fully covered with an offset 4'' down filled flap. Although it has been used successfully below 0°F., we suggest that for most people the CHAMOIS should be comfortable at 15°F. The CHAMOIS comes packed in a waterproof 6'' x 18'' stuff sack.

colors: We have BLUE in stock; GREEN, YELLOW, and ORANGE are available on special request (allow 3 weeks).

comfort range: To 15°F.

loft: 6''

down type: White northern goose down

fabric: 1.9 oz. Ripstop

construction: 6'' slant wall tubes

size:	Regular (to 5' 9'')	Large (to 6' 2'')	Extra Large (to 6' 9'')
down content: (no zipper)	24 oz.	27 oz.	29 oz.
total weight:	2 lb. 8 oz.	2 lb. 10 oz.	2 lb. 13 oz.
price:	$63.50	$66.50	$70.00
(½ zipper)			
total weight:	2 lb. 11 oz.	2 lb. 13 oz.	3 lb. 0 oz.
price:	$67.50	$70.50	$74.00
(full zipper)			
total weight:	2 lb. 14 oz.	3 lb. 0 oz.	3 lb. 3 oz.
price:	$70.00	$73.00	$76.50

Frame sack

The BACKPACKER FRAME SACK takes full advantage of the contoured frame's capacity to carry a large load comfortably and efficiently. No one should have trouble getting a two week mountaineering load in the BACKPACKER. This sack extends over the top of the MOUNTAIN MASTER FRAME and thus adds 4'' in height; another 2'' is gained at the bottom. Although the BACKPACKER SACK is only 9'' thick, its extra length results in almost twice the capacity of the MOUNTAIN MASTER STANDARD. The 24'' height of the sack is divided nearly in two by a sewn in floor, with access to the lower compartment by a #5 nylon zipper horizontal across the bag. This partition prevents sag, makes packing neater, and allows heavy items to be carried above the partition. The top of the BACKPACKER SACK is closed by a nylon draw cord so a light load can be held close to the frame. A zippered map pocket is attached to the extra long top flap. One 10'' high zippered pocket on each side of the sack provides plenty of room for small extras that are needed during the day. The pack is made of 8 oz. waterproof nylon duck in ORANGE or TURF BROWN. One size will fit all sizes of MOUNTAIN MASTER and most other frames. Please specify what frame will be used.

weight: 14 oz.
price: $19.00

Standard

This sack (not illustrated) is designed to hold all the equipment necessary for a week long backpacking trip in the Sierra Nevada. The entire body of the MOUNTAIN MASTER SACK is made from one piece of 6.3 oz. nylon duck wrapped from top to bottom and back to the top with no intervening seams. An aluminum tubular bar holds the top of the sack open for easy packing. The sack is undivided inside to facilitate packing a moderate load. The main bag is surrounded on both sides by four zippered pockets which are ideal for storing quickly needed items such as canteen and first aid kit. A map pocket on the back is protected from the weather by the main cover flap. The bag is attached to the frame with four clevis pins on each side through brass grommets. This attachment is always secure yet easily removed.

weight: 36 oz.
price: $41.50 (with frame)

Goggles

For the first time a well-designed glacier goggle is available in this country. Through our search in Europe we found an optical craftsman, and mountaineer as well, who makes the finest climbing glasses in France. These goggles have optically perfect round lenses of ground brown glass held in light metal frames. Leather side blinders and a snap-on nose piece protect the eyes from stray glare. Bendable bows with a rubber covering position the glasses securely and comfortably. Unbreakable case is included.

price: $9.50

Down hat

Can you suggest a more thoughtful use for one ounce of down? The new DOWN HAT was conceived by a veteran climber to control the most heat-sensitive part of the body. Like a balaclava, the DOWN HAT can be worn high as a toque or pulled down over the entire face. Unlike a balaclava, the DOWN HAT weighs only 2½ oz. and stuffs to the size of a tangerine. One size will fit anyone, with a choice of BLUE, GREEN, YELLOW, or ORANGE.

price: $7.00

Down mitts

Though rarely needed, DOWN MITTS are a luxury no expeditionary mountaineer would soon forgo. These DOWN MITTS are made as a companion to our EXPEDITION PARKA and their long gauntlets overlap the parka's sleeves to seal out drafts. 1 oz. of down expands each mitt to an over-all thickness of 3½''. The leather palm area protects the 1.9 oz. Ripstop from heavy wear. For delicate chores the hand may be inserted between the leather and its ensolite backing. Please send an outline of your hand.

weight: 6 oz.
price: $17.00

Down booties

When wet, frozen boots are removed at the end of the day, a pair of DOWN BOOTIES will let one move comfortably around the campsite. Their double layer 1/8'' ensolite soles are covered outside with a tough, waterproof fabric. The 8'' top snaps snugly around the ankle to hold up the thick, warm cocoon formed by 1 oz. of down. The Ripstop nylon shell comes in BLUE or YELLOW.

size (corresponds to socks):	Small	Medium	Large
	7–9	10–11	12–13

weight: 5 oz.
price: $7.50

LINES
Pieces where illustrations are the primary form of expression.

Contributions by Avery Trufelman (p. 287), Jaimus Tailor (p. 294), Dr Rachel S. Gross (p. 295), Brittany Bosco (p. 298), Nicole McLaughlin (p. 299), Thibo Denis (p. 302), Nick and Willa Martire (p. 303), Yoon Ahn (p. 311), Shigeru Kaneko (p. 315), Nova / Marianna Mukhametzyanova (p. 321), Solene Roge (p. 325)

Painting and illustration are ancient forms of expression in which the composition, content, focal point, perspective and subject matter are limited only by the artist's imagination. With some forty thousand years of history, these mediums are almost as fundamental to the human experience as nature itself, which uncoincidentally is a dominant motif in such works. Indeed, nature features prominently on the covers of many outdoor-oriented catalogues and magazines, including depictions of mountains, forests, lakes and wildlife. Cover paintings and illustrations also highlight gear, either being used by people in the context of the natural environment or standing alone. These works can take a variety of forms, from pen and ink and coloured pencil drawings to watercolours and oil paintings. Some are realistic, others are more abstract, but all are done with care in the artist's individual style.

By taking advantage of the trends and technologies of the time, artists of this medium were able to produce contemporary works that appealed to an evolving audience. The earliest covers were more purely illustrative in nature, with minimal design beyond the painting or drawing itself. Take the early L. L. Bean catalogues, for instance, which featured fairly realistic oil paintings of various outdoor scenes and little else. Helping to define the company's aesthetic — showing the ability of a distinctive illustration style to create a strong and instantly recognizable brand identity — L. L. Bean sustained the style well into the 1980s, even as other cover designs evolved. By the 1950s, more 'cartoony' illustrations became popular, as seen on the orange *Summit* cover of 1958 (see p. 304), which places it very much in that decade. By the turn of the twenty-first century, artwork composed on the computer or paired with computer-generated elements is common, as evidenced by the 2000 Lowa and Osprey covers (see p. 298 and p. 306). While the styles change, the purpose is still the same: to catch the viewer's eye with beautiful, creative and playful paintings and illustrations that prompt them to look beyond the cover.

Carikit		YEAR:	1972
DIMS:	28 × 22 CM (11 × 8.75 IN)	TEAM:	UNKNOWN
PAGES:	14		

KARHU MOVES 1980
Karhu Cross Country Skis, Boots, Poles, Bindings

Karhu	
YEAR:	1980
DIMS:	22 × 29 CM
	8.75 × 11.25 IN
PAGES:	17
TEAM:	UNKNOWN

Marmot	
YEAR:	2002
DIMS:	29 × 20 CM
	11.25 × 7.75 IN
PAGES:	80
TEAM:	GALEN ROWELL

283

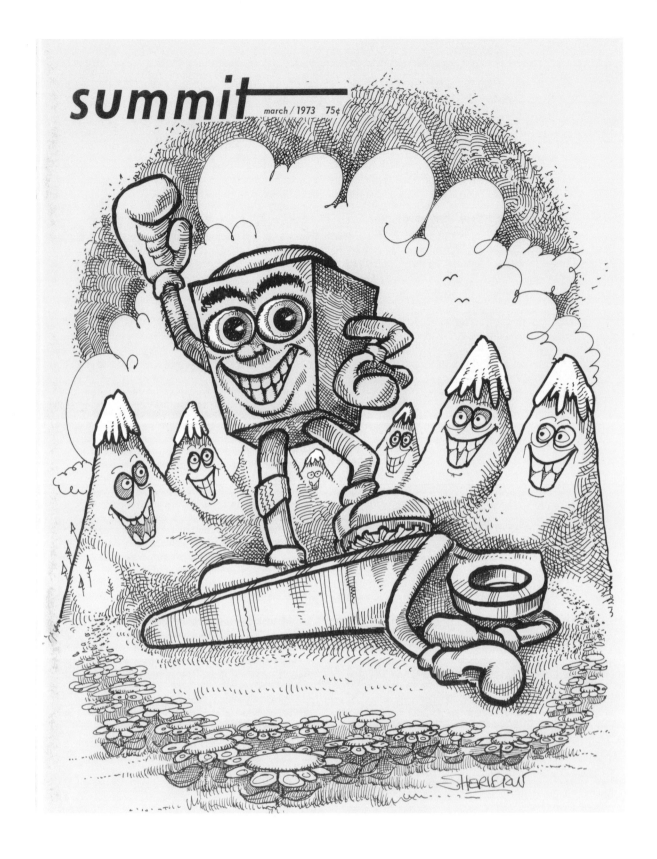

summit

march / 1973 75¢

Summit		YEAR:	1973	For decades, pitons — steel spikes hammered into rock — were choice climbing protection. But in the 1960s, 'clean-climbing' advocates pushed for less damaging devices such as chocks or hexes. Here, a climbing chock stands triumphant over the vanquished piton.
DIMS:	28 × 22 CM	PAGES:	44	
	11 × 8.75 IN	TEAM:	SHERIDAN ANDERSON	

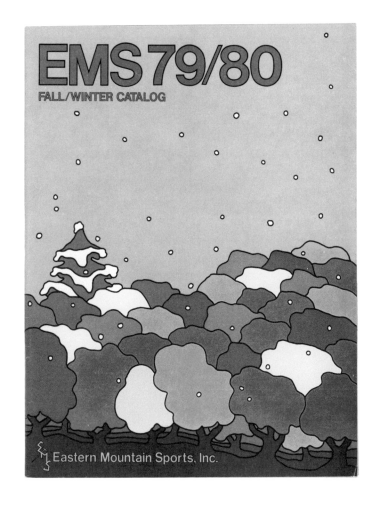

Eastern Mountain Sports	
YEAR:	1979
DIMS:	28 × 22 CM
	11 × 8.75 IN
PAGES:	103
TEAM:	UNKNOWN

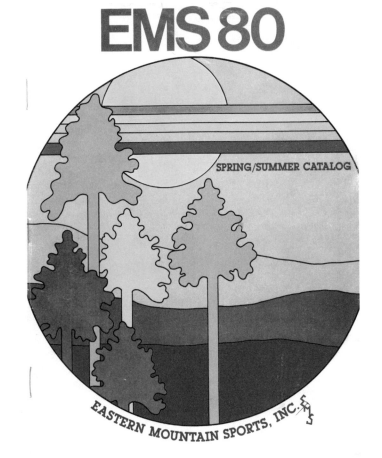

Eastern Mountain Sports	
YEAR:	1980
DIMS:	28 × 22 CM
	11 × 8.75 IN
PAGES:	97
TEAM:	UNKNOWN

Radial Sleeve™
design

Waterproof / breathable
Omni-Tech™ fabric

High-loft
insulation

Tasty price appeals
to consumers

Radial wing
design

Water repellent
feathers

Down
insulation

Tasty in
orange
marmalade
glaze

Fig 1

Fig 2

AVERY TRUFELMAN
Podcaster and radio producer

After decades of assuring city-dwellers and indoor creatures that camping and hiking are for everyone, Columbia brings the message full circle with an ad about *huntin'*! Here is where so much of the outdoor industry began: as a way for manly hunters to kit up. But, now, hunting gear is presented with a wink, modelled by Gertrude Boyle, the daughter of the founder of Columbia, who took over the company in 1970. Gert looks more ready to lead a board meeting or referee a tennis match than to kill a duck, but the message is clear. This practical jacket also looks great, no matter what.

This is where I see the latent seeds of the high-fashion 'gorpcore' movement yet to come; a fashion movement that claims that nature is everywhere. It's in the cities, it's in the suburbs. It's when you go out to go to the corner shop. One has every right to be suited against the elements, even when not on the trail, because our human environment is not something separate from some idea of 'pristine' 'untouched' nature.

The cherry on top of this ad, for me, is that the exact pattern of this iconic Columbia jacket would be the very kind that would become popular — this time, in the 90s — with hip-hop musicians like Boot Camp Clik. Black rappers and musicians in New York City carried brands like Columbia, Carhartt and The North Face out of the supply store and into the music video, wearing, say, ski goggles — just for style, because they'd never hit the slope in their life. Gear became streetwear and, recontextualized, helped to reimagine what constitutes 'outside'. To this day, all around me, on the streets of Brooklyn, I can go outside my apartment and see almost the exact same Columbia jacket.

Columbia Sportswear Co., 1992, 28 × 22 cm (11 × 8.75 in), 23 pages

Voilé	
YEAR:	UNKNOWN
DIMS:	11 × 17 CM
	4.25 × 6.75 IN
PAGES:	1
TEAM:	UNKNOWN

Voilé	
YEAR:	UNKNOWN
DIMS:	22 × 15 CM
	8.75 × 5.75 IN
PAGES:	30
TEAM:	KAY NIELSEN

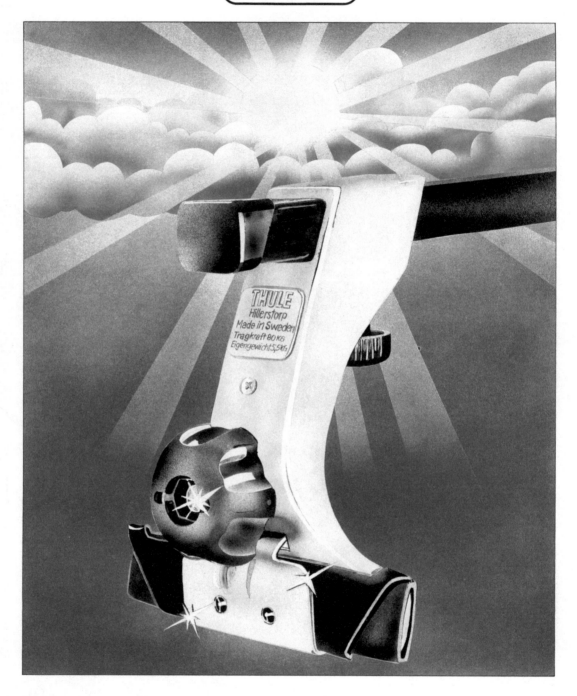

Thule		YEAR:	UNKNOWN
DIMS:	28 × 21 CM (11 × 8.25 IN)	TEAM:	UNKNOWN
PAGES:	15		

WILDERNESS EXPERIENCE, UNKNOWN

WILDERNESS EXPERIENCE, UNKNOWN

WOOLRICH, 1977

WOOLRICH, 1986

WENZEL, 1966

WENZEL, UNKNOWN

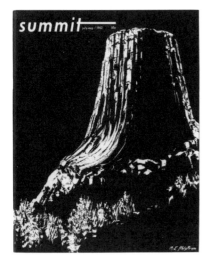

SUMMIT, 1963

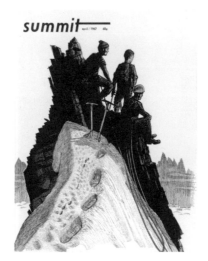

SUMMIT, 1967

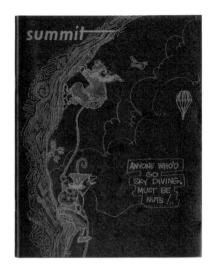

SUMMIT, 1968

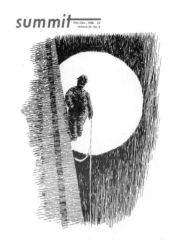

SUMMIT, 1986

MOUNTAIN GAZETTE, 2003

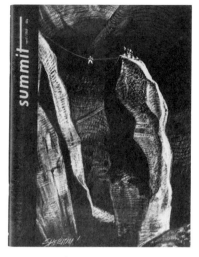

SUMMIT, 1969

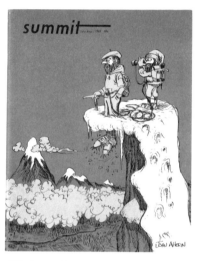

SUMMIT, 1969

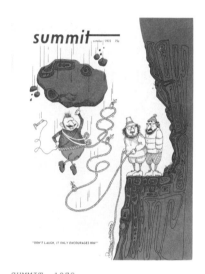

SUMMIT, 1972

EASTERN MOUNTAIN SPORTS, 1978

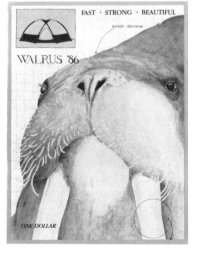

WALRUS, 1986

OSPREY, 1985

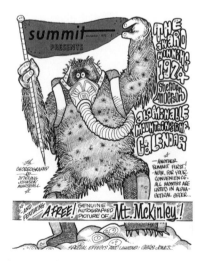

SUMMIT, 1973

291

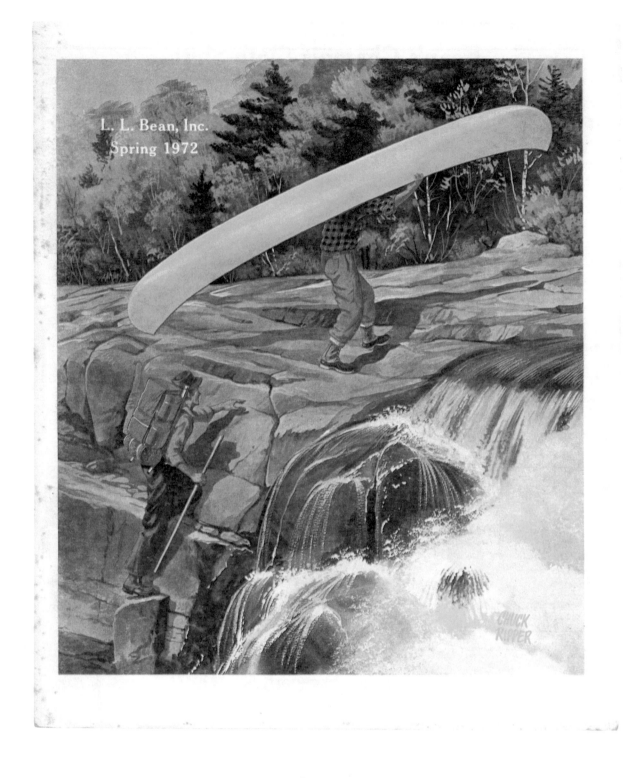

L. L. Bean, Inc.
Spring 1972

L. L. Bean		YEAR:	1972
DIMS:	23 × 20 CM (9 × 7.75 IN)	TEAM:	CHUCK RIPPER
PAGES:	120		

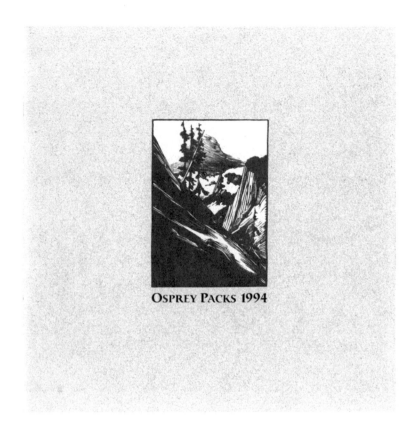

OSPREY PACKS 1994

Osprey	
YEAR:	1994
DIMS:	22 × 22 CM
	8.75 × 8.75 IN
PAGES:	24
TEAM:	RICHARDSON ROME

Osprey	
YEAR:	1995
DIMS:	22 × 22 CM
	8.75 × 8.75 IN
PAGES:	24
TEAM:	RICHARDSON ROME

JAIMUS TAILOR
Designer and founder

The Cannondale 79 cover sparked my interest on multiple levels, the first being my love for retro Cannondale bike frames from the 90s and early 2000s. Their vivid colours and bold branding feel timeless in a carefree sense; this design language and boundary-pushing frame geometry can be seen in early models such as the Delta V series and their Lefty fork to name a few.

When I was young, my dad purchased a Cannondale F700 bike from a local car-boot sale, which was my gateway into the Cannondale rabbit hole that I still find myself in fifteen years later. The bike was in a signature blue-and-yellow Martyn Ashton colourway and at the time, I remember calling it the 'IKEA' bike. We held onto that bike for years, until I was big enough to fit the size-large frame. I would take it out on a ride around my local block with none of the brakes working and my feet barely touching the ground.

When I first saw this cover, I couldn't quite register what I was looking at. Is it a painting? Is it an opaque watercolour? The cover clearly depicts the Cannondale Railway station, but it was only when I paused for a moment to really observe that I noticed it was a scanned appliqué quilt. The varied fabric textures and topstitching grabbed my interest, the shadows and stitching creating a sense of depth in the sky. Similarly, with the trees and foliage being created from a change of green tones and patterns, each element feeling very tactile and 'real'. The wide range of fabrics gives me the sense that each piece was cut from a garment; although this can't be confirmed, it's not uncommon for scrap fabrics to be used for appliqué.

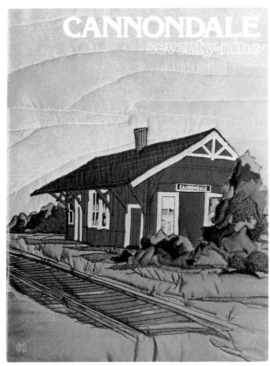

Cannondale, 1979, 28 × 22 cm (11 × 8.75 in), 18 pages
Team: John Conboy

DR RACHEL S. GROSS
Outdoor historian and author

How did outdoor customers know where to buy reliable clothing and equipment? In the postwar period, small mountain shops such as Gerry Cunningham's positioned themselves as the source of specialized equipment by emphasizing the outdoor expertise of the gearmakers. Cunningham was a mountaineer, these catalogue covers explained, which is why customers ought to trust him. The hand-drawn image offered another reason for curious shoppers to put their faith in Cunningham. The positioning of the Gerry Mountaineering Equipment shopfront on the slope of a mountainside, with a line of trees in the foreground and a grand view of the peaks beyond, was wholly imagined. Visitors went to the Boulder, Colorado location, not to a mountain meadow, to buy their jackets and tents. Nonetheless, intimating that Gerry Mountaineering was based at Cunningham's home in Ward in the hills above Boulder showed that the gear was truly of the mountains. In the decade that followed Gerry Mountaineering Equipment catalogues used far flashier images on the cover, such as one that featured models in brightly coloured down jackets. The success of these images was predicated on the reputation that Gerry Cunningham built as an outdoor expert and purveyor of specialized gear for the outdoors.

Gerry, 1955–56, 22 × 15 cm (8.75 × 5.75 in), 24 pages

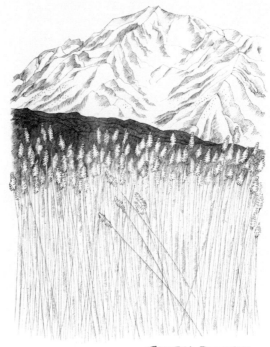

SIERRA DESIGNS
Fall/Winter 1975

Sierra Designs	
YEAR:	1975
DIMS:	28 × 18 CM
	11 × 7 IN
PAGES:	31
TEAM:	EARL THOLLANDER

Mountain Safety Research (MSR)	
YEAR:	UNKNOWN
DIMS:	22 × 15 CM
	8.75 × 5.75 IN
PAGES:	6
TEAM:	UNKNOWN

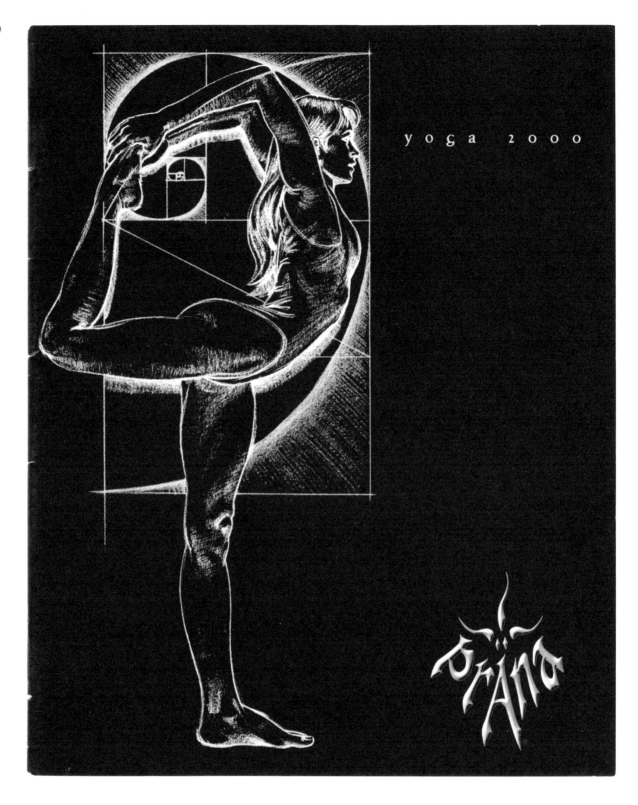

yoga 2000

prAna

Prana		YEAR:	2000	PAGES:	14	Prana co-founder Beaver Theodosakis was inspired by György Doczi's work on the golden ratio — an expression of order and beauty in nature. This yoga pose becomes a golden spiral, widening by a factor of phi (1.618) at each quarter turn.
DIMS:	21 × 17 CM	TEAM:	PHIL ROBERTS, MJ HILL, BROUDY, MOTT, WORRALL, THORNBURG			
	8.25 × 6.75 IN					

BRITTANY BOSCO
Multidisciplinary artist and founder

This Lowa cover from 2000 spoke to me for many reasons. From the colour story to the font choice, the layout and punchy tagline, it represented the perfect piece for me.

At first glance, I immediately thought of the earlier Apple computer and Gap commercials from the 90s and 00s. This specific blue pulls from the softcore, Y2K and early internet craze. It evokes a sense of nostalgia, discovery and exploration into what the new world may look and feel like. The tagline — 'Step by step into the new millennium' — reads like a call-to-action for all walks of life to embrace the experiences that connect us together. I could almost hear songs of the era playing in the background while looking at this ad: 'Virtual Insanity' by Jamiroquai, 'Bitter-sweet Symphony' by The Verve and 'Lady' by Lenny Kravitz. Space and IBM Mono fonts are very reflective of where we were in technology and the dial-up era at the time — what we call 'Slow Tech' today. The shifting pastel gradient behind the shoes themselves, meanwhile, echoes the youthfulness and artistic freedom of the 90s and early 00s. It's a freedom and playfulness that we are still chasing.

Lowa, 2000, 30 × 22 cm (11.75 × 8.75 in), 47 pages

NICOLE MCLAUGHLIN
Designer

Campmor is an iconic outdoor re-
tailer based in New Jersey. Since
opening in the 1970s, Campmor has
established itself as the shop for
those looking for ideal outdoor
gear. Being from New Jersey myself,
and having bought my Columbia ski
jackets and other winter kit there
with my family, I was naturally
drawn to the Campmor catalogue.

My love for the outdoors
started in New Jersey, where I
spent summers going to the Jersey
shore and winters sledding and
skiing up at Mountain Creek in Ver-
non. This relationship with nature
was crucial to my development as
a person and designer. Many of the
references in my work are inspired
by the childhood memories spent
in the great outdoors.

A few years ago, I went to
Campmor and spotted a DIY hiking
backpack hanging on the wall. I
noticed it because it was made
entirely of AstroTurf. I asked if
I could get information on it and
whether they'd let me purchase it.
The manager/owner said it had been
there for many years — a bit of
a relic — but he was happy to sell
me the piece! It's now one of my
most prized possessions: a piece
of Campmor history resides in my
studio, and it's a great reminder
of where I've come from and how
far I want to go.

Campmor, 1986, 28 × 21 cm (11 × 8.25 in), 71 pages

Summit		YEAR:	1970	Look closely and you'll see that the rock ledge is offering more than just an anchor point for the rope. Illustrator Sheridan Anderson snuck in these tongue-in-cheek elements to prank more strait-laced *Summit* founders Jean Crenshaw and Helen Kilness.
DIMS:	28 × 22 CM	PAGES:	44	
	11 × 8.75 IN	TEAM:	SHERIDAN ANDERSON	

Mountain Gazette	
YEAR:	1975
DIMS:	38 × 26 CM
	15 × 10.25 IN
PAGES:	36
TEAM:	TOM BENTON

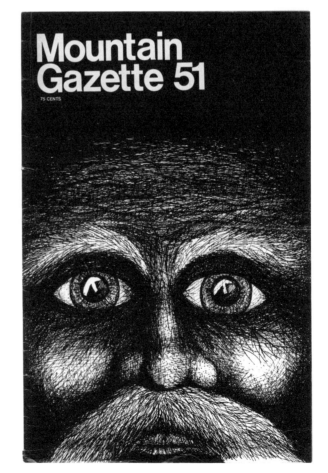

Mountain Gazette	
YEAR:	1976
DIMS:	38 × 26 CM
	15 × 10.26 IN
PAGES:	36
TEAM:	MARION REYNOLDS

THIBO DENIS
Footwear designer

It was very easy for me to select this image, from the Dana Design cover of 1999. There is an obvious reference that comes straight to my mind. The silhouette, running with a backpack, shorts and mountain shoes, depicted in red against a black background, reminds me of the famous 'Jumpman' — the Nike logo used to promote the iconic Air Jordan.

The design is radical and strong; the image is minimalistic but full of energy. There's no snow, no mountains, no blue sky … it's all about the graphism. We can feel the power of the brand just by the logo — no frills. This striking and confident image, boldly forgoing the use of nature at all, takes the outdoor brand to another level.

Dana Design, 1999, 29 × 22 cm (11.25 × 8.75 in), 30 pages
Team: Palmquist & Palmquist, Bozeman, Montana

NICK AND WILLA MARTIRE
Co-founders

Trails are the locus of movement and imagination. When these are in perfect harmony, we achieve a certain transcendent flow. It is powerful and potent. We feel we can keep going forever and the horizons are limitless. The sky melts into the earth and new paths unfurl before us. In this space, running feels more like dancing: biomechanics become subconscious, the head meets the heart. We find new rhythms, suspended and grounded all at once — our imaginations are set free while our bodies are more connected to the earth than ever. We see the embodiment of this sensation in this image: the flow-state trail goddess. Movement through nature is not some masculine pursuit predicated on conquering or defeating. Trail running is moving mindfully through the natural world, finding harmony with Mother Nature, achieving this flow-state in order to blaze new paths that will continue to lead us towards a better future as we expand the horizons of our minds.

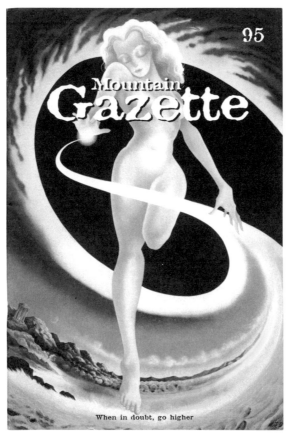

Mountain Gazette, 2003, 38 × 26 cm (15 × 10.25 in), 50 pages
Team: Neil Passey

Summit	
YEAR:	1958
DIMS:	27 × 21 CM
	10.75 × 8.25 IN
PAGES:	24
TEAM:	KEITH BRIGHT

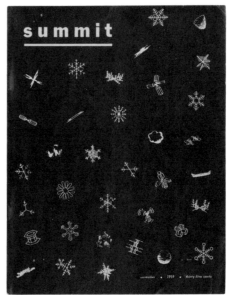

Summit	
YEAR:	1959
DIMS:	27 × 21 CM
	10.75 × 8.25 IN
PAGES:	24
TEAM:	KEITH BRIGHT

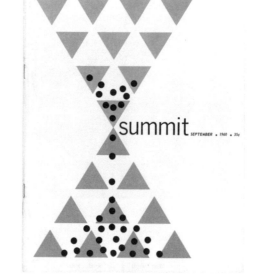

304

Summit	
YEAR:	1960
DIMS:	27 × 22 CM
	10.75 × 8.75 IN
PAGES:	24
TEAM:	UNKNOWN

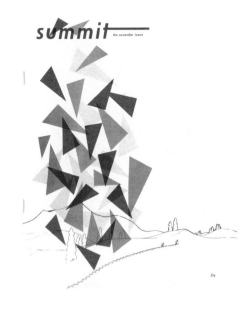

Summit	
YEAR:	1961
DIMS:	28 × 22 CM
	11 × 8.75 IN
PAGES:	24
TEAM:	KEITH BRIGHT

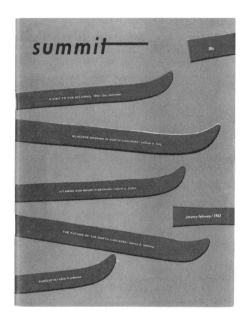

Summit	
YEAR:	1963
DIMS:	27 × 22 CM
	10.75 × 8.75 IN
PAGES:	40
TEAM:	UNKNOWN

Summit	
YEAR:	1963
DIMS:	27 × 22 CM
	10.75 × 8.75 IN
PAGES:	40
TEAM:	UNKNOWN

WILDERNESS EXPERIENCE, UNKNOWN

OSPREY, 1999

ROSSIGNOL, 1981

OSPREY, 2000

KELTY, 1980

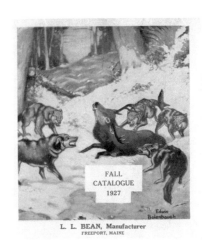

L. L. BEAN, 1927

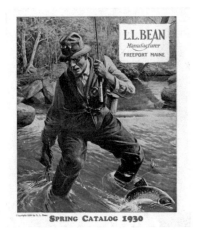

L. L. BEAN, 1930

L. L. BEAN, 1970

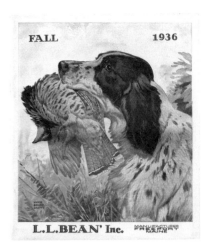

L. L. BEAN, 1936

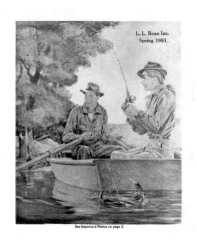

L. L. BEAN, 1951

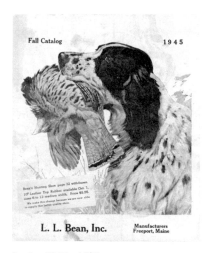

L. L. BEAN, 1945

MOUNTAIN HARDWEAR, 1994

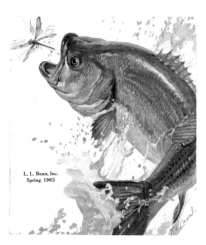

L. L. BEAN, 1963

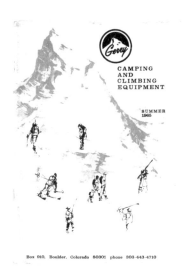

GERRY, 1965

GERRY, 1966

GERRY, 1972

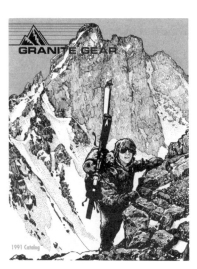

GRANITE GEAR, 1991

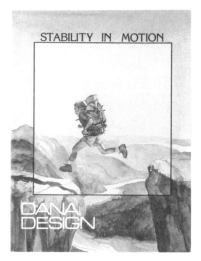

DANA DESIGN, UNKNOWN

307

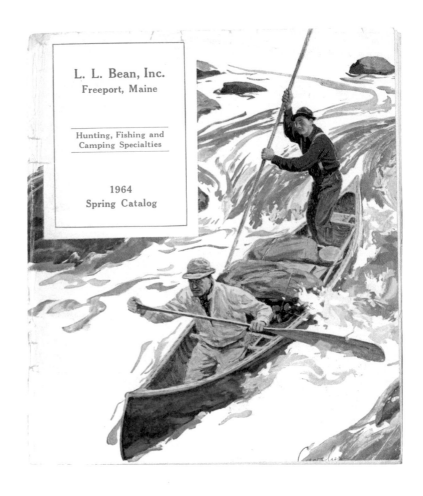

L. L. Bean	
YEAR:	1964
DIMS:	22 × 20 CM
	8.75 × 7.75 IN
PAGES:	100
TEAM:	RJ CAVALIERE

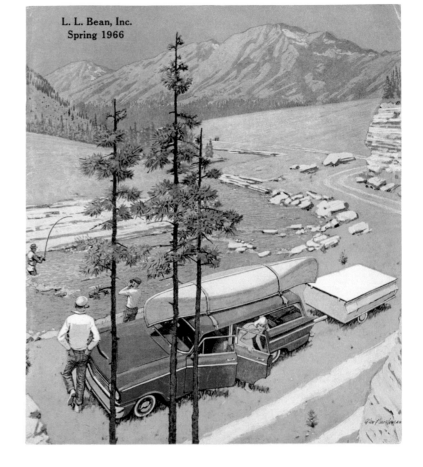

L. L. Bean	
YEAR:	1966
DIMS:	22 × 20 CM
	8.75 × 7.75 IN
PAGES:	100
TEAM:	UNKNOWN

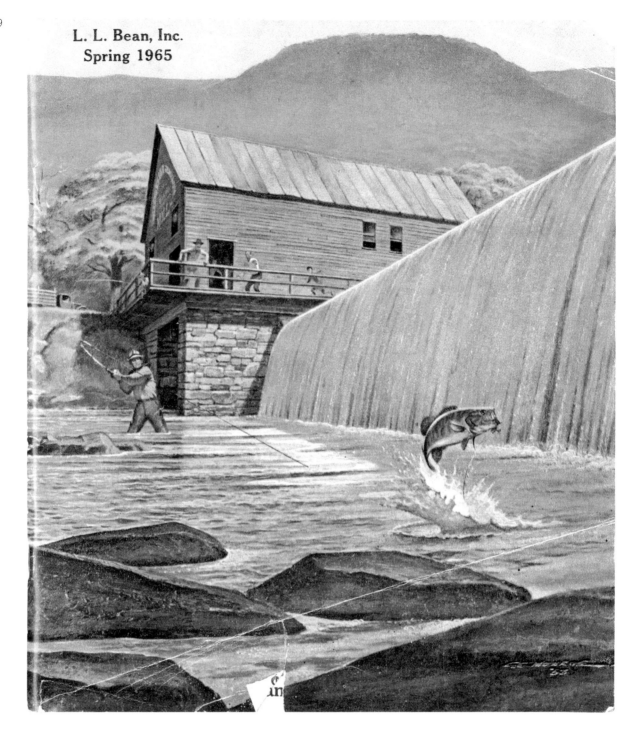

L. L. Bean, Inc.
Spring 1965

L. L. Bean			YEAR:	1965
DIMS:	22 × 20 CM (8.75 × 7.75 IN)		TEAM:	MONROE
PAGES:	100			

L. L. Bean, Inc. Fall 1965

YOON AHN
Graphic and fashion designer

I finally made it out to Yellowstone in the late spring of 2023. The road trip kicked off in Montana, driving through Yellowstone and then Idaho, ending in Jackson Hole, Wyoming.

Winter was so severe that most of the places were still covered in more than thirty centimetres (one foot) of snow, but in patches, we could catch new buds of grass emerging. While driving through the massive fields of Idaho, dead deer carcasses started to pile up on the side of the road. At first, it was a very frightening sight — the rural drive with endless decaying bodies seemed apocalyptic. This continued until we reached Wyoming. Later, I discovered that the past year's winter was so cold that it wiped out 70 per cent of the deer population, lost to hunger and chronic wasting disease. However, the locals were optimistic that the deer would bounce back, and they'd be reducing their hunting activities to help.

Driving through kilometres and kilometres of Teton, Gros Ventre and Snake River Ranges, it dawned on me that nature always takes its course. Mother Nature has an innate ability to rebound with the spring of life, even after a little setback. She is always finding ways to adapt to new circumstances, providing a model for hope in her regeneration.

I find the same message in this image. White — the harsh snow of winter — dominates the picture, and there are broad stubs of felled trees. But looking directly out from the frame are also strong, proud deer, bathed in hopeful sunlight. After the storm, wildlife returns to its habitat, plantlife sprouts after the frozen ground thaws, survivors mate and give birth to new life, which grows before autumn comes, until the winter cycle repeats without questioning. This is what I learned during my outdoor trip to Yellowstone. If Mother Nature can grow, regrow and regenerate, so must I.

L. L. Bean, 1965, 22 × 20 cm (8.75 × 7.75 in), 100 pages

L. L. Bean	
YEAR:	1932
DIMS:	23 × 20 CM
	9 × 7.75 IN
PAGES:	28
TEAM:	UNKNOWN

L. L. Bean	
YEAR:	1938
DIMS:	23 × 20 CM
	9 × 7.75 IN
PAGES:	68
TEAM:	UNKNOWN

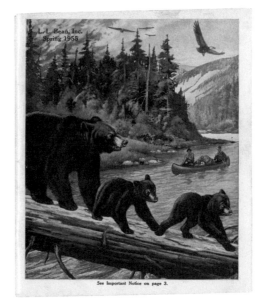

L. L. Bean	
YEAR:	1955
DIMS:	23 × 20 CM
	9 × 7.75 IN
PAGES:	104
TEAM:	EDWIN LEE HUFF

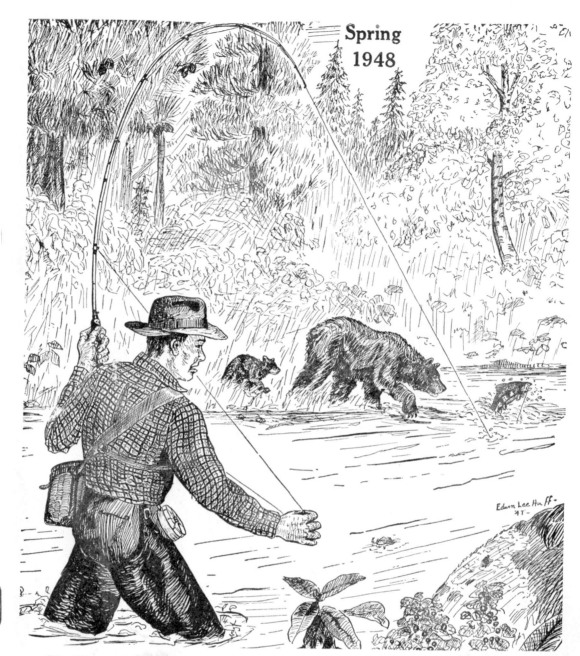

L. L. Bean			YEAR:	1948
DIMS:	23 × 20 CM (9 × 7.75 IN)		TEAM:	EDWIN LEE HUFF
PAGES:	80			

Chums		YEAR:	2003	The Chums mascot, often misidentified as a penguin, is actually a red-footed booby. 'The fastest way to anger a Booby is to mistake him for one of those sea-sailing, ground-bound bumpkins known as a penguin', warns a passage from one catalogue.
DIMS:	28 × 22 CM	PAGES:	27	
	11 × 8.75 IN	TEAM:	UNKNOWN	

SHIGERU KANEKO
Chief buyer

I chose this Sierra Designs cover because it represents an outdoor style that is uniquely American. The practical objects it depicts are designated for 'backpacking and wilderness camping' — a form of travel that originated in the 1960s in response to the Vietnam War and environmental degradation, reflecting a desire to reconnect with nature and, ultimately, to be free. I can almost see a backpacker journeying across the United States in this kit, an image that is particularly appealing to me.

Sierra Designs created 60/40 fabrics, which became a staple of US outdoor wear — lightweight and breathable, made of 60 per cent cotton and 40 per cent polyester — and also introduced the term 'mountain parka' to the world. I selected this image not just for its aesthetic value, but to pay homage to the company's contribution to the industry.

Sierra Designs, year unknown, 24 × 11 cm (9.5 × 4.25 in), 10 pages
Team: Linda Bennett

Black Diamond Equipment	
YEAR:	1994
DIMS:	25 × 16 CM
	9.75 × 6.25 IN
PAGES:	51
TEAM:	ACE KVALE

Blacks	
YEAR:	1970
DIMS:	24 × 24 CM
	9.5 × 9.5 IN
PAGES:	17
TEAM:	UNKNOWN

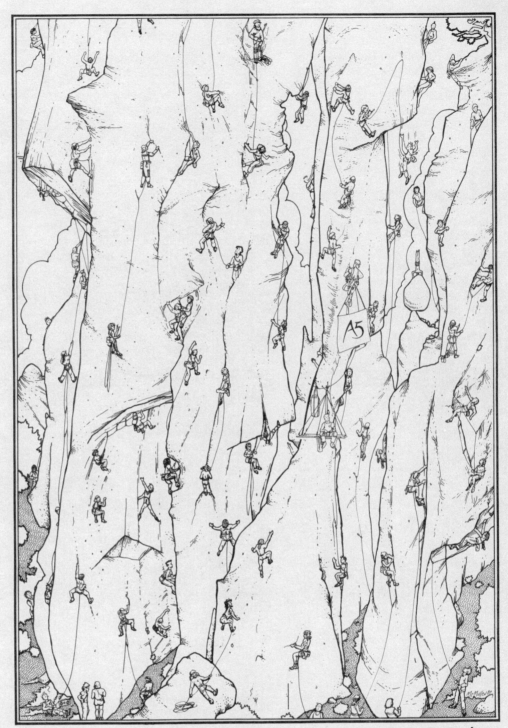

CATALOG la

A5 Adventures		YEAR:	1988
DIMS:	28 × 22 CM (11 × 8.75 IN)	TEAM:	J. MCMULLEN
PAGES:	20		

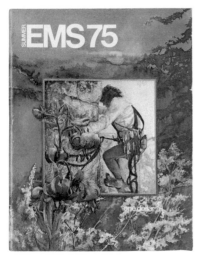

EASTERN MOUNTAIN SPORTS, 1975

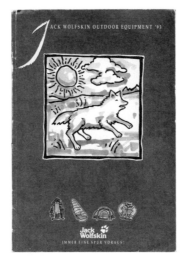

JACK WOLFSKIN OUTDOOR EQUIPMENT,
1993

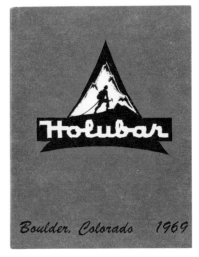

HOLUBAR, 1969

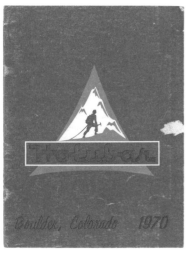

HOLUBAR, 1970

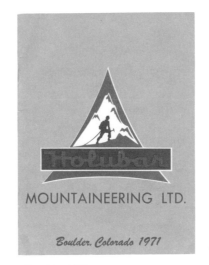

HOLUBAR, 1971

IBEX, 2000

COLEMAN, 1964

COLEMAN, 1969

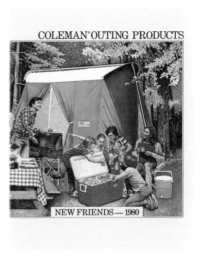

COLEMAN, 1980

COLEMAN, UNKNOWN

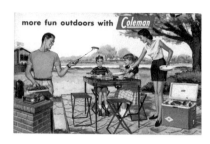

COLEMAN, UNKNOWN

COLEMAN, 1984

COLUMBIA SPORTSWEAR CO., 1987

COLUMBIA SPORTSWEAR CO., 1988

CHUMS, 2002

EASTERN MOUNTAIN SPORTS, 1979

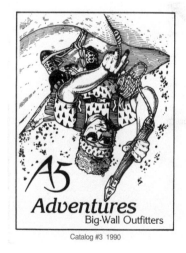

A5 ADVENTURES, 1990

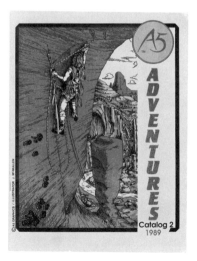

A5 ADVENTURES, 1989

NOVA / MARIANNA MUKHAMETZYANOVA
Senior brand creative

I love the simplicity of this image. I initially gravitated to it because of the vivid colours — the different blues, the moonlight on the water's surface, the little campfire. It looks like a good and relaxing time.

Considering the illustration dates from 1938, the person observing and painting the scene probably didn't have the same distractions that we have today. No photos for socials. No Arc'teryx jacket or Salomons on their feet. An interesting book instead of podcasts advocating cold showers. Seeing a possum or a beaver and not feeling the need to reach for a phone. Basically, a proper camping trip before gorpcore and social media became a thing.

I'm a big fan of the game *Animal Crossing* and, more recently, *LEGO Fortnite*. On *Animal Crossing*, you can construct a campsite wherever you like so that new visitors can come to your town. I put mine near the ocean on the edge of a cliff and planted a few trees all around it. I also placed a small lantern, a sleeping bag and a bike nearby (even though I can't ride a bike). And *LEGO Fortnite* is one big camping trip. You run around with fire torches, cook food on a grill and pick berries for nutrition.

Come summer, I'd like to sit in this exact spot — with a sun-dried salty fish (called 'taranka' in Ukrainian) in one hand and a cold beer in the other.

Blacks, 1938, 22 × 14 cm (8.75 × 5.5 in), 88 pages

SHELTER SYSTEMS
PO BOX 67
APTOS, CAL
95003

To:

322

Shelter Systems		YEAR:	1978	Bob Gillis founded Shelter Systems in 1976 with a deep
DIMS:	15 × 22 CM	PAGES:	6	commitment to developing simple, low-cost structures. He was so dedicated to his craft that he actually lived in tents of his own creation from 1968 to 1992.
	5.75 × 8.75 IN	TEAM:	JEFF GUNN	

Sierra Designs	
YEAR:	1985
DIMS:	28 × 22 CM
	11 × 8.75 IN
PAGES:	10
TEAM:	UNKNOWN

BINDING BUYING / MAINTENANCE
HOW TO USE BINDINGS
THOUGHTS ON BINDINGS

S Sponsored by Salomon as a Public Service

Salomon	
YEAR:	UNKNOWN
DIMS:	23 × 11 CM
	9 × 4.25 IN
PAGES:	7
TEAM:	UNKNOWN

summit

october / 1968 60¢

BAM

SOLENE ROGE
Magazine editor-in-chief

What's this? The bold design could be the cover of an underground fanzine or an album from some 70s punk band, but it turns out it's a climbing magazine — one of the first and most influential of its kind.

Summit has always impressed and inspired me with its editorial and design choices, both in my personal and professional life, and this cover is a perfect example of why. One recognizes an issue of *Summit* at first glance — remember those Warhol-esque patchworks of gear (p. 117) or that one photo of a dog wearing a helmet (p. 170)? Cover after cover, they don't feature the impressive mountains or crazy climbing performances you might expect — and I would dare to suggest that having two women as editors-in-chief might help explain why. Their magazine was as bold as they were. True mavericks, shar-

ing what was once a counterculture and raising questions that we are only starting to tackle properly today, such as what role sexism plays in the outdoors or ecology. They highlighted legends as much as anonymous climbers; grand exploits as much as your last Sunday climb.

There was something socially important in *Summit*. It was a magazine constantly looking ahead: liberating, inviting and profoundly independent. And always surprising. Ultimately, there is not just one way to climb a mountain, and there is understated creativity in going on an adventure. Finding your own routes through the unknown; apply-ingabstract knowledge and technique to the reality of nature; feeling the emotions of the moment. It might be called art. Or just fun.

Summit, 1968, 28 × 22 cm (11 × 8.75 in), 40 pages
Team: Richard Pargeter

Danner	
YEAR:	1971
DIMS:	22 × 15 CM
	8.75 × 5.75 IN
PAGES:	23
TEAM:	UNKNOWN

Holubar	
YEAR:	1960
DIMS:	23 × 16 CM
	9 × 6.25 IN
PAGES:	24
TEAM:	UNKNOWN

Tents

EMS

The Outdoors Specialists

Eastern Mountain Sports		YEAR:	UNKNOWN
DIMS:	22 × 10 CM (8.75 × 3.75 IN)	TEAM:	UNKNOWN
PAGES:	4		

WORDS & LETTERFORMS
Typographic pieces where words are the primary form of expression.

With so much focus on the photography and illustrations beautifying outdoor catalogues and magazines, it can be easy to overlook the words. But the typography of some covers makes it impossible to miss. In these designs, words are the primary form of expression, featuring prominently in the logo, or in big, bold statements emblazoned across the page. They may use different typefaces, from standard sans-serif fonts to illustrated or handwritten fonts. Attributes like colour, size and spacing, in addition to shadowing and embossing effects, serve to emphasize the characters even more. In an industry where natural settings and gear are so central to their business, it seems odd to focus on text, but somehow it works.

The designs that stand out range from simple layouts and bold treatments to kitschy fonts and impactful logos. The Fall & Winter 1973 Cannondale cover is simple, indeed: a black, all-caps font reads, 'BACKPACKING AND BICYCLING CANNONDALE' (p. 330). Though there are no images of packs or bikes, the bold approach almost screams at the viewer, who is left knowing exactly what to expect inside. A more playful take on type is found in the 1971 Gerry 'How to Enjoy Camping' booklet (p. 343), on which the title is printed in an outdoors-inspired log font. Perhaps the most memorable uses of typography are in company logos. Examples include the pointy 1970s-vintage Lowa logo (p. 338), which is wonderfully reminiscent of mountain peaks, as well as Marilyn Moss's signature-turned-logo (p. 332), which served as an instantly recognizable emblem for Moss Tent Works, which she ran for many years with her husband, Bill. The use of these striking logos exhibits ultimate confidence that consumers will connect with the brand name, and they look great to boot. If a picture paints a thousand words, then these covers show that words, too, can say more than just what is printed on the page.

Cannondale	
YEAR:	1973
DIMS:	21 × 21 CM
	8.25 × 8.25 IN
PAGES:	21
TEAM:	JOHN WISTRAND
	MARK LANGE

Cannondale	
YEAR:	1974
DIMS:	9 × 23 CM
	3.5 × 9 IN
PAGES:	48
TEAM:	JOHN WISTRAND
	MARK LANGE
The Archive's copy of this catalogue has actual grease smudges on the cover. It's easy to imagine a bike mechanic, fifty years ago, picking up the catalogue and thumbing through it in between repair jobs.	

330

"I taught mother everything she knows about kid's outerwear."

— Tim Boyle, President, Columbia Sportswear

1992 YOUTH WORKBOOK
COLUMBIA SPORTSWEAR COMPANY

Columbia Sportswear Co.		YEAR:	1992
DIMS:	28 × 22 CM (11 × 8.75 IN)	TEAM:	UNKNOWN
PAGES:	8		

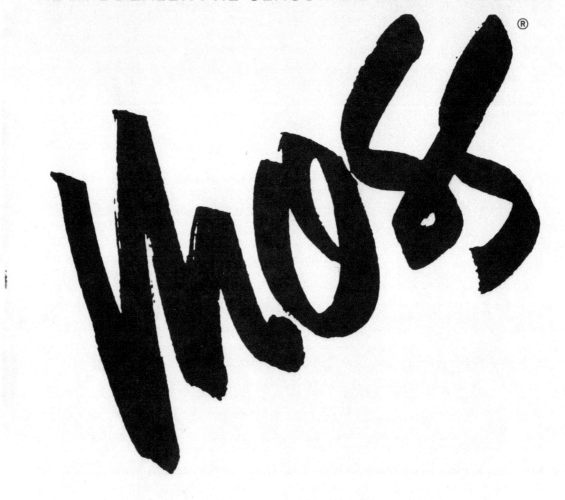

88/89

RETAIL DEALER PRE-SEASON DISCOUNT PROGRAM

Moss Tent Works		YEAR:	1988
DIMS:	28 × 22 CM (11 × 8.75 IN)	TEAM:	UNKNOWN
PAGES:	4		

Moss Tent Works	
YEAR:	1982
DIMS:	20 × 29 CM
	7.75 × 11.25 IN
PAGES:	14
TEAM:	UNKNOWN

Moss Tent Works, Camden, Maine 04843

Moss Tent Works	
YEAR:	UNKNOWN
DIMS:	28 × 10 CM
	11 × 3.75 IN
PAGES:	7
TEAM:	UNKNOWN

333

Columbia Sportswear Co.	
YEAR:	1983
DIMS:	28 × 22 CM
	11 × 8.75 IN
PAGES:	14
TEAM:	UNKNOWN

Caribou	
YEAR:	1983
DIMS:	22 × 28 CM
	8.75 × 11 IN
PAGES:	27
TEAM:	UNKNOWN

ALPINE

Afs 8000 • Afs Guida • Afs Evoluzione • Anapurna

BACK PACKING

Mtf 700 • Mtf 650 gv • Mtf 500 • Afx 520 gv nbk
Afx 520 gv • Afx 535 v • Cerro Torre gv • Shanxy gv • Davos

FSN

USA Customers Note
This is an International Catalog. For USA
product availability, refer to the enclosed price
list located inside the back cover. Thank you

Fsn 95 gtx • Fsn 90 gtx • Fsn 80 gtx • Fsn 70 gtx • Fsn 55 gtx • Fsn 150 gtx
Fsn 400 • Fsn 295 gtx • Fsn 280 gtx • Tiger gtx • Sunny

ENDURO

Volcano • Geo • Krypton • Nomad • Liberty
Electra • Daystar • Scrambler • Metropolis • Freedom

VOGUE

Infinity • Planet • Roamer • Tuareg • Cruiser

ASOLO®
www.asolo.com

ASOLO		YEAR:	2002
DIMS:	23 × 16 CM (9 × 6.25 IN)	TEAM:	LORENZO TRENTO
PAGES:	36		

The Karhu Edge

1985/86

Karhu		YEAR:	1985
DIMS:	22 × 15 CM (8.75 × 5.75 IN)	TEAM:	UNKNOWN
PAGES:	14		

Gerry	
YEAR:	1971
DIMS:	28 × 16 CM
	11 × 6.25 IN
PAGES:	5
TEAM:	UNKNOWN

337

Coleman	
YEAR:	1988
DIMS:	28 × 22 CM
	11 × 8.75 IN
PAGES:	22
TEAM:	UNKNOWN

Lowa	
YEAR:	UNKNOWN
DIMS:	22 × 21 CM
	8.75 × 8.5 IN
PAGES:	6
TEAM:	JIM CATLIN
	CHARLE GAIL

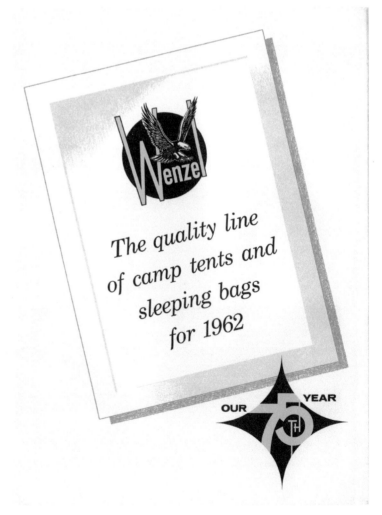

Wenzel	
YEAR:	1962
DIMS:	28 × 21 CM
	11 × 8.25 IN
PAGES:	18
TEAM:	UNKNOWN

338

Announcing....

Marmot Mountain Works

Annual Fall Sale

Sept. 30 - Oct. 3

6½-70% OFF ALL

SLEEPING BAGS

BOOTS

COOKWARE

BACKPACKS

TENTS

CLOTHING

SALE HOURS:	FRIDAY	SEPT. 30	10–8	LOCATION:
	SATURDAY	OCT. 1	10–6	3049 ADELINE ST.
	SUNDAY	OCT. 2	11–5	BERKELEY, CA 94703
	MONDAY	OCT. 3	10–6	(½ block south of Ashby)
	TUESDAY	OCT. 4	CLOSED	849-0735

Marmot		YEAR:	1983
DIMS:	28 × 22 CM (11 × 8.75 IN)	TEAM:	UNKNOWN
PAGES:	32		

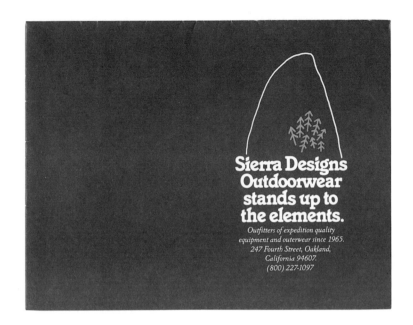

Sierra Designs	
YEAR:	1983
DIMS:	22 × 28 CM
	8.75 × 11.25 IN
PAGES:	2
TEAM:	UNKNOWN

Sierra Designs	
YEAR:	1983
DIMS:	22 × 28 CM
	8.75 × 11.25 IN
PAGES:	2
TEAM:	UNKNOWN

Sierra Designs	
YEAR:	1983
DIMS:	22 × 28 CM
	8.75 × 11.25 IN
PAGES:	2
TEAM:	UNKNOWN

MAMMUT
Ihr treuer Begleiter
in Fels und Eis...

MAMMOTH – your
trusty Companion
in Rock and Ice...

MAMMOUTH
votre fidèle camarade
dans le rocher
et dans la glace...

Mammut		YEAR:	UNKNOWN
DIMS:	16 × 11 CM (6.25 × 4.25 IN)	TEAM:	UNKNOWN
PAGES:	47		

Mountaineering Equipment

JANUARY 1947

Gerry		YEAR:	1947
DIMS:	16 × 12 CM (6.25 × 4.75 IN)	TEAM:	UNKNOWN
PAGES:	4		

Gerry	
YEAR:	1971
DIMS:	14 × 22 CM
	5.5 × 8.75 IN
PAGES:	50
TEAM:	WINCHESTER

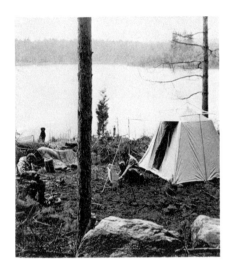

$1.00

HOW TO ENJOY CAMPING

...and discover the out-of-doors

Lowa	
YEAR:	UNKNOWN
DIMS:	18 × 18 CM
	7 × 7 IN
PAGES:	7
TEAM:	UNKNOWN

343

LOWA—the boots with experience

American Mount Everest Expedition 1963 • First Winter Ascent of the Eiger North Face 1961 • First Winter Ascent of the Diretissima through the Grosse Zinne North Face 1961 • International Himalayan Expedition 1971 • First Winter Ascent of the Matterhorn North Face 1962 • Eiger North Face Diretissima 1966 • Austrian Hindukusch Expedition 1969 • Piz Badille North East Face, Winter Ascent 1968 • First Ascent Dombai Maly Ulgen North Face, Caucasus 1968 (icewall heights 3.000 feet) • French Himalayan Jannu Expedition 1962 • German Andean Expedition 1962 • American Hindukusch Expedition 1964 • Japanese Diretissima of the Eiger North Wall 1969 • Austrian Karakorum Expedition 1964 • Swedish Greenland Expedition 1966 • Austrian Pamir Expedition Vienna 1967 • German Himalayan Expedition 1964 • Jugoslavian Himalayan Expedition 1965 • Karakorum Expedition with Hermann Buhl, First Ascent of the Broad Peak 1957 • First Winter Ascent of the Super Diretissima through the Grosse Zinne North Face 1963 • German Diamar Expedition 1961 • Austrian Andean Peru Expedition 1966 • Hindukusch Exploration DAV Schorndorf Germany 1967 • First Steirische Karakorum Himalayan Expedition 1964

Moss Tent Works	
YEAR:	1980
DIMS:	22 × 29 CM
	8.75 × 11.25 IN
PAGES:	14
TEAM:	SPECTRUM ARTWORKS

Columbia Sportswear Co.	
YEAR:	1992
DIMS:	28 × 22 CM
	11 × 8.75 IN
PAGES:	5
TEAM:	UNKNOWN

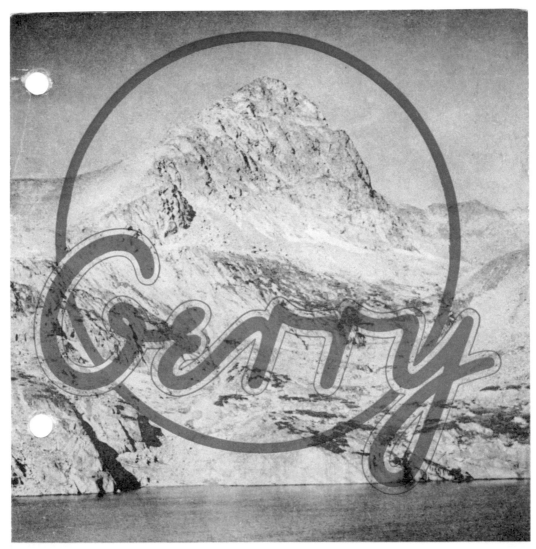

Christmas Gift Suggestions Marked

Mountain equipment
made in the mountains
by mountaineers like yourself

1958
WINTER
SPRING

GERRY, Ward, Colorado

Phone 388

U. S. A.

Gerry		YEAR:	1958
DIMS:	22 × 14 CM (8.75 × 5.5 IN)	TEAM:	UNKNOWN
PAGES:	28		

Rivendell Mountain Works	
YEAR:	UNKNOWN
DIMS:	22 × 10 CM
	8.75 × 3.75 IN
PAGES:	11
TEAM:	UNKNOWN

P.O. Box 198, Victor, Idaho 83455
(208) 787-2746

WINTER 78/79

Exciting New Products for the Serious Outdoorsman!

Rivendell Mountain Works	
YEAR:	1978
DIMS:	22 × 15 CM
	8.75 × 5.75 IN
PAGES:	30
TEAM:	UNKNOWN

IMPORTANT! You will NOT receive future catalogs unless you return enclosed card!

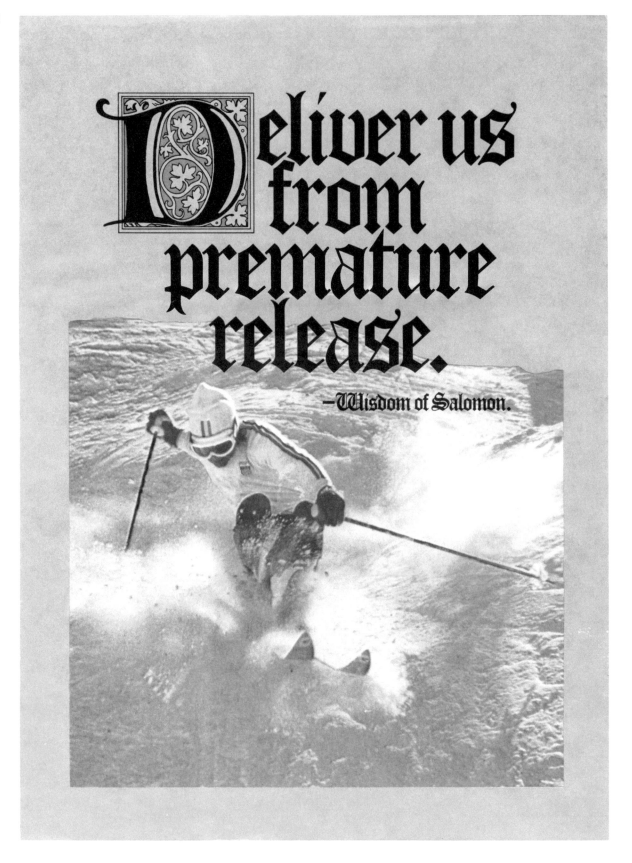

Salomon		YEAR:	UNKNOWN
DIMS:	29 × 21 CM (11.5 × 8.25 IN)	TEAM:	UNKNOWN
PAGES:	3		

78/79 FALL/WINTER PRICE LIST

348

Woolrich			YEAR:	1978
DIMS:	28 × 11 CM (11 × 4.25 IN)		TEAM:	UNKNOWN
PAGES:	22			

Wenzel		YEAR:	1936
DIMS:	24 × 11 CM (9.5 × 4.25 IN)	TEAM:	UNKNOWN
PAGES:	15		

Scarpa	
YEAR:	2001
DIMS:	29 × 22 CM
	11.25 × 8.75 IN
PAGES:	32
TEAM:	UNKNOWN

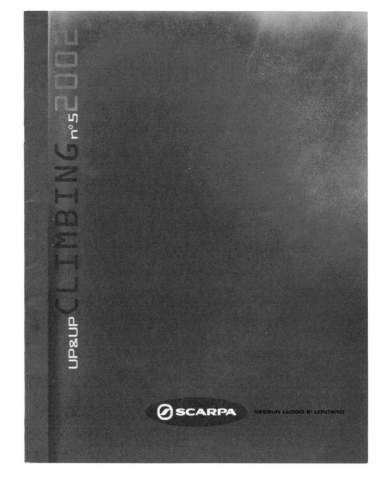

Scarpa	
YEAR:	2002
DIMS:	26 × 21 CM
	10.25 × 8.25 IN
PAGES:	22
TEAM:	B&B RESI ASOLO

350

*Backcountry
Ski and
Snowboard
Equipment
97*

Voilé		YEAR:	1997
DIMS:	22 × 14 CM (8.75 × 5.5 IN)	TEAM:	UNKNOWN
PAGES:	31		

"In developing
this year's winter line,
we faced only one thing
more demanding
than the conditions."

—Tim Boyle

Columbia Sportswear Co.		YEAR:	1988
DIMS:	28 × 22 CM (11 × 8.75 IN)	TEAM:	UNKNOWN
PAGES:	31		

Better Eating

*for those who follow
the Road to Adventure*

Handbook: 35c

11333 Atlantic
Lynwood, Calif. 90262

Dri Lite	
YEAR:	UNKNOWN
DIMS:	23 × 17 CM
	9 × 6.75 IN
PAGES:	20
TEAM:	UNKNOWN

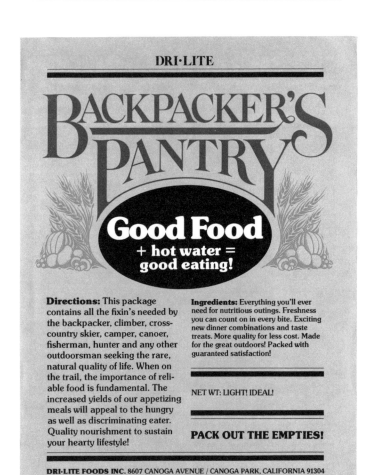

353

Dri Lite	
YEAR:	UNKNOWN
DIMS:	28 × 22 CM
	11 × 8.75 IN
PAGES:	3
TEAM:	UNKNOWN

If your feet are cold, put your hat on. That may sound facetious, but to those who understand how the human body works in a cold environment it is a simple statement of fact.

Man is essentially a tropical animal. He is able to survive and enjoy life in cold climates, where he is also more efficient and productive, only because his ingenuity allows him to maintain his body temperature within the very narrow limits dictated by his physiology. The viable temperature limits are actually about 75°F to 100°F for deep body teamperature, but nature has provided us with a comfort threshold well within these limits. Since the purpose of this booklet is comfort, not survival, we will concern ourselves with keeping comfortable, and touch on only enough theory to give a background for the practical suggestions offered (see page 9 if you want to skip the theory). It is important to realize that you are interested in your own comfort, not in tables of averages as we are forced to use here. Since there is a very wide difference in how individuals react to cold, the data presented here must be tempered by your own reaction. These suggestions will tell you how to be warmer, but not how warm you will be.

Gerry	
YEAR:	1967
DIMS:	18 × 13 CM
	7 × 5.25 IN
PAGES:	15
TEAM:	UNKNOWN

WILDERNESS TRIPS YOU CAN ENJOY

by GERRY CUNNINGHAM

Each year Americans are earning more and more time for recreation. For some of us recreation means bowling, or do-it-yourself projects in the basement, or watching T. V. To many, however, recreation means getting away from throngs of people and the constant pressure of modern civilization.

This need for solitude was recognized by President Johnson in his Natural Beauty Message of February 8, 1967, in which he said in part, "The forgotten outdoorsmen of today are those who like to walk, hike, ride horseback, or bicycle. For them we must have trails as well as highways. Nor should motor vehicles be permitted to tyrannize the more leisurely human traffic." Tyrannize is a good word for what the ubiquitous gasoline engine has done to civilized man. We Americans will go to great lengths to avoid physical exercise. Trail bikes are found deep in the forest where foot traffic is much more appropriate. In winter, snow machines carry people where they should be skiing or snow shoeing. Others will haul a 600 lb. fully loaded motor boat over a mile long portage to avoid paddling a canoe. Half the exercise has even gone out of a game of golf for those who ride around the course in an electric buggy. All in all it is hard to see how this attitude can benefit the health of our nation. It should be a source of pride to a man, as to how far he can walk, not how far he can force his jeep past the end of the road.

To escape from the noise and smell of motor vehicles is to shed half the pressure of modern life. To travel through an unspoiled countryside under one's own power and at one's own pace is to return for a moment to the serenity of nature. Walking is the basic form of natural travel, but horses, bicycles, canoes and sail boats are all means of quietly enjoying the natural scene. The question is; "Where can we enjoy these peaceful pursuits and not be disturbed by the noise and smell of gasoline?"

On the water, motor boats can go almost anywhere, but there are still a few opportunities to outwit the motorist: Floating down an Ozark river, running the wild rivers of the West, or the white water rivers of the East, traveling remote ponds and lakes where portaging is necessary.

Gerry	
YEAR:	1967
DIMS:	18 × 13 CM
	7 × 5.25 IN
PAGES:	15
TEAM:	UNKNOWN

A GUIDE TO BACKPACKING & CAMPING

GERRY

Gerry		YEAR:	1977	One of founder Gerry Cunningham's innovations was not only creating great gear, but also educating consumers about how to use it. Alongside the company's catalogues, Cunningham published informational booklets such as this one.
DIMS:	22 × 14 CM	PAGES:	55	
	8.75 × 5.5 IN	TEAM:	LEE REEDY	

VISUAL INDEX
Featured artworks from 71 brands

Organized alphabetically by brand name and chronologically by year

A

A5 ADVENTURES

 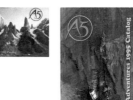

1988, p. 317 1989, pp. 41, 319 1990, p. 319 1993, p. 38 1995, p. 229

ADVENTURE 16

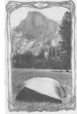 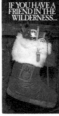 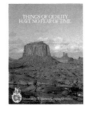 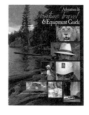 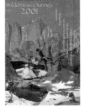

1976, p. 250 1981, p. 66 1983, p. 18 1987, p. 268 2001, p. 268 UNKNOWN, p. 268

ASOLO

 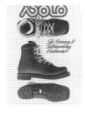

1981, p. 238 1981, p. 238 1981, p. 238 1998, p. 109 1999, p. 194 2000, p. 109

2000, p. 109 2001, p. 220 2002, p. 335 2003, p. 237 2005, p. 268 2010, p. 237

ATHLETA

 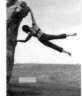 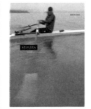

1999, p. 71 2000, p. 147 2000, p. 228 2003, p. 228

ATOMIC

1993, p. 77 1995, p. 220 1995, p. 268 1996, p. 265 2002, p. 222 2003, p. 123

UNKNOWN, p. 220

B

BLACK DIAMOND
EQUIPMENT

 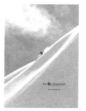 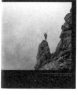

1990, p. 188 1991, p. 217 1992, pp. 10, 80 1994, p. 316 1996, p. 32 1998, p. 32

 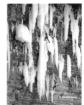

1998, p. 220 1999, p. 66 2001, p. 80 2001, p. 81 2002, p. 82 2002, p. 85

 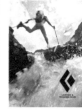

2002, p. 221 2003, p. 221 2003, p. 221 2004, p. 223 2005, p. 223 2010, p. 223

BLACKS

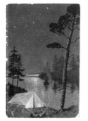 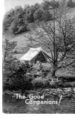 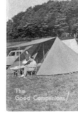 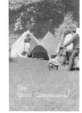 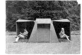

1938, p. 320 1952, p. 130 1960, p. 131 1961, p. 131 1963, p. 244 1964, p. 134

1967, p. 147 1968, p. 244 1970, p. 316 1971, p. 198 1972, p. 75

BURTON

1985, p. 231 1988, p. 212 1993, p. 213 UNKNOWN, p. 212

BUTTERMILK
MOUNTAIN WORKS

1985, p. 216

C

CAMPMOR

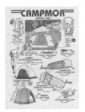

1986, p. 299

CANNONDALE

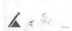
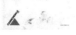
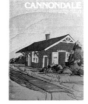

1973, p. 330 1974, p. 330 1979, p. 294

CARIBOU

1983, p. 334 1984, p. 247 1984, p. 247 UNKNOWN, p. 249

CARIKIT

1972, p. 282

CASCADE DESIGNS

1991, p. 134 1995, p. 22 1997, p. 155

CHUMS

1997, p. 139 1999, p. 66 2000, p. 66 2002, p. 319 2003, p. 314 UNKNOWN, p. 66

UNKNOWN, p. 244

COLEMAN

1963, p. 74 1964, p. 318 1968, p. 133 1969, p. 318 1970, p. 132 1971, p. 135

1974, p. 142 1976, p. 133 1980, p. 155 1980, p. 318 1982, p. 159 1984, p. 186

 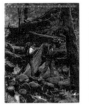 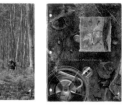

1984, p. 319 1988, p. 337 1992, p. 129 1993, p. 183 1994, p. 188 1995, p. 22

 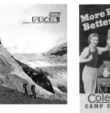

1995, p. 200 2003, p. 120 2005, p. 95 UNKNOWN, p. 16 UNKNOWN, p. 266 UNKNOWN, p. 319

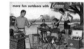

UNKNOWN, p. 319

COLUMBIA SPORTSWEAR CO.

1978, p. 22 1983, p. 334 1987, p. 319 1988, p. 319 1992, p. 286 1992, p. 344

 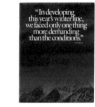 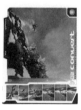

1992, p. 331 1994, p. 138 1998, p. 352 2001, p. 204 2002, p. 204

D

DANA DESIGN

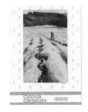

1989, p. 35 1991, p. 261 1992, p. 261 1993, p. 95 1998, p. 261 1999, p. 302

UNKNOWN, p. 307

DANNER

1971, p. 326 1974, p. 139 1983, p. 67

DRI LITE

UNKNOWN, p. 353 UNKNOWN, p. 353

E

EASTERN MOUNTAIN SPORTS

1972, p. 239 1975, p. 318 1976, p. 243 1977, p. 243 1978, p. 291 1979, p. 285

 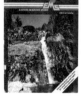

1979, p. 319 1980, p. 285 1981, p. 201 1982, p. 171 UNKNOWN, p. 327

EDDYLINE

2014, p. 50 2016, p. 248 UNKNOWN, p. 121

G

GERRY

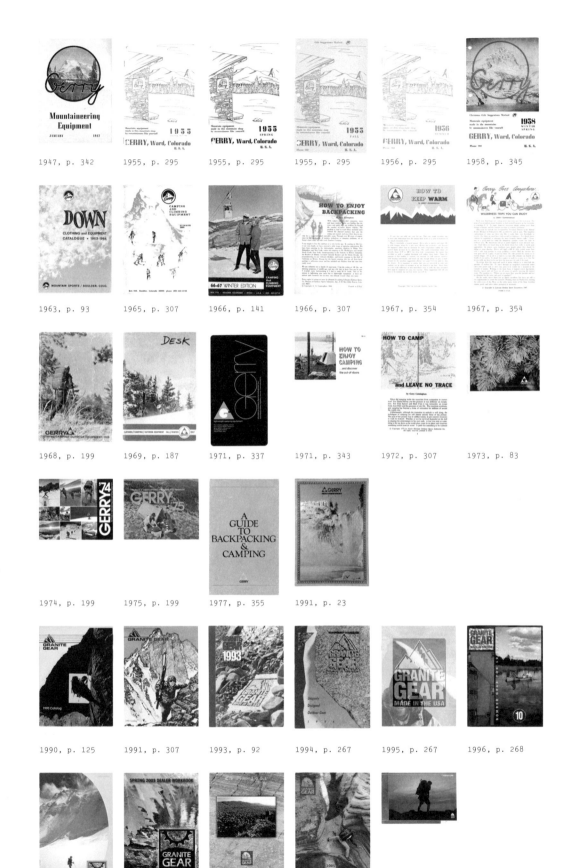

1947, p. 342 1955, p. 295 1955, p. 295 1955, p. 295 1956, p. 295 1958, p. 345

1963, p. 93 1965, p. 307 1966, p. 141 1966, p. 307 1967, p. 354 1967, p. 354

1968, p. 199 1969, p. 187 1971, p. 337 1971, p. 343 1972, p. 307 1973, p. 83

1974, p. 199 1975, p. 199 1977, p. 355 1991, p. 23

GRANITE GEAR

1990, p. 125 1991, p. 307 1993, p. 92 1994, p. 267 1995, p. 267 1996, p. 268

2002, p. 188 2003, p. 23 2004, p. 23 2005, p. 221 2007, p. 189

GRANITE STAIRWAY
MOUNTAINEERING

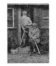

1974, pp. 97, 182 1977, p. 22

H

HINE SNOWBRIDGE

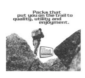

1974, p. 268 1975, p. 242 1976, p. 221 1977, p. 23 1978, p. 66 1979, p. 189

1980, p. 107

HOLUBAR

1960, p. 326 1962, p. 206 1964, p. 195 1969, p. 318 1970, p. 318 1971, p. 318

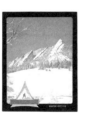

1973, p. 28 1973, p. 28 1974, p. 248 1974, p. 66 1978, p. 146 1978, p. 153

1979, p. 140

I

IBEX

UNKNOWN, p. 74 2000, p. 263 2000, p. 318

J

JACK WOLFSKIN
OUTDOOR EQUIPMENT

1991, p. 271 1993, p. 318

K

KARHU

1980, p. 283 1985, p. 336 1991, p. 210

KELTY

1965, p. 140 1969, p. 33 1976, p. 257 1977, p. 52 1980, p. 306 1985, p. 257

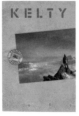

1989, p. 23 1989, p. 220 1996, p. 52 1997, p. 72 UNKNOWN, p. 66 UNKNOWN, p. 66

UNKNOWN, p. 67 UNKNOWN, p. 264

KIRTLAND TOUR PAK

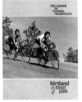

1974, p. 155 1975, p. 242 1976, p. 151 1978, p. 151 1979, p. 151 1980, p. 106

 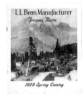

1981, p. 220 1982, p. 146 1984, p. 54

L

L. L. BEAN

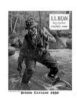 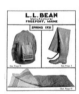

1922, p. 269 1927, pp. 161, 306 1929, p. 186 1930, p. 306 1931, p. 56 1932, p. 312

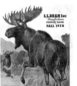

1936, p. 306 1938, p. 137 1938, p. 312 1945, p. 307 1948, p. 313 1951, p. 307

 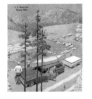

1955, p. 312 1963, p. 307 1964, p. 308 1965, p. 309 1965, p. 310 1966, p. 308

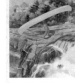

1970, p. 306 1972, pp. 6, 292

LOWA

1999, p. 246 2000, p. 298 2002, p. 234 2005, p. 108 UNKNOWN, p. 111 UNKNOWN, p. 338

UNKNOWN, p. 343

LOWE ALPINE SYSTEMS

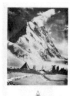
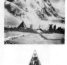
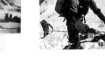

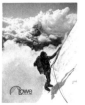
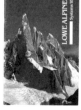
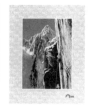

1975, p. 20 1978, p. 178 1979, p. 147 1981, p. 188 1985, p. 22 1985, p. 226

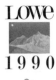
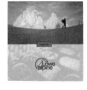

1987, p. 268 1990, p. 26 1996, p. 271

M

MAMMUT

UNKNOWN, p. 341

MARMOT

1977, p. 21 1978, p. 21 1980, p. 21 1983, p. 196 1983, p. 339 1988, p. 178

1994, p. 256 1997, p. 188 1999, p. 120 1999, p. 256 2000, p. 22 2002, p. 283

2004, p. 270 2005, p. 269 UNKNOWN, p. 119

MILLETS

1971, p. 146

MOSS TENT WORKS

1979, p. 58 1980, p. 344 1982, p. 333 1983, p. 58 1984, p. 172 1988, p. 332

1989, p. 173 1990, p. 173 1994, p. 83 1994, p. 106 1997, p. 146 UNKNOWN, p. 333

MOUNTAIN GAZETTE

1974, p. 24 1975, p. 88 1975, p. 301 1976, p. 115 1976, p. 190 1976, p. 301

1977, p. 24 1977, p. 65 1977, p. 87 1977, p. 115 1978, p. 25 1978, p. 86

 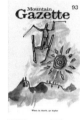 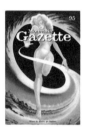

2001, p. 259 2003, p. 114 2003, p. 291 2003, p. 303

MOUNTAIN HARDWEAR

 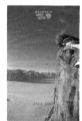

1994, p. 307 1995, p. 245 1998, p. 174 2001, p. 38 2002, p. 175 2003, p. 221

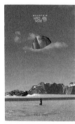 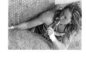

2004, p. 189 2006, p. 200 2008, p. 194

MOUNTAIN HOUSE

 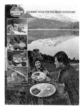

1978, p. 263 1981, p. 154

MOUNTAIN SAFETY
RESEARCH (MSR)

 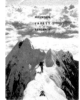

1980, p. 192 1981, p. 69 1994, p. 221 1995, p. 192 2005, p. 69 UNKNOWN, p. 296

MYSTERY RANCH

2000, p. 61 2000, p. 92

N

NALGENE

1999, p. 174

O

OSPREY

1985, p. 291 1986, p. 73 1992, p. 218 1994, p. 293 1995, p. 293 1999, p. 306

2000, p. 306

P

PRANA

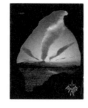 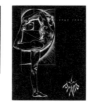

1996, p. 39 2000, p. 235 2000, p. 297 2002, p. 89 2002, p. 90 2002, p. 91

R

RIVENDELL
MOUNTAIN WORKS

1974, p. 205 1978, p. 346 UNKNOWN, p. 23 UNKNOWN, p. 346

ROSSIGNOL

1980, p. 67 1981, p. 227 1981, p. 306 1983, p. 76 1984, p. 67 1991, p. 67

1992, p. 221 1993, p. 221 1994, p. 269 1994, p. 269 1999, p. 227 1999, p. 264

2000, p. 189 2001, p. 125

S

SALOMON

1983, p. 262 1991, p. 269 1991, p. 269 1995, p. 220 1996, p. 59 1996, p. 67

 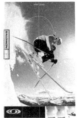 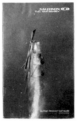 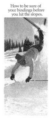

1997, p. 136 1999, p. 219 2001, p. 219 UNKNOWN, p. 77 UNKNOWN, p. 150 UNKNOWN, p. 323

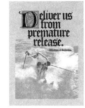

UNKNOWN, p. 347

SCARPA

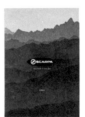

2000, p. 22 2001, p. 350 2002, p. 22 2002, p. 350

SHELTER SYSTEMS

 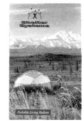

1978, p. 322 1993, p. 176 1996, p. 146

SIERRA DESIGNS

1969, p. 118 1973, p. 179 1974, p. 23

1974, p. 189 1975, p. 296 1976, p. 62

1976, p. 260 1977, p. 62 1977, p. 67 1978, p. 190 1983, p. 340 1983, p. 340

 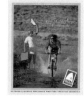

1983, p. 340 1985, p. 323 1988, p. 269 1989, p. 147 1989, p. 189 1990, p. 147

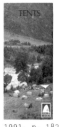

1991, p. 182 1992, p. 188 2002, p. 269 2004, p. 269 UNKNOWN, p. 315

SLUMBERJACK

1994, p. 23

SNOW PEAK

 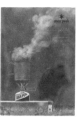 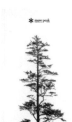

2000, p. 53 2001, p. 67 2004, p. 55 2017, p. 29

SPRINGBAR TENTS

1983, p. 158

STEPHENSON'S WARMLITE
EQUIPMENT

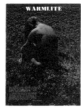

1974, p. 30

SUMMIT

1956, p. 240 1957, p. 157 1958, p. 116 1958, p. 304 1959, p. 252 1959, p. 304

1960, p. 253 1960, p. 304 1961, p. 305 1962, p. 252 1963, p. 94 1963, p. 290

1963, p. 305 1963, p. 305 1965, p. 251 1965, p. 253 1966, p. 116 1966, p. 258

1967, p. 117 1967, p. 258 1967, p. 290 1968, p. 290 1968, p. 324 1969, p. 112

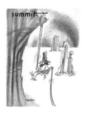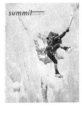

1969, p. 291 1969, p. 291 1970, p. 253 1970, p. 300 1971, p. 117 1972, pp. 8, 208

 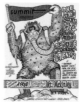 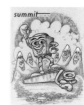

1972, p. 252 1972, p. 291 1973, p. 119 1973, p. 110 1973, p. 291 1973, p. 284

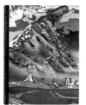 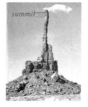 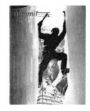

1974, p. 17 1974, p. 208 1975, p. 110 1976, p. 16 1978, p. 180 1979, p. 208

 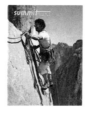

1980, p. 170 1983, p. 70 1985, p. 170 1986, p. 291

T

THE NORTH FACE

 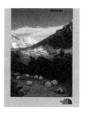 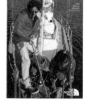

1966, p. 273 1977, p. 34 1978, p. 34 1982, p. 36 1983, p. 193 1984, p. 184

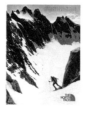

1984, p. 224 1985, p. 211

THERM-A-REST

1984, p. 60

THULE

1982, p. 51 1999, p. 188 2002, p. 234 UNKNOWN, p. 289

TITLE NINE

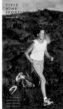 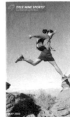

1998, p. 215 2002, p. 146 2003, p. 214 2005, p. 214

U

ULTIMATE DIRECTION

1991, p. 230 1992, p. 146 1993, p. 188 1996, p. 230 1997, p. 220

V

VASQUE

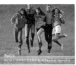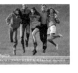 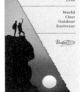 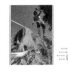

1987, p. 147 1996, p. 268 1998, p. 234 1999, p. 84 2001, p. 255 2005, p. 152

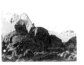

2010, p. 122 UNKNOWN, p. 236 UNKNOWN, p. 136

VOILE

1997, p. 351 UNKNOWN, p. 207 UNKNOWN, p. 207 UNKNOWN, p. 209 UNKNOWN, p. 220 UNKNOWN, p. 288 UNKNOWN, p. 288

WALRUS

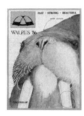

1986, p. 291 1991, p. 22 1992, p. 122 1999, p. 68

WAVE PRODUCTS

UNKNOWN, p. 23 UNKNOWN, p. 226

WENZEL

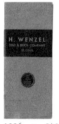 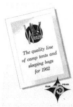 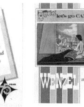 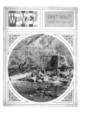

1936, p. 349 1962, p. 338 1966, p.290 1967, p. 146 1972, p. 144 1974, p. 147

 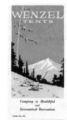

1979, p. 145 1980, p. 189 UNKNOWN, p. 290

WILDERNESS EXPERIENCE

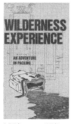

1974, p. 254 1974, p. 67 1976, p. 254 1984, p. 189 1984, p. 224 1985, p. 147

1986, p. 188

1986, p. 225

1986, p. 225

UNKNOWN, p. 189

UNKNOWN, p. 290

UNKNOWN, p. 290

UNKNOWN, p. 306

UNKNOWN, p. 61

WINTERSTICK

UNKNOWN, p. 231

WOOLRICH

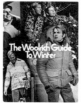
1976, p. 149

1977 p. 290

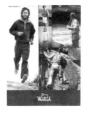
1978, p. 348

1979, p. 146

1980, p. 64

1981, p. 63

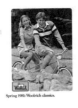
1981, p. 148

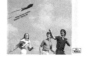
1982, p. 128

1983, p. 147

1984, p. 251

1985, p. 156

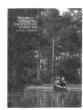
1986, p. 124

1986, p. 64

1986, p. 290

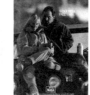
1986, p. 156

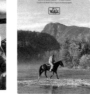
1988, p. 191

1988, p. 128

1989, p. 148

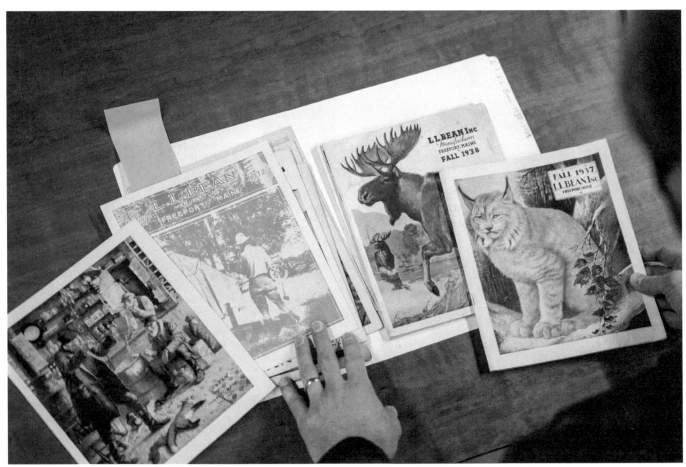

MAKING OF

To visit the world's largest public collection of historical outdoor-gear catalogues, you have to know where to look. Logan, nestled in the beautiful Cache Valley in Utah, is home to Utah State University (USU) and its 'nexus for curiosity, collaboration and inclusive community', the Merrill-Cazier Library. Enter through the front doors, step into the sunbathed atrium, head down the main stairwell and you'll arrive at Special Collections and Archives (SCA), which holds the library's rare and unique materials, including the Outdoor Recreation Archive (ORA). Here, in a wood-panelled reading room, friendly staff are happy retrieve any of the catalogues, magazines, documents and photographs that comprise this treasure trove of outdoor history. The collections themselves are stored onsite in a staff-only, temperature- and humidity-controlled facility, where grey archival boxes fill row after row of beige mobile shelving.

While most of SCA's collections are focused on documenting the history of USU and the Intermountain West, the subset of materials that make up the ORA have somewhat unexpectedly become the most utilized. It all started in 2017 when Sean Michael, a professor in the university's Outdoor Product Design and Development (OPDD) programme approached the then-head of SCA, Brad Cole, about building a collection of historical outdoor-gear catalogues to support Michael's History of Outdoor Products course. The task was soon handed over to us, the authors, Chase Anderson and Clint Pumphrey, and we quickly got to work. Chase, the OPDD Programme Coordinator, was able to leverage his industry connections to identify an initial donation of catalogues in 2018, and Clint, an archivist, coordinated the cataloguing and digitization of the covers.

Increased attention came when Chase began posting a cover image a day on the Archive's Instagram. Soon, people from all over the world were asking about visiting the Archive or getting scans of certain catalogues. Recognizing the broad appeal of the collection, we sought to build it through additional donations and purchases. As of 2024, there about 6,100 catalogues from more than 900 brands dating from 1900 to the present. The Archive has also grown to include other materials, such as outdoor magazines and unpublished documents and photographs from brands, company founders and former employees.

While collecting these materials is important, the ultimate goal is to share them as freely and widely as possible, and this book represents an exciting way to do just that. Selecting the imagery was daunting given the volume of the collection. We set aside several days where we reviewed box after box of catalogues, laying each one out on a large table and choosing some of our favourites as well as ones we knew would appeal to our audience.

We hope you'll find your way to the Archive sometime, but until then, we hope this book is the next best thing to seeing it in person.

Acknowledgments

This book represents a culmination of the significant work and support we've received from our colleagues, collaborators and families since launching the Outdoor Recreation Archive project in 2018.

There are many people we'd like to thank from Utah State University (USU), including the Dean of Libraries, Jennifer Duncan; the Department Head for Library Collections and Discovery, Liz Woolcott; the Digital Assets Librarian, Darcy Pumphrey; and the Department Head for Technology, Design and Technical Education, Brian Warnick, who have allowed us to take the idea for the Archive and run with it. The work of the Archive is much bigger than the two of us, so we'd also like to thank USU Special Collections curators and staff who helped to ensure collections are catalogued and made available to the public. Our student employees deserve a huge amount of this credit as well for their unfaltering work describing, filing and digitizing new materials that come in the Archive. We'd especially like to thank our Karen Oelerich Outdoor Recreation Archive intern, Lincoln Johnson, who, in addition to the tasks mentioned above, gathered all the caption information for each catalogue and magazine.

We're also grateful to our donors and collaborators outside the university who have shown their support for the Archive project through financial and material contributions. To those who have given materials to the collection, thank you for entrusting your prized possessions to us; we are truly honoured to help preserve it for generations to come. A big thanks as well to the brands who are represented in this book for granting us permission to use their imagery and to our contributing authors for their incredible insights. The fact that you all were willing give your content, time and energy to be a part of this project means a lot.

As this was our first time publishing a book, we are grateful to our contacts at Thames & Hudson, Lucas Dietrich and Helen Fanthorpe, for patiently answering our many questions and sticking with us as we figured out how to make this project work. USU Associate General Counsel, Ryan Brady, was also a tremendous help in this process, and we appreciate him carving out time in his busy schedule to work through our questions as well. And to the design team at Actual Source: we are always so impressed by your work and so happy we got to collaborate with another great group of Utahns on this project!

Chase: Tal, thanks for your love, patience and support throughout this process. This book required late nights and a lot of my focus and attention beyond the traditional 9–5. I routinely brought this project home with me and you now probably know more about obscure outdoor brands than you ever expected.

Clint: Darcy, as your colleague, I appreciate the many hours you put in, ensuring the imagery was scanned properly and to specifications. As your partner, I'm grateful for your support during all the late nights it took to finish this project. It's been a crazy year, but I'm glad to have gone through it with you. And to our son, Dean: thanks for being the best little kid a dad could ask for. Hopefully, you'll think this book is cool one day!

About the Authors

CHASE ANDERSON is the Industry Relations Manager for the Outdoor Product Design & Development programme at Utah State University (USU). Chase earned a master's degree in Instructional Technology and a bachelor's degree in International Business, both from USU. He fell into the outdoor industry volunteering for Cotopaxi during their early years. During this time, he started attending Outdoor Retailer trade shows and developed a love for the industry. He went on to work in the outdoor/fitness space for brands like NordicTrack, Proform, iFit and Altra. As one of the collaborators behind the Outdoor Recreation Archive, Chase markets and promotes the collection and works with industry and donors to find new materials. He is also the host of the *Highlander Podcast*, a weekly show focused on talking about the past, present and future of the outdoor industry.

He loves cycling and exploring Cache Valley, Utah, where he lives with his wife, Talia.

CLINT PUMPHREY is the Manuscript Curator and Program Chair for Archives Outreach and Instruction at Utah State University (USU) Special Collections and Archives in Logan, Utah. He manages more than 550 collections of letters, diaries and other unpublished records related to local and regional history including his most recent project, the Outdoor Recreation Archive. Previously, he was employed as the National Register Historian for the Arkansas Historic Preservation Program after earning a master's degree in history from USU. Clint lives with his wife, Darcy, and son, Dean, in Logan's Island neighbourhood, using his 1892 farmhouse as a base camp for hikes, snowshoe treks and trail runs.

CHRIS BURKARD is an explorer, photographer, creative director and author. His photographs frequently feature untamed, powerful landscapes as Burkard works to capture stories that ask humans to consider their relationship with nature.

JEFF STAPLE is a creative visionary whose work encompasses graphic, fashion and footwear design, as well as brand marketing. He is the founder of Reed Art Department, where has worked on countless creative projects for clients ranging from start-up brands for *Fortune* 100 companies.

NUR ABBAS is a menswear designer. He founded Gnuhr in 2022, bringing experience from previous roles including Senior Menswear Designer at Louis Vuitton, Head Menswear Designer at UNIQLO, Design Director at Nike ACG and Head of Design at Yeezy.

YOON AHN is the founder and creative director of AMBUSH®, a jewellery and ready-to-wear brand based in Tokyo. She is the current Nike Global Women's Curator and has collaborated with brands such as Beats by Dre, Bvlgari, Rimowa, Moët & Chandon, Levi's and Coca-Cola.

SAEED AL-RUBEYI co-founded socially conscious unisex fashion brand STORY mfg. with his wife,

Katy. STORY mfg. was born of a desire for a more authentic, fulfilling and kind approach to fashion.

CONRAD ANKER is a US climber, mountaineer and author. He has spent decades in the mountains, travelling the globe from Antarctica to the Himalaya, and is continually inspired by the value of immersion in other ecosystems and cultures.

AMY AUSCHERMAN is the Director of Archives and Brand Heritage at MillerKnoll, where she contributes to research, exhibition curation and design scholarship. Since the 1930s, Herman Miller and Knoll have produced some of the most iconic pieces of American Modernist furniture.

BRITTANY BOSCO is a multidisciplinary artist best known as an R&B singer and by her stage name, BOSCO. Recognized in the *Adweek* Creative 100, Bosco is founder of Slug Global, a team of young artists from diverse backgrounds creating visual experiences infused with music and culture.

THIBO DENIS is the leading men's footwear designer at Dior. He has worked on collaborations with brands including Jordan, Sacai and Birkenstock.

RONNIE FIEG is a footwear and clothing designer, and founder, CEO and creative director of sneaker and streetwear brand Kith. Fieg has collaborated with many other brands, including Adidas, Converse, New Balance and Nike. As of 2022, he is also the first-ever creative director of the New York Knicks.

ELIZABETH GOODSPEED is an independent graphic designer and art director who specializes in idea-driven and archivally inspired identity and print projects. She also teaches at RISD and Parsons, and serves as the US editor-at-large for arts publication *It's Nice That*, where she writes about aesthetic trends, industry news and design history.

DR RACHEL S. GROSS is a historian of the outdoor gear and apparel industry. She is assistant professor at the University of Colorado

Denver and the author of *Shopping
All the Way to the Woods: How
the Outdoor Industry Sold Nature
to America*.

KATIE HARGRAVE AND MEREDITH LAURA
LYNN are artists and educators who
work collaboratively to explore the
historic, cultural and environ-
mental impacts of so-called public
land. Hargrave is an associate
professor of art at the University
of Tennessee at Chattanooga and
Lynn is an assistant professor of
art at Florida State University.

SHIGERU KANEKO is chief buyer at
Beams Plus, a vintage clothing
lover who collects vintage outdoor
wear while enjoying a log-cabin
lifestyle in Tokyo.

DR JULIE LAMARRA, an esteemed
assistant professor at Utah State
University, specializes in Outdoor
Product Design and Development.
Her work centres on unravelling the
narratives and connections within
brand identity structures. She has
been moulding young minds since
2009.

ALASDAIR LEIGHTON-CRAWFORD is
founder of CIMORO, a London-based
design company making high-perfor-
mance bespoke sportswear and
accessories. CIMORO focuses on ath-
leticism, craftsmanship and design
in the pursuit of excellence.

NICK AND WILLAMINA MARTIRE co-
founded specialist trail-shoe brand
NORDA Run in 2020. Avid trail run-
ners and footwear industry experts,
the husband-and-wife team released
their first high-strength, ultra-
light shoe in 2021.

W. DAVID MARX is the author of
*Ametora: How Japan Saved American
Style* and *Status and Culture: How
Our Desire for Social Rank Creates
Taste, Identity, Art, Fashion, and
Constant Change*. He lives in Tokyo,
Japan, and his newsletter is 'Cul-
ture: An Owner's Manual' (culture.
ghost.io).

NICOLE MCLAUGHLIN is a Colorado-
based designer focused on
upcycling. By reworking discarded
miscellanea, McLaughlin breathes
new life into old products in a
fun and functional way.

KIMOU MEYER is an artist, co-founder
of sports-focused creative agency
Doubleday & Cartwright and magazine
Victory Journal and currently a
creative director for Nike. He has
worked on major commercial projects
including rebranding NBA's Milwau-
kee Bucks and developing the brand
vision for David Beckham's MLS
franchise, Inter Miami CF.

NOVA / MARIANNA MUKHAMETZYANOVA
lives in London and works as
a Senior Brand Creative at Nike.
She likes playing *Fortnite*,
sticking magazine cut-outs in
her Hobonichi book, drinking
Sapporos and buying trainers.

JEANINE PESCE is a dynamic brand
strategist and trend forecaster.
As the founder of RANGE, an inde-
pendent consulting agency and
magazine, she is the industry
leader for tracking global trends
in the outdoor, active and life-
style market. Jeanine is also the
Director of Insights at Monday
Creative, a digital marketing and
branding agency in Vancouver, BC.

SOLENE ROGE is a journalist, cur-
ator and translator, and Editor-in-
Chief of *Les Others* magazine. *Les
Others* combines long-form stories,
interviews, illustrations and photo
series into a paper publication for
lovers of the outdoors.

CHARLES ROSS is an academic lead
in Performance Sportswear Design at
the Royal College of Art in London.
He returned to England from being an
outward-bound instructor in the USA
at the end of the 80s; it was cold,
dark, wet and windy so he decided
to work in the dry of the outdoor
industry — in product design.

ASHIMA SHIRAISHI is a professional
rock climber from New York City.
She is also the founder of AllRise,
an experimental programme in the
world of DEI with Braindead and
Long Beach Rising, and author of
the children's book *How to Solve
a Problem*.

JAIMUS TAILOR is a London-based
designer and founder of the crea-
tive studio Greater Goods.

LEI TAKANASHI is a fashion jour-
nalist and writer who works at
The Business of Fashion magazine.

Before joining *The Business of Fashion*, he covered hip-hop, streetwear, graffiti and New York City culture for publications such as *New York Magazine, Mass Appeal, Complex* and 12ozProphet.

AVERY TRUFELMAN is the host and creator of *Articles Of Interest*, a podcast about what we wear. She has been named one of the five hundred most important people in fashion by Business of Fashion, and she was a fellow at the Outdoor Recreation Archive in 2023.

WAI TSUI is the founder and Creative Director of Hiking Patrol®, a curated digital platform based in Oslo. Founded in 2019, Hiking Patrol® is centred around achieving the perfect balance between lifestyle and outdoor exploration. They collaborate with other brands to develop products while prioritizing the creation of socially engaging brand content and experiences.

On the cover: Lowa, date unknown © LOWA Sportschuhe (p. 111)
On the jacket (*left to right*):
Front: Voilé, date unknown (p. 209); Sierra Designs, 1969 by Sierra
Designs | Exxel Outdoors, LLC (p. 118); *Summit*, 1967, Copyrights owned
by Summit Journal / Rewritten Media LLC, summitjournal.com (p. 117)
Inside flap: Salomon, 1996 (p. 59); Title Nine Sports, 2003 (p. 214)
Spine: Prana, 2002 (p. 91)
Back: Black Diamond, 2002 (p. 85); Atomic, 1995 (p. 220); Marmot®, 1983
by Marmot ©Newell Brands. (p. 197)
Inside flap: Blacks, 1952 (p. 130); *Mountain Gazette*, 1978 (p. 25).

First published in the United Kingdom in 2025 by
Thames & Hudson Ltd, 181A High Holborn, London WC1V 7QX

First published in the United States of America in 2025 by
Thames & Hudson Inc., 500 Fifth Avenue, New York, New York 10110

*The Outdoor Archive: The Ultimate Collection of Adventure & Sporting
Graphics, Illustrations and Gear* © 2025 Thames & Hudson Ltd, London

Text by Clint Pumphrey and Chase Anderson © 2025 Utah State University
Foreword © 2025 Chris Burkard

Design by ACTUAL SOURCE (actualsource.work)

All imagery by publications as listed, with additional picture credits
on page 383

British Library Cataloguing-in-Publication Data
A catalogue record for this book is available from the British Library

Library of Congress Control Number 2024944347

ISBN 978-0-500-02599-4

Impression 01

Printed and bound in China by Toppan Leefung Printing Limited

Be the first to know about our new releases,
exclusive content and author events by visiting
thamesandhudson.com
thamesandhudsonusa.com
thamesandhudson.com.au